A Personal Journey: Central African Art from the Lawrence Gussman Collection

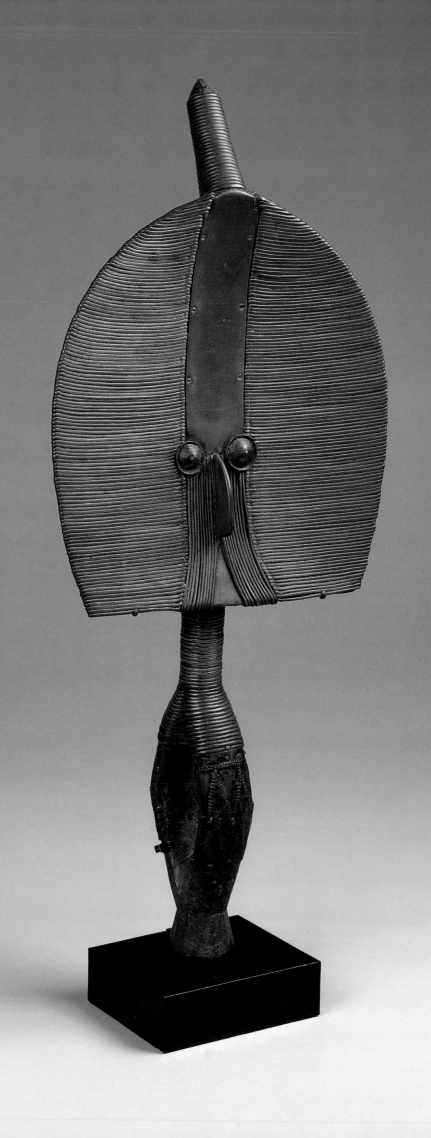

A Personal
Journey

Central African Art

from the
Lawrence Gussman
Collection

Essay by Christa Clarke

With Catalogue Entries by
David Binkley, Christa Clarke, Bryna Freyer,
and Douglas Newton

Neuberger Museum of Art
Purchase College, State University of New York, Purchase, New York

National Museum of African Art
Smithsonian Institution, Washington DC

The Israel Museum, Jerusalem

Published in conjunction with the exhibition:
A Personal Journey: Central African Art from the Lawrence Gussman Collection

February 1, 2001 – June 14, 2001
The Israel Museum, Jerusalem

September 30, 2001 – January 13, 2002
Neuberger Museum of Art, Purchase, New York

February 10, 2002 – April 7, 2002
The Philbrook Museum of Art, Tulsa, Oklahoma

June 9, 2002 – August 14, 2002
National Museum of African Art, Smithsonian Institution,
Washington, DC

© 2001 Neuberger Museum of Art
Purchase College
State University of New York
735 Anderson Hill Road
Purchase, New York 10577-1400
www.neuberger.org

Library of Congress Card Number: 00-106220

ISBN: 0-934032-16-5

General Editors: Lucinda H. Gedeon, Christa Clarke
Manuscript Editor: Stephen Robert Frankel

Design: Marc Zaref Design, Inc.
Printed in China

Photography Credits:
Neuberger Museum of Art/Jim Frank: catalogue numbers 3, 4, 9, 11–12, 13,
15, 18, 19, 21, 23, 26, 27, 29, 31, 32, 33, 38, 39, 41, 42, 45, 46, 47, 49, 52, 54, 55,
58, 59, 60, 62, 63, 68, 69, 70, 71, 72, 73
National Museum of African Art/Franko Khoury: catalogue numbers 5, 22, 24,
28, 34, 35, 36, 43, 74
The Israel Museum/Avshalom Avital: catalogue numbers 1–2, 4, 6, 7, 8, 10, 14,
16, 17, 20, 25, 30, 37, 40, 44, 48, 50, 51, 53, 56, 61, 64, 65, 66, 67, 75
The Metropolitan Museum of Art: catalogue number 57
LeRay, c. 1910, pg. 16; P.A., c. 1905, pg. 18; Eliot Elisofon, 1966, pg. 19; pg. 20
Courtesy Eliot Elisofon Photographic Archives, National Museum of African Art

cover illustration:
Harp *(ngombi),* Fang peoples, Gabon, Early 20th century, wood, hide,
pigment, metal, nylon strings, 68.6 x 17.8 x 55.9 cm (27 x 7 x 22 in.),
Collection Neuberger Museum of Art, Purchase College, State University of
New York, gift of Lawrence Gussman in memory of Dr. Albert Schweitzer,
1999.06.39. Photo Jim Frank

back cover illustration:
Bell *(dibu),* Kongo peoples, Democratic Republic of the Congo
Late 19th–early 20th century, wood, stone, 21.8 x 12.1 x 10.5 cm
(8 9/16 x 4 3/4 x 4 1/8 in.), Collection National Museum of African Art,
Smithsonian Institution, Washington, DC, gift of Lawrence Gussman in
memory of Dr. Albert Schweitzer, 98-15-9. Photo Franko Khoury

frontispiece:
Reliquary Guardian Figure *(bwiti),* Hongwe peoples, Gabon, 19th–early
20th century, wood, copper-alloy sheet and wire, iron, 58.4 x 24.8 x 7.6 cm
(23 x 9 3/4 x 3 in.), Collection The Israel Museum, Jerusalem, gift of Lawrence
Gussman, New York, to American Friends of the Israel Museum in memory
of Dr. Albert Schweitzer, B97.0009. Photo Avshalom Avital

Contents

Foreword

Lawrence Gussman began collecting African art in 1965, after several preparatory years of reading, visiting museum collections and consulting internationally with scholars, collectors and dealers. He began to build his exceptional collection with works from Gabon, a country he knew intimately through his experiences there as a businessman and volunteer. While President and Chairman for many years of Stein & Hall, a chemical company, Gussman also volunteered in Lambaréné, Gabon at the hospital built by the legendary medical missionary Dr. Albert Schweitzer. Schweitzer became a close personal friend of Gussman and his wife Kaye, a nurse who also assisted at the hospital until her death in 1991.

Over the decades, Gussman gradually came to focus his collection on the art of central Africa, a region with which he was familiar from his travels, though he saw beauty in African art from throughout the entire continent. As a collector, he has always been extraordinarily generous, not only in lending his works to numerous museum exhibitions but also in supporting African cultural patrimony. Gussman's quiet but essential role in the repatriation of the Afo-a-Kom, a large beaded throne figure from the Kom Kingdom, which appeared in 1973 on the art market under questionable circumstances, is but one instance of this sensitive commitment.

In yet another remarkable gesture, Lawrence Gussman decided recently to donate his African collection, not to one institution, but rather to three museums with which he has maintained long ties: The Israel Museum, Jerusalem; the National Museum of African Art, Smithsonian Institution; and the Neuberger Museum of Art, Purchase College, State University of New York. As beneficiaries of the collection that he so thoughtfully and carefully built, each of us is grateful for Larry's extraordinary gifts, and for the breadth, depth and quality that his generosity has added to our respective collections of African art. We are pleased to demonstrate our profound gratitude through this publication and the exhibition it accompanies, and delighted with this opportunity to share his gifts with the world.

Lucinda H. Gedeon, *Director*
Neuberger Museum of Art, Purchase, NY

James S. Snyder, *Anne and Jerome Fisher Director*
The Israel Museum, Jerusalem

Roslyn Adele Walker, *Director*
National Museum of African Art, Washington DC

Acknowledgments

This traveling exhibition has come together over a two-year period through the collaborative efforts of three institutions: The Israel Museum, Jerusalem; the National Museum of African Art, Smithsonian Institution; and the Neuberger Museum of Art, State University of New York, Purchase College. Its organizers, Martin Wright, Acting Curator, Arts of Africa, Oceania and the Americas, The Israel Museum; Roslyn A. Walker, Director, National Museum of African Art, and Lucinda H. Gedeon, Director, Neuberger Museum of Art, wish to extend their thanks to the exhibition planning team (whose names are indicated with an (*) below) and the many individuals who helped to bring the exhibition and its publication to fruition. First and foremost, our gratitude and warm appreciation go to Larry Gussman, whose generous gifts to our institutions have enriched our collections significantly and have enabled us to share these extraordinary works with so many others.

At The Israel Museum, Jerusalem, deep appreciation is extended to Douglas Newton, former Chairman of the Department of Africa, Oceania and the Americas at The Metropolitan Museum of Art, who helped to make the selections from the Gussman Collection for the Israel Museum's permanent collection, and who wrote the entries in this catalogue that pertain to the works in the Israel Museum's collection. In addition, thanks go to Kate Ezra, former curator of African Art at The Metropolitan Museum of Art for reviewing and commenting on the text. Many members of the Israel Museum staff contributed to the realization of the exhibition in Jerusalem. In particular, thanks are offered to Dorit Shafir*, Associate Curator of African and Oceanic Art, for all her hard work. Moreover, appreciation is

extended to Yigai Zalmona, Chief Curator-at-Large; Suzanne Landau, Yulla and Jacques Lipchitz Chief Curator of the Arts; Yvonne Fleitman. Associate Curator, Art of the Americas; Daphna Lapidot and the Shipping Department; Miriam Apfeldorf, Registrar; and the members of the staff of the Exhibition Design Department, the Publications Department and the Chemistry Conservation Laboratory. In addition, thanks go to photographer Avshalom Avital, exhibition designer Talma Levine, and Shana Kaplan of the New York office of American Friends of the Israel Museum for their help.

At the National Museum of African Art, grateful appreciation is extended to Chief Curator David Binkley* and Assistant Curator Bryna Freyer* for their contributions of the catalogue entries of works belonging to the Smithsonian Institution. Associate Curator Christine Mullen Kreamer provided much-needed assistance, as did Registrar Julie L. Haifley and her staff: Liesl Scheer Dana, Katherine Sthreshley and Jeffrey Smith. Thanks also go to Photographer Franko Khoury, Exhibition Designer Alan Knezevich and his staff: Keith Conway, who made mounts for the sculptures, and Lisa Vann, who generated the map. In addition, we thank Chief Conservator Stephen Mellor, who accompanied the exhibition to all the venues, and Assistant Conservator Dana Moffett, Editor Migs Grove, and Assistant Director Patricia Fiske. We acknowledge the contributions of the entire staff, all of whom in some way contributed to the success of this exhibition.

At the Neuberger Museum of Art, much appreciation is extended to Curator of African Art Christa Clarke* for her introductory essay to this catalogue and for her contribution of the entries that accompany works in the Neuberger's collection.

She was involved with every aspect of the project's overall coordination for which we extend our grateful appreciation. In preparing the exhibition and publication, Clarke benefited from the generosity of many colleagues who offered their expertise, advice and insights, and she would like to express her gratitude to the following individuals: Niangi Batulukisi, University of Lubumbashi, Democratic Republic of the Congo; Frank Herreman, Museum for African Art, New York; Alisa LaGamma, The Metropolitan Museum of Art, New York; Jessica Levin, Harvard University, Cambridge, Massachusetts; Constantine Petridis, Antwerp, Belgium; Guy van Rijn, Antwerp, Belgium; Mary "Polly" Nooter Roberts, Fowler Museum of Cultural History, UCLA; Allen F. Roberts, Department of World Arts and Culture, UCLA; Roy Sieber, Professor Emeritus, Indiana University and Research Scholar Emeritus, National Museum of African Art, Smithsonian Institution; and Zoe Strother, Department of Art History, UCLA. Thanks also go to Ross Day, Leslie Preston and Joy Garnet of the Robert Goldwater Library at The Metropolitan Museum of Art who assisted in bibliographic research.

Also on the Neuberger staff grateful appreciation is offered to Registrar Patricia Magnani, who not only coordinated the Neuberger loans but also served as Registrar for the traveling exhibition. In addition, special thanks go to Associate Registrar Alison Lowey, Photographer Jim Frank, Curatorial Assistants Jacqueline Shilkoff and Michele Matusic, José Smith and the staff of the Exhibition Design Department, and the staff of the Education Department. We are extremely grateful to Director of Development Jill Westgard and to Suzanne Grossberg, Director of Sponsored Research for Purchase College, for their efforts to secure funding for the project. The organization of any exhibition is a team effort, thus we acknowledge the contributions of the entire staff.

Thanks also to our colleagues at The Metropolitan Museum of Art who offered willing and cheerful assistance with various aspects of exhibition preparation: Deanna Cross, Photograph and Slide Library; Nina Maruca, Registrar; and, in Objects Conservation, Nancy Reynolds, Sandy Walcott, and Leslie Gat. We appreciate the exceptional work of Lorry Wall at Masterpiece in facilitating international permits to travel the exhibition overseas.

For catalogue design the organizers would like to thank Marc and Cindy Zaref of Marc Zaref Design, Inc., and for his copy editing skills our appreciation goes to Stephen Robert Frankel.

In addition to traveling to Jerusalem, Washington, DC and Purchase, New York, the exhibition will be presented by the Philbrook Museum in Tulsa, Oklahoma. While not part of the organizing team, in the past the Philbrook Museum also has been the recipient of Larry Gussman's generosity and joins us as a venue to share his gifts with the world.

Lucinda H. Gedeon, *Director*
Neuberger Museum of Art

Roslyn A. Walker, *Director*
National Museum of African Art

Martin Wright, *Acting Curator*
Arts of Africa, Oceania and the Americas,
The Israel Museum, Jerusalem

Contributors

David Binkley
Chief Curator, National Museum of African Art,
Smithsonian Institution

Prior to his appointment at the National Museum of African Art, David Binkley served as Curator of Arts of Africa, Oceania and the Americas at the Nelson Atkins Museum and as Research Associate Professor in the Department of Art History at University of Missouri, Kansas City. Dr. Binkley has published a number of articles on Kuba and northern Kete arts associated with funeral and initiation rites and is developing a major exhibition entitled *Kuba—Art of a Central African Kingdom*. His current research interests include colonial and post-colonial discourse on central African artistic traditions and their interpretation in Western scientific and popular thought.

Christa Clarke
Curator of African Art, Neuberger Museum of Art,
Purchase College, State University of New York

Over the past eight years, Christa Clarke has held fellowships at the Metropolitan Museum of Art and the National Museum of African Art and has served as curatorial consultant for various projects for the Philadelphia Museum of Art, the Barnes Foundation, and the World Bank, before assuming her position at the Neuberger Museum of Art in 1999. She has taught at Rutgers University, George Washington University, and the Corcoran School of Art. Dr. Clarke is the author of *The Art of Mor Faye, 1969-1984* (1997) and a contributor to *Mad for Modernism: Earl Horter and His Collection* (1999), among other publications.

Bryna Freyer
Assistant Curator, National Museum of African Art,
Smithsonian Institution

Bryna Freyer has curated or co-curated more than 19 exhibitions at the National Museum of African Art and also serves as Collections Manager for the curatorial department. She is a contributor to the 1999 publication, *Selected Works from the Collection of The National Museum of African Art* and the author of the 1987 publication, *Royal Benin Art in the Collection of the National Museum of African Art*. Her research interests include Benin royal arts and the history of collecting African art.

Douglas Newton
Senior Advisor, Department of Africa, Oceania, and the
Americas, The Israel Museum, Jerusalem

From 1957 until 1978, Douglas Newton was Curator and eventually Director of the Museum of Primitive Art in New York, where he organized more than 60 exhibitions. Beginning in 1974 he was Chair of the Department of the Arts of Africa, Oceania, and the Americas at the Metropolitan Museum of Art and has also served as Advisor on non-Western art, National Gallery of Australia, Canberra from 1974 until 1988. He is currently a member of the acquisitions committee of the Musée du Quai Branly, Paris. Mr. Newton is widely published and has edited a number of books on non-Western art.

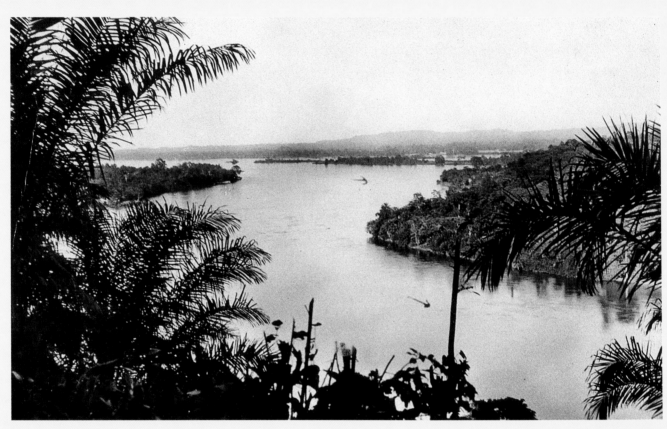

View of the Ogowe River in Lambaréné, Gabon, from a photographic postcard in the collection of Lawrence Gussman.

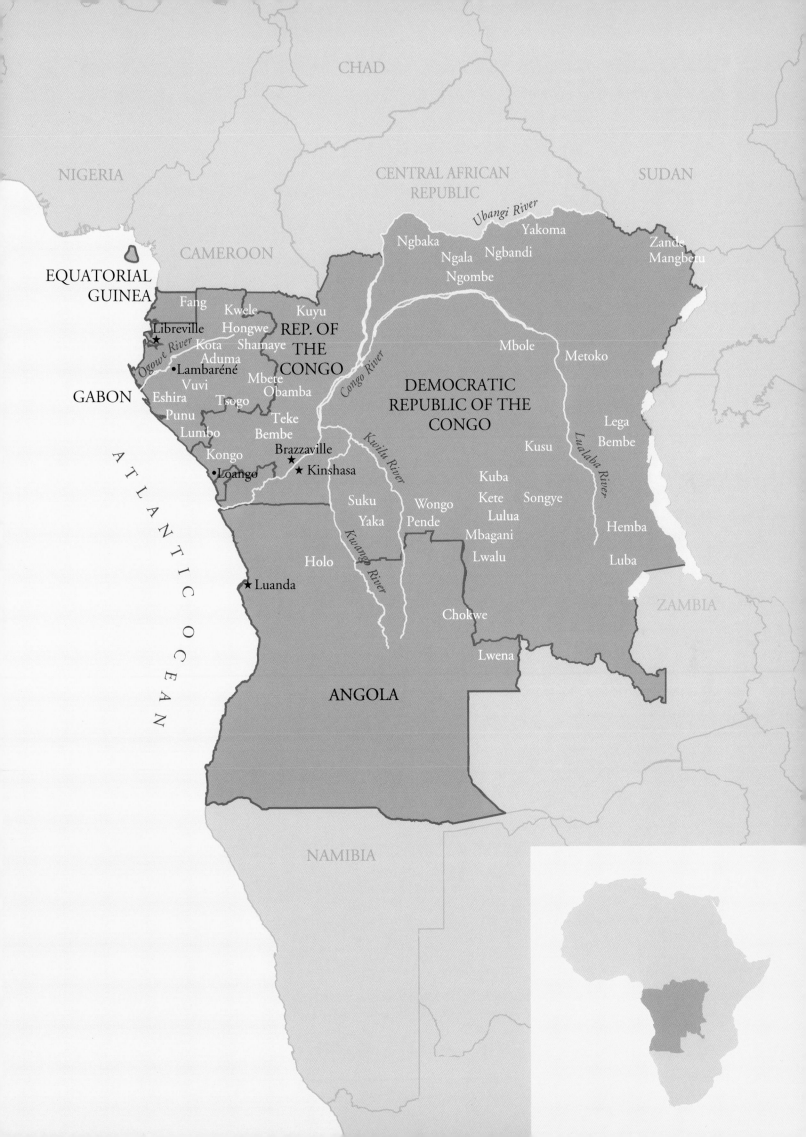

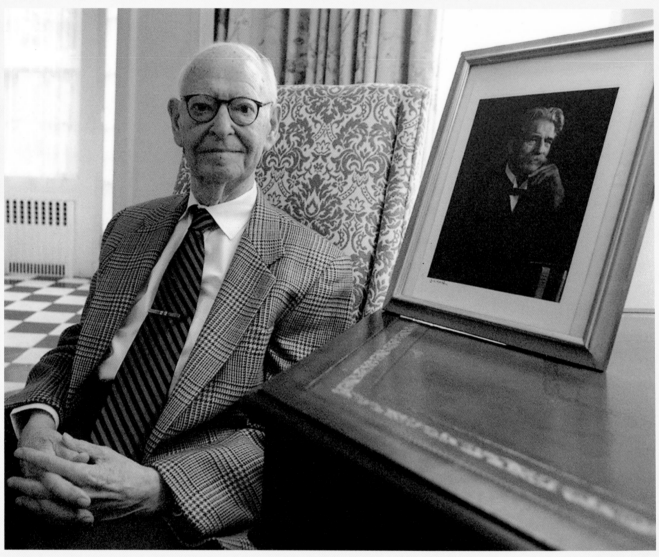

Lawrence Gussman at his home with a photographic portrait of Albert Schweitzer, 1999. Photo courtesy The New York Times/Roberta Herschenson

Beyond Borders:
A Collector's Vision

Christa Clarke

Lawrence Gussman's interest in African art developed over the course of a personal journey of discovery through his involvement with the peoples and cultures of central Africa. The collection he developed over many decades is notable for its strong regional concentration as well as for its representation of the breadth and diversity of artistic creation within that area. This exhibition brings together seventy-five highlights of central African art formerly in the Gussman Collection, now dispersed among the three organizing institutions—the Israel Museum, the Neuberger Museum of Art, and the National Museum of African Art.

The works selected for this exhibition come from more than thirty different African cultures spanning the present-day nations of Cameroon, Gabon, Equatorial Guinea, the Republic of the Congo, the Democratic Republic of the Congo, Angola and Zambia. While the exhibition includes many well-known genres of African art, such as Fang reliquary figures and Luba leadership arts, it also presents works less familiar to Western audiences, such as a rare Holo stringed instrument and an unusual Kota metal-covered mask. Viewed together, the works in the exhibition offer a broad portrait of central African art, emphasizing the dynamic nature of cultural exchange in the region while recognizing the singular expressions of African artists.

Lawrence Gussman traces the beginning of his interest in African art to a trip he made to Gabon in 1957. A year earlier, when he was in South Africa for his specialty chemical business, Gussman had been invited to visit the hospital that Dr. Albert Schweitzer—the legendary Nobel Prize–winning medical missionary—had established in Lambaréné, Gabon, in 1913. In 1957,

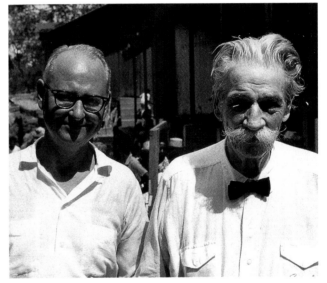

Fig. 1 Lawrence Gussman with Albert Schweitzer in Lambaréné, Gabon, ca. 1957. Photograph by Erica Anderson, courtesy of Lawrence Gussman

on their first trip there, Gussman and his wife, Katherine, a nurse, arrived at the hospital hesitant and unsure of what to expect. The Gussmans were welcomed by Schweitzer himself and soon afterward were immersed in work at the hospital (fig. 1). By this time, the hospital had grown to serve more than five hundred patients daily for the treatment of leprosy and other ailments. During their first week there, the Gussmans spent many hours with Schweitzer, learning more about his work in Gabon and how it led him to develop the core principle that guided his life's mission. Their friendship throughout the years would be marked by Schweitzer's strong humanitarian beliefs, the origin of which Schweitzer later recounted to Gussman in a message on a picture postcard of three islands near the village of Igendji

The three islands near the village Igendju, 80 km downstream from Lambaréné on the Ogowe. It was here, on a September day in 19.. that the idea that reverence for life is the basic principle of ethics and humanity came to me. To Lawrence Gussman in memory. ... Albert Schweitz.

Fig. 2 Photographic postcard showing three islands near the village of Igendji, Gabon. In the inscription to Gussman, Schweitzer notes that it was there, in September of 1915, that he began to develop his humanitarian philosophy.
Courtesy of Lawrence Gussman

(fig. 2): "It was here on a September day in 1915 that the idea that reverence for life is the basic principle of ethics and humanity came to me."

Today, Gussman looks back on that trip as one that changed the course of his life, leading directly to his desire to collect African art. Impressed with Schweitzer's work in Gabon, Gussman returned to Lambaréné every summer for more than thirty years, often accompanied by his wife, to assist in the hospital. There, he would work in the pharmacy, helping out by sweeping the floors and stocking the shelves. During the course of his visits, Gussman developed a long and close friendship with Schweitzer that lasted until Schweitzer's death in 1965. Through Gussman's work at the hospital and his visits throughout Gabon, he also came to know many African people on a personal level and to appreciate their diverse cultural backgrounds.

Lawrence Gussman's visits to Gabon and his involvement with the peoples and cultures there inspired him to begin studying African art. He began by reading books on African art, visiting museum collections, and consulting scholars, dealers, and collectors. He carefully studied the collections of the Museum of Primitive Art in New York (now part of the Metropolitan Museum of Art's African collection), the British Museum in London, and the Royal Museum for Central Africa (also known as the Africa-Museum) in Tervuren, Belgium, among others. Beginning around 1963, Gussman started to collect African art, initially acquiring examples of art from all over sub-Saharan Africa. After a few years, however, he began to specialize in the arts of central Africa, in particular Gabon and the Congo, feeling that he could "relate more" to these cultures because of his work at the Schweitzer Hospital.

Although he traveled to Gabon annually, Gussman did not collect African art on these trips. Instead, he acquired works in Europe and the United States, primarily through dealers, auction houses, and other collectors. Gussman's own life experiences in Gabon led him to think about African art in new ways. An examination of his collection reveals him not to be wedded to the idea of "tribal style"—the notion of certain shared formal characteristics corresponding to ethnic groups defined by fixed societal borders. Indeed, many of the objects represent genres and styles that span different languages and cultures, exemplifying the free exchange of ideas, beliefs, and artistic practices across ethnic boundaries. Moreover, because he had never collected any other types of art, Gussman had no preconceived ideas about African art and thus was open to forms that Western collectors rarely acquired. Rather than merely following precedents set by earlier collectors and limiting himself to objects regarded as belonging to an established canon, he was also interested in works from cultures that were not as well known in the West. Gussman maintains that his primary motivation in choosing these works was aesthetic: he was simply drawn to objects that he considered beautiful. Yet he also recognizes the critical impact of his experiences in central Africa not only in terms of developing his interest in African art but also in opening his eyes to new ways of seeing. He eventually amassed an extraordinary collection of several hundred works of African art, each picked for its intrinsic artistry and not for any external resemblance to Western art forms.

The seventy-five highlights of the Gussman Collection selected for this exhibition reflect the regional focus of the overall collection as well as the diversity of works within it. In this

overview of the exhibition, instead of grouping these works into discrete ethnic units, I have focused on several thematic issues that cross cultural boundaries, emphasizing commonalities of belief in the region and the dynamics of cultural exchange. Central Africa is an area rich in cultural borrowings, a fact that is apparent in the use, style, or materials of many works in this exhibition. At the same time, many of the works exhibited here represent little-known artistic traditions and objects that, while of a familiar genre, have unique or unusual features. The Gussman Collection provides an opportunity to see the connections between cultures and the individuality of artistic expression within a particular culture.

A major portion of the Gussman Collection is devoted to figurative sculpture associated with the preservation of ancestral relics. Several cultures from Cameroon to central Gabon subscribe to the belief that the bones of a deceased relative provide power, in the form of wealth and protection, to its extended family. This wide-ranging system of belief has resulted in distinct ritual traditions and artistic genres. The reliquary figures produced by Fang artists (cat. nos. 1–8) are among the most well-known types of objects in all African art. Used in the rituals of Bieri, an association honoring the ancestors, Fang reliquary statues were placed on top of tree-bark boxes containing the bones of revered ancestors. These sculptures, with their stylized form and glossy dark patina, have appealed to Western collectors since the late nineteenth century. The eight Fang reliquary figures in the Gussman Collection, from an area spanning Cameroon to northern Gabon,

demonstrate an enormous variety of form, iconographic detail, and surface treatment. This stylistic diversity probably resulted from the migration of the Fang peoples over the last century and their subsequent assimilation with neighboring cultures.

The cultures collectively known as Kota, to the east of the Fang in Gabon, produce a variant of reliquary statuary in which the wooden substructure is encased by copper-alloy wire and sheeting (cat. nos. 14–16). The guardian figures created by Kota-speaking groups (including the Hongwe, Shamaye, and Obamba peoples) are used in Bwiti, an ancestral association similar to the Fang peoples' Bieri (fig. 3). Kota use of reliquary figures was somewhat more individualized than that of the Fang, in that the figures were not only placed in baskets housing the bones of important ancestors but were also given specific names. However, Kota reliquary figures are considerably more abstract than those of the Fang, although it is possible to discern human features in the Kota figures' strikingly geometric forms. The sheathing of such works in copper alloy, a costly medium, is a technique unique to the region and signifies the high status of the individual whose bones were guarded. Copper alloy, most often brass, was obtained through trade with Europe and also served as a form of currency among Kota peoples.

Reliquary figures created by the Mbete, Tsogo, and Vuvi peoples are not as well represented in Western collections as those of the Fang and Kota peoples to the north, and their presence in the collection reflects the breadth of Gussman's vision. A distinctive feature of Mbete reliquary figures is the use of the body of

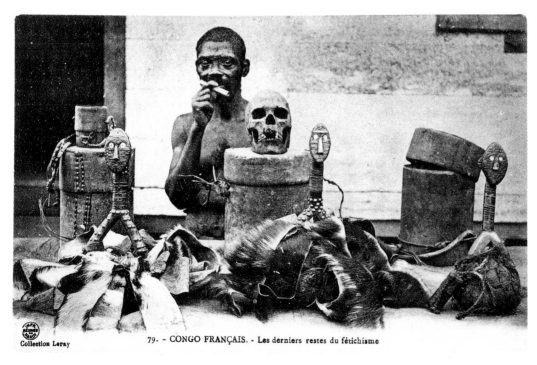

Fig. 3 Collotype postcard of Shamaye reliquaries, French Congo (now Gabon).

Photograph by LeRay, c. 1910. Published by Réunies de Nancy. Eliot Elisofon Photographic Archives, National Museum of African Art

Collection Leray

79. - CONGO FRANÇAIS. - Les derniers restes du fétichisme

the figure itself as a container for the relics of the deceased. The Mbete reliquary in the Gussman Collection (cat. no. 21) shows stylistic links to several cultures throughout Gabon, especially in its use of color symbolism. The contrasting areas of red, black, and white pigment on the figure probably correspond to basic Mbete principles of cosmic and social order, stemming from a conceptual system that is shared by many cultures in the region. Similar color symbolism is found in a reliquary half-figure sculpted by a Tsogo artist (cat. no. 23) and a wooden head attributed to either the Vuvi or Tsogo (cat. no. 24). Both are pigmented with red (a color often associated with life, beauty, and prosperity) and accented with white (alluding to the spirits and the ancestral realm).

Many of the masks in the Gussman Collection reveal the high degree of cultural borrowing throughout central Africa. Several works in the exhibition demonstrate the widespread dispersal of one genre—the white-faced mask—throughout Gabon. The white pigment used in these works is usually derived from kaolin, a fine white clay found near riverbeds. In the Ogowe River region, the Punu, Eshira, and neighboring peoples create naturalistic white-faced masks called *mukudj* (cat. nos. 25, 26) that represent idealized visions of womanhood. Worn by dancers during funeral ceremonies, *mukudj* are considered to be portraits of local women renowned for their beauty who, through the application of symbolic white pigment to the face, have been elevated to the status of a spiritual entity (fig. 4).

The Fang peoples produce variants of white-faced masks that may represent more recent artistic developments. The four-faced helmet mask known as *ngontang* (cat. no. 10), for example, is believed to have originated during the colonial period near the present-day borders of southwestern Cameroon, northern Equatorial Guinea, and northern Gabon as a synthesis of mask styles previously established in the region. Here, the color white alludes not only to the spiritual realm but also to European ancestry, both considered by Fang peoples to be sources of supernatural power in the late nineteenth century. Miniature replicas of white-faced masks (cat. nos. 11, 12), worn on a dancer's upper arm in Bwiti performances, may have been introduced by Fang groups in Equatorial Guinea around the turn of the twentieth century. The traces of white kaolin on the faces of these small arm masks echo the cosmetic preparations of Bwiti dancers who coat their face and body with a thin layer of kaolin before a performance.

For some Gabonese masks in the Gussman Collection, patterns of extensive cultural exchange—further complicated by trade networks established during the colonial era—make it difficult to determine the artist or cultural origin, or even the origin of its

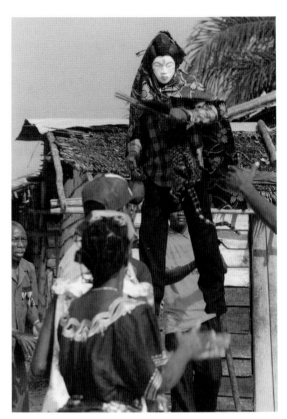

Fig. 4 Punu dancer performing the *mukudj* masquerade, Louango village, Gabon, 1993. Photograph by Alisa LaGamma

particular style or genre. For many years, the white-faced *mukudj* masks were attributed to the M'pongwe, a society that often served as a trade intermediary, selling to Western collectors. On the back of one *mukudj* (cat. no. 26), a tag reads "M'pongwe ca. 1850"—a legacy of this collecting history but not an indication of the work's cultural origin, which remains undetermined. The starkly geometric *mvudi* (cat. no. 20) is a genre of mask that has historically been attributed to the Aduma peoples, expert boatsmen credited with the transmittal of various style elements over a broad area of the Ogowe River region. However, the Aduma may be just one of several cultures in the area, including the Mbete, Nzabi, Teke, and Obamba peoples, that create similar masks.

Several of the masks in the Gussman Collection from what is now the Democratic Republic of the Congo reflect how masking traditions move between or among societies, resulting in stylistically related works that may have different uses in their respective cultures. The Kuba, for instance, adopted a northern Kete mask type called *mukasha ka muadi* (literally, "female mask") and renamed it Ngady amwaash (cat. no. 47). Ngady amwaash is the only female masquerade figure that performs with other masked figures during funeral rites and on other ceremonial occasions associated with leadership at the royal capital of Nsheng. Abstract, geometric masks notable for their enormous protrud-

ing eyes (cat. no. 50) are made by both the Kete and the Mbagani, borrowing additional stylistic elements from the neighboring Salampasu and Lwalu peoples. The domed mask with parallel striations known as *kifwebe* (cat. no. 61) may have been created by either a Songye or a Luba artist. Among the Songye, the mask is associated with dangerous, menacing spirits, while among the Luba, it alludes to benevolent beings.

The Gussman Collection includes several works that demonstrate the variety of ways that Africans employ artistic creations in their everyday lives to effect change and to remedy problems. From southern Gabon to the Democratic Republic of the Congo, artists of varying cultural backgrounds carve figurative wooden sculptures that are designed to be manipulated by a ritual specialist or diviner in ways that tap into the power of spiritual forces (fig. 5). The female figures called *kosi* (cat. nos. 27, 28), sculpted by the Punu and neighboring Lumbo peoples in Gabon, harness the power of a spirit within the sculpture itself and are used by a ritual specialist to exact retribution on behalf of a wronged client. The *buti* figure (cat. no. 31), a genre of the Teke peoples in the Republic of the Congo, is designed to be activated by a diviner who applies symbolic "medicines" tailored to specific functions, such as success in hunting and protection against disease. The Kongo peoples in the Democratic Republic of the Congo are well-known for their use of *minkisi (nkisi,* singular), figures that have "medicines" inserted into or attached to the body, often placed in a mirror-covered box, as in the Gussman example in the form of a dog (cat. no. 35). The neighboring Bembe peoples, primarily in the Republic of the Congo, produce figures that are usually consecrated by a strong breath contained in a cavity in the body, such as cat. no. 34. However, this particular work has more in common with Kongo power objects, since it also features a mirror-covered box filled with medicinal substances similar to that in cat. no. 35, as well as the addition of feathers. Near the Kwango and Kwilu rivers in the southern Democratic Republic of the Congo, the Yaka and Suku peoples both create carved figures that serve a therapeutic ritual function. The Yaka *khosi* (cat. no. 39) and the Suku *biteki* (cat. no. 40) presented in this exhibition would each originally have had horns or packets filled with medicinal substances attached to the figure.

Despite the diversity of form that is apparent in these "power objects," their imagery and use reveal certain commonalities of belief in the region. The application of symbolically charged "medicines"—often no longer identifiable—is a feature of most of the works. In some, the critical empowering ingredi-

ent is invisible, as in the Teke *nkira* (cat. no. 32) and the Bembe figure (cat. no. 34), which are activated by a forceful breath of their owner, a fundamental tenet of the Kongo peoples' belief system as well. In other objects, the power substances are alluded to, as in the miniature *kosi* (cat. no. 27) depicted grasping a gourd, commonly used as a ritual "medicine" container. Several of the works have eyes inlaid with shiny porcelain or traces of white kaolin (cat. nos. 28, 33–35). Such shiny or white eyes symbolize the ability to see beyond the human world into the spiritual realm.

In addition to these "power objects," other works in the Gussman Collection facilitate communication between the spiritual realm and humans in different ways. The spirits of the dead are believed to activate the Luba *kakishi* (cat. no. 59), an oracle employed by practitioners of *kashekesheke*, one of the oldest forms of divination among the Luba in the Democratic Republic of the Congo. Held by both client and diviner together, the *kakishi* communicates with ancestral forces that respond to questions by moving the instrument back and forth across a woven mat or the ground. The rare Fang harp from Gabon (cat. no. 9) is one of the most sacred objects used in Bwiti, a syncretist religious

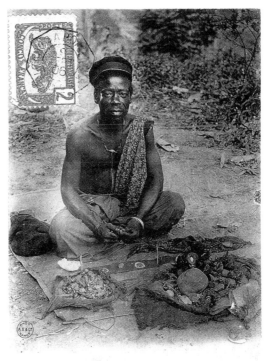

CONGO FRANÇAIS. - Un médecin fiote à Loango

Cliché P. A.

Fig. 5 Collotype postcard of a Kongo ritual specialist, or *nganga,* Loango region, Congo.
Photographed by P.A., c. 1905. Published by A.B. & Co., Nancy.
Eliot Elisofon Photographic Archives, National Museum of African Art

organization that combines local ritual practices and Western Christianity. The harp is believed to contain the spirits of the dead, and in performance, the sounds of the harp create a musical liturgy that gives voice not only to the sacred teachings of Bwiti but to the spirits themselves. Other musical instruments are also associated with the spiritual realm. The elaborately carved *dibu* (cat. no. 36), once part of the public regalia of a Kongo diviner and healer, advertised its owner's ability to summon powerful spiritual forces. The miniature Yaka whistle (cat. no. 38) may also have been used by a diviner or healer to enlist the assistance of benevolent ancestors.

Arts related to status and leadership comprise another extensive category of the Gussman Collection. This grouping includes utilitarian works that serve as ceremonial emblems of association membership or political status, a category of objects often overlooked by Western collectors in favor of figurative sculpture. In Gabon, both the fan (cat. no. 13) and the gong (cat. no. 22) are insignia of membership in a male professional association known as Evóvi among the Tsogo and as Ntol among the Fang. Members of this group serve in multiple capacities as judges, lawyers,

diplomats, and orators. Their distinguishing emblems not only identify these individuals' membership in the association, but also enhance their gestures and pronouncements. Ritual knives are also found throughout central Africa as markers of status. The Kota knife (cat. no. 18) would have been used either as an insignia of a dignitary in the Mungala association or as a funerary marker honoring a deceased chief. Among the Suku, the small, carved wooden cup (cat. no. 41) would be owned by a matrilineage headman or regional chief as a symbol of his authority. Used in highly ritualized drinking ceremonies, such a cup is so symbolically meaningful that the headman on his deathbed passes it on to his successor.

Better known, and more widely collected, are arts associated with the powerful centralized systems of government that developed around the mouth of the Congo River and, further south, in the Zaïre Basin of the Democratic Republic of the Congo. In the Kongo kingdom, the stone *ntadi* (cat. no. 37), placed on the grave of a chief or other distinguished person, represents an artistic tradition that may date to the sixteenth century. Most of the Luba objects in this exhibition are also related to leadership. Staffs of office (cat. nos. 53–55) featured prominently in Luba rituals of investiture, while the ceremonial axe and adze (cat. nos. 56–57) indicated high status. Along with the Luba female figure that was once part of a larger royal emblem (cat. no. 58), these objects all incorporate female imagery, demonstrating the important role of Luba women in the expansion, protection, and success of the Luba kingdom.

Elsewhere in the Democratic Republic of the Congo, initiation associations provided political structure for many societies. The Lega objects in this exhibition (cat. nos. 66–69) are all associated with Bwami, a hierarchically graded association to which all Lega men and women aspire to belong (fig. 6). Each object, owned by high-ranking initiates as emblems of their status, serves as a symbolic expression of Lega values and morals. The neighboring Metoko peoples, whose artistic traditions have not been as extensively researched as those of the Lega and are less well known, have a similarly graded association called Bukota, in which large figurative sculpture (cat. no. 70) are employed, although their specific use is not known. Among the Mbole peoples, the male initiation association known as Lilwa oversees the education of young men in the physical, social, and moral responsibilities of adulthood. During the long and arduous initiation process, the initiates are shown figures depicting a person condemned to death by hanging (cat. no. 71)—the exceptional fate of those who transgress the judicial and moral code of Lilwa.

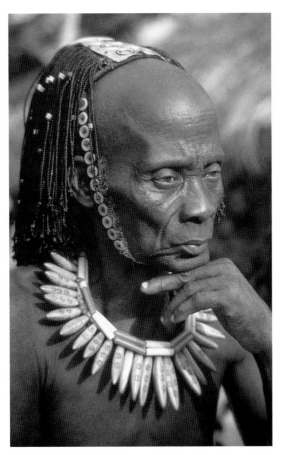

Fig. 6 Lega man wearing the hat and necklace of a Bwami society elder near Kalima, Democratic Republic of the Congo. Photograph by Eliot Elisofon, 1966. Eliot Elisofon Photographic Archives, National Museum of African Art

In central Africa, as in most of sub-Saharan Africa, intricately carved and decorated utilitarian objects are indicators of personal status and prestige. An elegantly carved spoon from southern Gabon (cat. no. 29), with its miniature female figure, was probably a ceremonial prestige object owned by a man. Among the Kuba peoples in the Democratic Republic of the Congo, decorated wooden vessels (cat. nos. 44–46) were purchased by men for their personal use in drinking palm wine. The finely detailed surface decoration of these vessels and their often elaborate form reflected the status of the owner. The Wongo peoples, perhaps influenced by their Kuba neighbors, also produce finely carved palm-wine vessels, often in figural form. However, the Wongo vessel in this exhibition (cat. no. 43) bears many stylistic similarities to the artistic traditions of the Pende peoples, a cultural group whose territorial borders are intermingled with those of the Wongo. The Luba, renowned in the colonial period for their elaborate coiffures, created small wooden headrests to protect their labor-intensive hairstyles. The graceful example presented here (cat. no. 60) is in a style that is distinct from the other Luba works in the exhibition but common to several other known works attributable to a single artist or workshop.

Among the various figurative sculptures in the Gussman Collection, many works emphasize body decoration, allowing for a cross-cultural consideration of aesthetic ideals and social identity in central Africa. The two Lulua female figures from the Democratic Republic of the Congo (cat. nos. 48, 49) are exemplars of *bwimpe*, a single word that conveys the inextricably linked concepts of "goodness" and "beauty" in Lulua thought. Owned by women that have borne healthy and beautiful children, these Lulua sculptures were given exaggerated details of anatomy and symbolically meaningful patterns of scarification that signify the ideal union of moral and physical beauty. Similarly, female figures created by Lwena artists living in the Democratic Republic of the Congo, Angola, and Zambia are often sculptural images of the ideal woman, embodying the physical and social characteristics of a desirable wife and strong mother. Both Lwena figures in this exhibition (cat. nos. 51, 52) emphasize the beautification of the body through their cicatrizations and extended labia, bodily manipulations associated with the process of female initiation. The Hemba male figure from the Democratic Republic of the Congo (cat. no. 63), although it represents a specific, named ancestor, is not intended as a realistic depiction of that person. Instead, the deceased individual is given form as the embodiment of a youthful ideal, with a cruciform coiffure that symbolically evokes the universe. The Kuyu female figure (cat. no. 30),

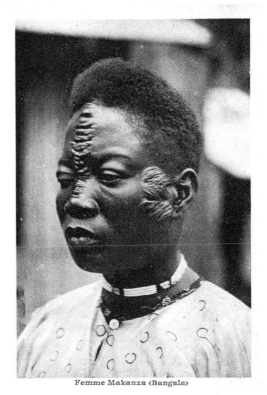

Femme Makanza (Bangala)

Reproduction interdite

Fig. 7 Collotype postcard of an Ngala woman with scarification in what is now the Democratic Republic of the Congo.
Photographer and publisher unknown, c. 1915. Eliot Elisofon Photographic Archives, National Museum of African Art

from the Republic of the Congo, has finely carved details of scarification on the face and torso, about which little has been recorded that explains their cultural meaning.

The Gussman Collection includes some unusual examples of figurative sculpture from the northwestern Democratic Republic of the Congo, a region with a long history of migration and interaction that has resulted in a great diversity of artistic styles. It is therefore often difficult to identify the particular cultural origin for sculpture from the region with any degree of certainty. For some of these objects, representations of culturally specific body arts, including scarification and coiffure, suggest a possible cultural attribution in the absence of collection data. Cat. no. 72, for example, is a female figure that exhibits stylistic traits characteristic of several cultures in the region, including the Ngala, Ngbaka, Ngombe, and Ngbandi. On the basis of the figure's distinctive coiffure and scarification, documented a century ago by travellers to the region, an identification as Ngala has been proposed (fig. 7). Likewise, for cat. no. 74, a male figure, an Ngbandi attribution is suggested by the singular hairstyle recorded by a Capuchin priest early in the twentieth century. More securely attributed is cat. no. 75, a minimalist figure identified

as being from the Zande peoples, whose artistic traditions are better known.

The Gussman Collection also includes some objects that, though related in form or technique to well-known traditions in central Africa, remain largely unknown and/or little-studied by scholars of African art and culture. One such example is a metal-covered face mask from Gabon (cat. no. 17), one of three known works in this style. Its context is undocumented, but the technique of attaching sheet metal to a wooden base strongly supports its attribution to the Kota. Similarly, the Holo stringed instrument (cat. no. 42) is one of only a few such objects in museum collections today. Although its form resembles that of the better-known slit drums used in divination rituals, this type of instrument is played with the aid of an arched bow by a professional musician or storyteller. A diminutive figure set on an iron spike (cat. no. 62), from the Kusu peoples, whose sculpture is relatively rare, was probably used as a power object. This function is suggested by the presence of a cavity in the top of the head filled with symbolically charged ingredients, seen also in objects created by the neighboring Luba peoples.

With its regional focus and breadth of representation, the Gussman Collection invites reflection and reconsideration of the artistic traditions of central Africa. The objects in this exhibition, far from being static markers of ethnic identity, allow us to see the dynamism and diversity of African artistic expression. Considering the works from a cross-cultural perspective reveals the commonalities of belief between and among various cultures that have resulted in such distinctive art forms. At the same time, the variety of objects included in the exhibition broadens our knowledge of central African artistry, introducing little-known traditions and overlooked art forms. This extraordinary collection allows us to share in Lawrence Gussman's personal journey and experience the richness of central African artistry.

Catalogue

Entries 1–75

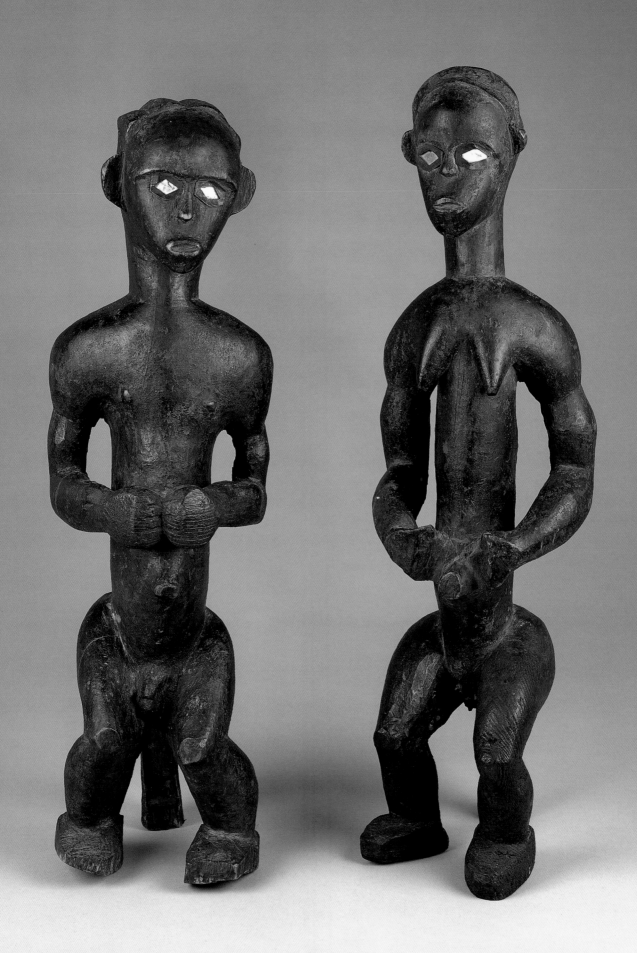

Male Reliquary Guardian Figure
(eyema bieri) (one of a pair)
Fang peoples, Ngumba style,
Cameroon

Late 19th–early 20th century
Wood, brass sheet, mirror glass
51.1 x 17.1 x 12.7 cm (20 1/8 x 6 3/4 x 5 in.)
Collection The Israel Museum, Jerusalem,
gift of Lawrence Gussman, New York, to
American Friends of the Israel Museum in
memory of Dr. Albert Schweitzer, and
David C. Miller, and in honor of Rhena
Schweitzer Miller, B97.004a

Female Reliquary Guardian Figure
(eyema bieri) (second of a pair)
Fang peoples, Ngumba style,
Cameroon

Late 19th–early 20th century
Wood, brass sheet, mirror glass
53.3 x 17.1 x 13.2 cm (21 x 6 3/4 x 5 1/4 in.)
Collection The Israel Museum, Jerusalem,
gift of Lawrence Gussman, New York, to
American Friends of the Israel Museum in
memory of Dr. Albert Schweitzer, and
David C. Miller, and in honor of Rhena
Schweitzer Miller, B97.004b

Reliquary Guardian Figures 1–8
The peoples known collectively as the Fang live dispersed throughout southern Cameroon, Equatorial Guinea, and northern Gabon. European explorers and colonial officials began collecting Fang reliquary figures in the late nineteenth century and continued until about 1930, when such figures seem to have disappeared from use (Perrois, in Fry 1978: 136); however, later carvings done in a more commercial style were documented in the 1940s and 1950s (Fernandez and Fernandez 1975).

Reliquary guardian figures are among the ritual objects and paraphernalia associated with the Bieri ancestor cult, devoted to the ritual honoring of the ancestors in order to obtain their goodwill. To the Fang, these figurative sculptures were replaceable, whereas what they guarded—the physical presence of the ancestors—was irreplaceable. Ancestral bones, especially the skulls of male ancestors, were kept inside cylindrical boxes of bent and sewn bark. The most important relic was a bone from the founder of the lineage and of the village where those particular Fang lived (Perrois, in Perrois and Delage 1990: 45); they also honored women whose exceptional spiritual powers were indicated by their many children. These ancestors, the great of the lineage, could be called upon to assist the living in solving critical problems and dealing with issues important to the survival of the extended family and village: where to locate a village; curing illness or infertility; help with hunting and fishing, or in warfare. It was essential that the ancestors be pleased with the libations, sacrifices, and gifts of jewelry and feather headdresses offered to them by their living descendants.

Bieri sculptures take the form either of heads on stakes (not represented in this catalogue), or of male or female figures, *eyema*

bieri. The latter were attached to the reliquary box by the figure's projecting third "leg," which extends down from the lower portion of the torso. Among the eight Fang reliquary figures shown here, one of them (cat. no. 8) is a half-figure that retains the original lid to its bark box container. During the ritual practices of Bieri, figures were removed from their boxes for ceremonies that dramatized the raising of the dead and were employed almost as puppets (Tessman 1913: vol. 2, 121–23; Perrois, in Perrois and Delage 1990: 50, 53).

The reliquary figures in the Gussman Collection offer contrasts in form and details, providing an intriguing study in theme and variation. The proportions vary from relatively compact with swelling volumetric curves (cat. nos. 5 and 6) to taller figures with more elongated torsos (cat. nos. 1–3). Focusing particularly on the faces, one notes the contrast between soft- versus hard-edge modeling—that is, some figures have round heads with gentle but still distinct heart-shaped facial depressions, while others have pronounced cheekbones and chins. The softly modeled faces have inspired somewhat contradictory comparisons with both infants and skulls. According to field reports, the Fang associate the relatively big heads, large eyes, and flexed legs with infants (Fernandez and Fernandez 1975: 743). The projecting umbilicus or navel, a feature that is widespread in African art, is found on many of these figures—clearly serving as a symbol of fertility linking the ancestors with the future existence of the group.

The artists of these figures appear to have been interested in depicting the ancestors, not in a representational portrait in the Western sense, but through indications of gender, status and power. Details of the head, including carved crests and exten-

sions, refer to the plant-fiber wigs or headdresses once worn by the Fang. These wigs were elaborately ornamented with cowrie shells, glass beads, buttons, and brass tacks. Brass or copper alloy—always associated with wealth and prestige because of its ties to long-distance trade, either within Africa or with Europe—appears as carved jewelry (the armlets on the upper arms of cat. no. 6) or as actual pieces (the neckring on cat. no. 5). The shiny metal is also associated with daylight, and may be applied to the figure to strengthen its defense against intruders of the night, when evil is stronger (Siroto 1995:15). The shining eyes would convey spiritual power, and would provide added drama when the figures were used in rituals. Power can also be deduced from the pose of clasped hands across the torso, a gesture that, though not overtly threatening, suggests a degree of alertness and implies strong arms and chest. The pose also refers to hands holding a container. It is not clear whether, originally, more of the figures actually held a functional container, since many from the Cameroons were collected with integral carved representations of horns, and others from Equatorial Guinea and neighboring Gabon do hold cups. These could have contained spiritually powerful substances that would punish intruders into the Bieri precinct (Perrois, in Fry 1978: 135) might be associated with offerings (Siroto 1995: 17).

One final variation among the figures is in the general surface treatment of the wood. The Cameroon examples (cat. nos. 1 and 2) have honey brown, polished surfaces, perhaps due in part to alterations made by early collectors. More common in reliquary figures from northern Gabon and Equatorial Guinea is the darkened surface that results from the ritual application of

Male Reliquary Guardian Figure
Fang peoples, Ntumu style,
Equatorial Guinea

Late 19th–early 20th century
Wood, pigment
73.7 x 16.5 x 15.2 cm (29 x 6 1/2 x 6 in.)
Collection Neuberger Museum of Art,
Purchase College, State University of New York,
gift of Lawrence Gussman in memory of
Dr. Albert Schweitzer, 1999.06.51

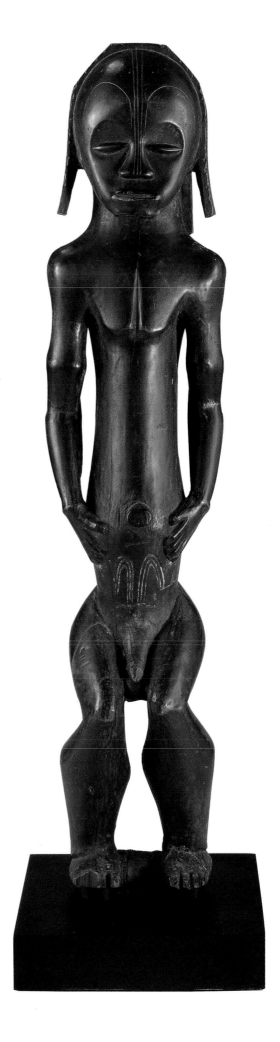

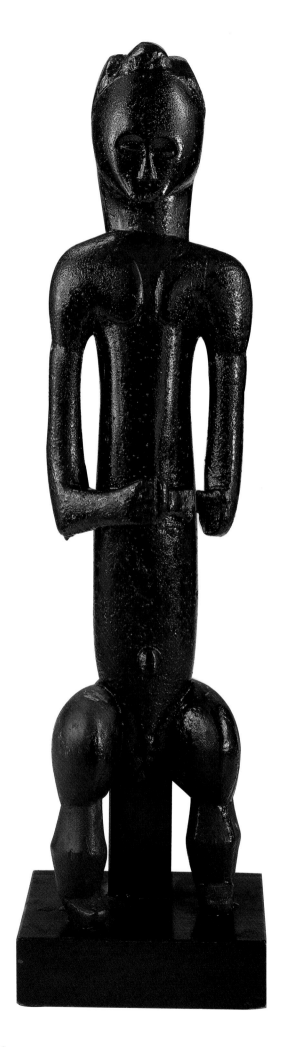

5

Male Reliquary Guardian Figure
(eyema bieri), Fang peoples, Ntumu
style, Oyem region, Gabon

Late 19th–early 20th century
Wood, pigment, fiber, nails
34.4 x 9.4 x 9.5 cm (13 9/16 x 3 11/16 x 3 3/4 in.)
Collection National Museum of African Art,
Smithsonian Institution, Washington, DC,
gift of Lawrence Gussman in memory of
Dr. Albert Schweitzer, 98-15-13

4

Male Reliquary Guardian Figure
(eyema bieri), Fang peoples, Gabon

Late 19th–early 20th century
Wood, oil
69.9 x 16.5 x 12.1 cm (27 1/2 x 6 1/2 x 4 3/4 in.)
Collection Neuberger Museum of Art,
Purchase College, State University of New York,
gift of Lawrence Gussman in memory of
Dr. Albert Schweitzer, 1999.06.47

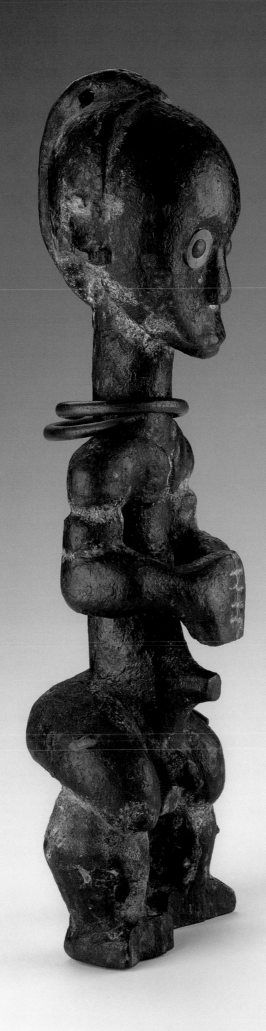

Female Reliquary Guardian Figure
(eyema bieri), Fang peoples, Gabon

Late 19th–early 20th century
Wood
49.5 x 16.8 x 15.2 cm (19 1/2 x 6 5/8 x 6 in.)
Collection The Israel Museum, Jerusalem,
gift of Lawrence Gussman, New York,
to American Friends of the Israel Museum
in memory of Catharine R. Gussman,
B97.0071

Female Reliquary Guardian Figure
(eyema bieri), Fang peoples, Gabon

Late 19th–early 20th century
Wood, brass
49.2 x 14.9 x 15.2 cm (19 3/8 x 5 7/8 x 6 in.)
Collection The Israel Museum, Jerusalem,
gift of Lawrence Gussman, New York,
to American Friends of the Israel Museum in
memory of Dr. Albert Schweitzer, B98.0055

copal resin and vegetable oils (Perrois, in Fry 1978:132), as in cat. no. 4. James Fernandez reports seeing the figures cleaned with palm oil before the ceremony of taking requests from the living family (Fernandez and Fernandez 1975: 743). Even some time after it is applied, the surface may still exude oil, especially when it is warm (as under photo or exhibition lights). This oil patina has on one figure been coated with white and red pigments (cat. no. 5). This is perhaps a European addition, although red and white pigments were part of the "medicines"—power-enhancing substances—applied to the bones in the reliquaries (Perrois, in Perrois and Delage 1990: 44). The colors red and white are also commonly found on more recent Bwiti association objects among the Fang and neighboring groups.

The variations in figural styles among Fang reliquary sculptures can be attributed to the effects of migration and assimilation over more than a century. Louis Perrois has created a system by which to identify regional styles based on the proportions—of head to torso to leg—of the reliquary statuary (see Perrois in Bibliography). However, Perrois's theories are difficult to apply consistently and have been criticized as being too isolated from field data (Fernandez and Fernandez 1975; Siroto 1995: 9–10). Since the Gussman Collection was not assembled with any formal or encyclopedic agenda guiding its formation, stylistic attributions made previously are noted but not carried further. BF

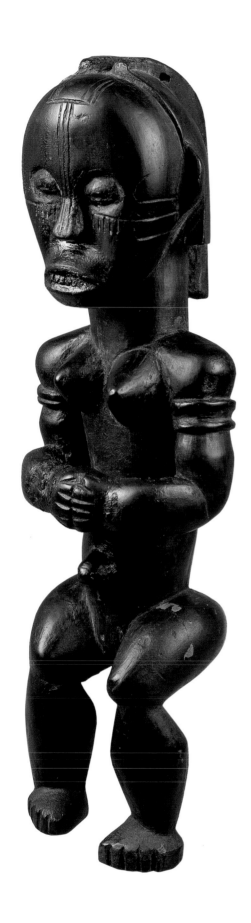
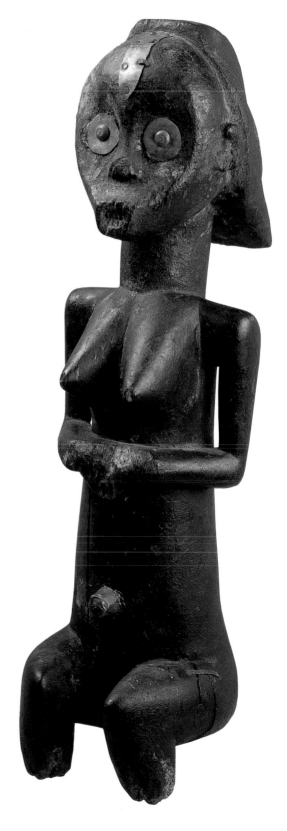

Half-length Figure on Reliquary Lid
Fang peoples, Gabon

Late 19th–early 20th century
Wood, bark, cane, brass tacks
35.6 x 14.9 x 16.2 cm (14 x 5 7/8 x 6 3/8 in.)
Collection The Israel Museum, Jerusalem,
gift of Lawrence Gussman, New York,
to American Friends of the Israel Museum in
memory of Dr. Albert Schweitzer, B97.0005

Provenance:
Cat. nos. 1–2:
 Emil Storrer, Paris, 1969
 Lawrence Gussman, New York, 1969–97
Cat. no. 3
 Alain de Monbrison, Paris, 1978
 Lawrence Gussman, New York, 1978–99
Cat. no. 4
 Paul Guillaume, Paris
 Harold Rome, New York, 1970
 Lawrence Gussman, New York, 1970–99
Cat. no. 5
 Unknown missionary, Oyem region, Gabon
 Don Virgilio Perozzi, Sienna, Italy
 Eric de Kolb, Gallery d'Hautbarr, New York, 1969
 Lawrence Gussman, New York, 1969–98
Cat. no. 6
 Gil Lipton, London
 John J. Klejman, New York
 Lawrence Gussman, New York, before 1997
Cat. no. 7
 Eric de Kolb, Gallery d'Hautbarr, New York, 1969
 Lawrence Gussman, New York, 1969–97
Cat. no. 8
 Eric de Kolb, Gallery d'Hautbarr, New York, 1969
 Lawrence Gussman, New York, 1969–97

Publication history:
Cat. nos. 1–2
 Hudson River Museum 1971: cat. no. 145
Cat. no. 5
 Perrois 1979: 70, fig. 48
 Perrois 1992: 128–29
Cat. no. 7
 Hudson River Museum 1971: cat. no. 162
Cat. no. 8
 National Museum of African Art 1981: cat. no. 87

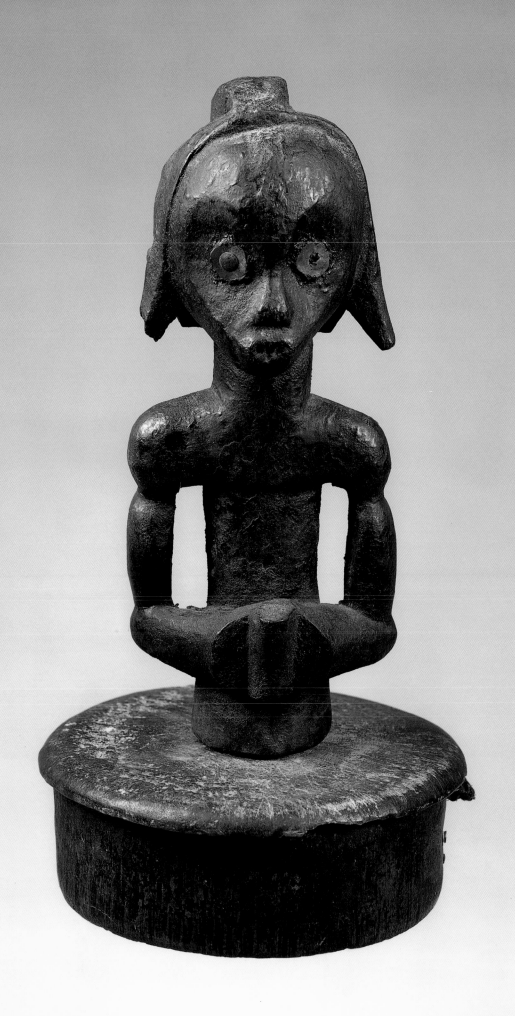

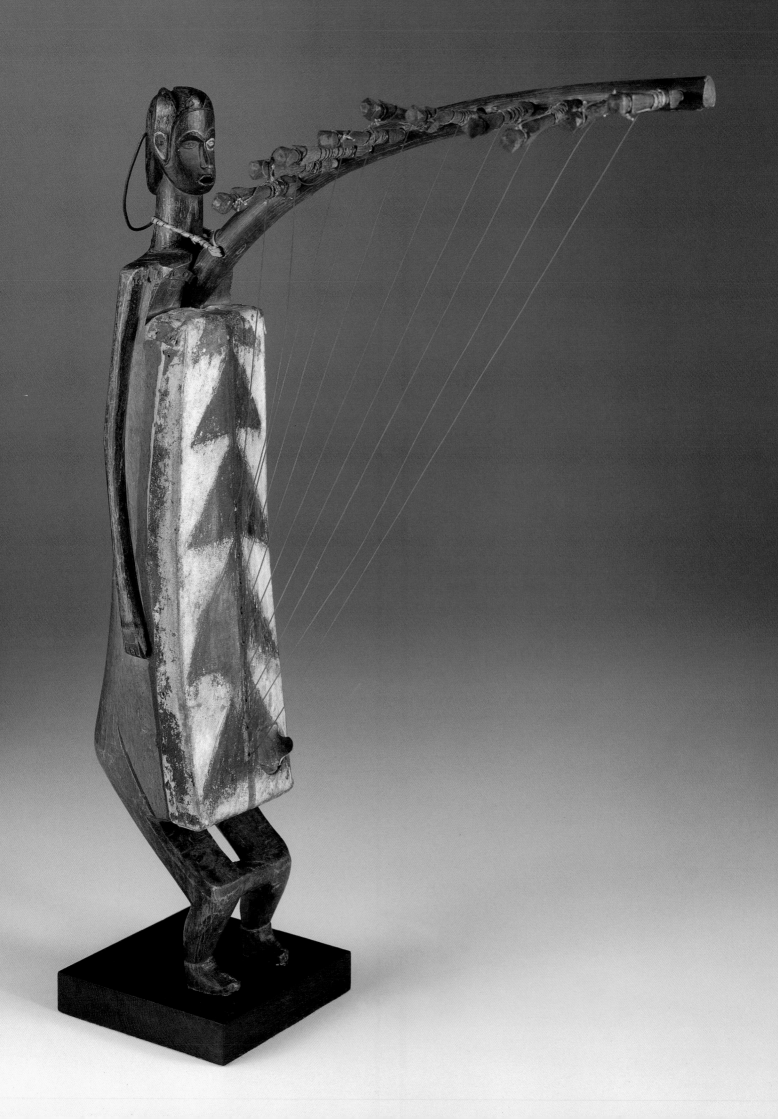

Harp *(ngombi)*
Fang peoples, Gabon

Early 20th century
Wood, hide, pigment, metal, nylon strings
69.9 x 19.1 x 53.3 cm (27 1/2 x 7 1/2 x 21 in.)
Collection Neuberger Museum of Art,
Purchase College, State University of New York,
gift of Lawrence Gussman in memory of
Dr. Albert Schweitzer, 1999.06.39

The harp *(ngombi)* is one of the most sacred objects used by members of Bwiti, a syncretist religious organization of the Fang and neighboring peoples in Gabon. They regard the harp as the primary instrument of communication between the living and the dead, and it is therefore performed at every Bwiti ritual. Bwiti was adopted by the Fang around the beginning of the twentieth century, having originated among the neighboring Tsogo as an association dedicated to the veneration of ancestors. Fang Bwiti introduced elements of Christian liturgy into its teachings and practice, and developed rapidly, with numerous branches.

The harp shown here is a type known as a shelf harp, in which a "shelf" projects from the carved resonator box, and the neck of the harp is a separate component attached to the body (DeVale 1989: 55). In this example, a human figure forms the body of the harp. The elongated, hollow torso serves as the resonator and is covered with whitened animal hide decorated with triangles of black pigment. Long, thin arms carved into the sides of the body accentuate its graceful curved form, while squat, bent legs provide support. The recessed, heart-shaped face has arching brows, a straight nose, and eyes that are daubed on one side with white kaolin (a fine, white clay) and on the other with red pigment. The neck of the harp has ten tuning pegs, which is unusual (Bwiti harps typically have eight strings). It is likely that the neck now on the harp is not original—indeed, in an earlier publication, the harp is shown without a neck (Delange 1967: cat. no. 119)—and the two upper holes in the resonator appear to have been added more recently than the others.

Members of Bwiti conceive of the harp as the body and voice of Nyingwam Mbege, the Sister of God "to whose life-giving benevolence Bwiti members appeal" (Fernandez 1982: 538). The instrument is played by an older male initiate, known as a *beti ngombi*, who is considered pure of heart and mind and who is, in effect, "married" to Nyingwam Mbege (ibid.: 416). In performance, the harp creates a musical liturgy that gives voice not only to the sacred teaching of Bwiti but also to the spirits themselves, facilitating communication between humans and the ancestral realm. As such, the harp is functionally related to Fang reliquary guardian figures in that they both contain the dead: the reliquary holds bones—the material remains of the dead—while the *ngombi* contains spirits (ibid.: 539).

The tradition of creating and playing harps dates back at least five thousand years in Africa, and, in Gabon, shelf harps have been documented as early as 1619. In addition to using them in Bwiti rituals, the Fang also play harps to invoke the spirit Ombwiri, who diagnoses and cures illnesses, and to accompany epic stories (Norborg 1989: 310–11). CC

Provenance:
André Fourquet, Paris
Jean Roudillon, Paris, 1969
Lawrence Gussman, New York, 1969–99

Publication history:
Delange 1967: cat. no. 119
Fagg 1970a: cat. no. 346
Brincard 1989: cat. no. 5
Robbins and Nooter 1989: cat. no. 1536

Four-faced Helmet Mask *(ngontang)*
Fang peoples, Gabon

Early 20th century
Wood, kaolin, pigment
33.3 x 22.2 x 26.7 cm (13 1/8 x 8 3/4 x 10 1/2 in.)
Collection The Israel Museum, Jerusalem,
gift of Lawrence Gussman, New York,
to American Friends of the Israel Museum in
memory of Dr. Albert Schweitzer, B97.0006

The work shown here is a type of mask that can have just one face, or as many as six faces. On this mask, as is usual when there are multiple faces, one is larger than the others. The wearer sees through eyeholes in the cylindrical wooden hood into which they are carved. Each face is decorated with a different pattern, probably representing tattoos or scarification marks.

According to Leon Siroto, this type of mask probably originated near the juncture of southwestern Cameroon, northern Equatorial Guinea, and northern Gabon, and features a synthesis of mask styles already established in the region (Siroto 1995: 26). The name for this mask *(ngontang)* presents a small mystery: it apparently means "face of a young white girl" (Perrois 1986: 48, 142), but her identity has not been determined. The name could refer to a visitor from the afterlife, where the spirits are white, rather than a literal interpretation of "white" as European; however, it could also be a combination of the two, since some Fang peoples believe that their ancestors are reincarnated in the countries where the "whites" live.

Masks such as this one were worn by male dancers in ritual performances. At one time, a dancer who was to wear the mask underwent an initiatory rite, and was possessed by the "white girl" spirit when he danced. Among some of the Fang, the performance was a ritual of the Bieri ancestor cult (see cat. nos. 1–8 for explanation of Bieri). Today, such dancing still takes place at feasts as part of the celebrations, but is now entertainment rather than a religious ritual. DN

Provenance:
Ralph Nash, London, 1973
Lawrence Gussman, New York, 1973–99

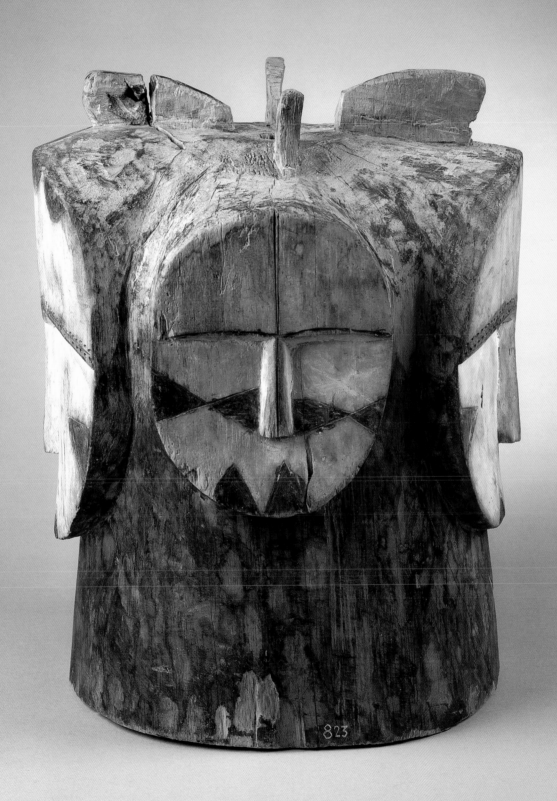

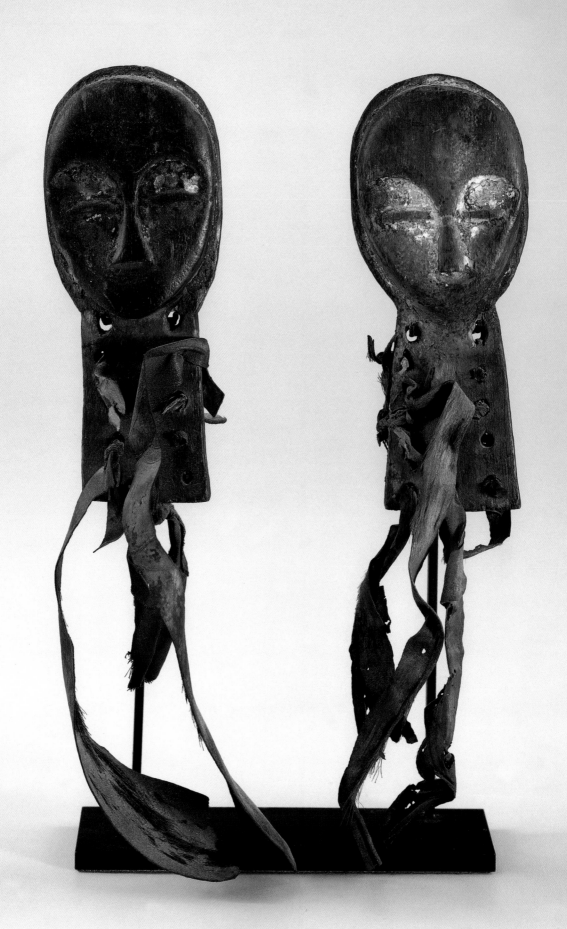

Pair of Arm Masks *(betsuga)*
Fang peoples, Gabon

Early 20th century
Wood, leather, kaolin
left: 15.2 x 5.7 x 1.3 cm (6 x 2 1/4 x 1/2 in.)
right: 15.2 x 5.7 x 1.9 cm (6 x 2 1/4 x 3/4 in.)
Collection Neuberger Museum of Art,
Purchase College, State University of New York,
gift of Lawrence Gussman in memory
of Dr. Albert Schweitzer, 1999.06.44 and
1999.06.45

Among the Fang peoples and several neighboring cultures in Gabon, there are slightly varying forms of the religious organization known as Bwiti (see cat. no. 9), and of the rituals associated with it. Only the Fang, however, create wooden arm masks *(betsuga)* and wear them in Bwiti dance performances (Raponda-Walker and Sillans 1962: 58). The arm masks replicate in miniature the form of a mask. A rectangular panel below the face of each arm mask is pierced for attachment to the dancer's upper arms. This wooden structure may be additionally embellished with raffia or, as in the pair shown here, strips of leather. Such arm masks were worn—usually by female performers—in dances that originated among Fang groups in Equatorial Guinea and later extended into adjacent parts of Gabon and Cameroon, possibly in the 1920s (Siroto 1996: 792).

On this pair, the elegant, tapered oval heads with their heart-shaped faces are characteristic of Fang sculpture. Traces of kaolin (a fine, white clay) remain in the concave recesses below the brow. The application of kaolin on the arm masks parallels the cosmetic bodily embellishments of Bwiti performers. According to André Raponda-Walker and Roger Sillans, a public performance may begin with the introduction of a single dancer whose face and body have been coated with a thin layer of kaolin (Raponda-Walker and Sillans 1962: 211). The use of kaolin on the arm masks and on the dancer's skin is not only visually striking but also symbolically relevant: among the Fang, the color white is associated with the realm of the ancestors. CC

Provenance:
Georges Rodrigues, New York, 1970
Lawrence Gussman, New York, 1970–99

Publication history:
Robbins and Nooter 1989: cat. no. 870

Fan
Fang or neighboring peoples, Gabon

20th century
Wood, hide, gold paint
34.3 x 21.6 x 2.5 cm (13 1/2 x 8 1/2 x 1 in.)
Collection Neuberger Museum of Art,
Purchase College, State University of New York,
gift of Lawrence Gussman in memory of
Dr. Albert Schweitzer, 1999.06.49

In central Gabon, the fan is an insignia of membership in a male professional association called Ntol among the Fang and Evóvi among the Tsogo (see also cat. no. 22). Association members, who are regarded as possessing the gift of eloquent speech, serve in multiple capacities as judges, lawyers, diplomats, and orators. The fan is part of a group of accessories, including canes, fly-whisks, and ritual gongs, that are given to a recently initiated member as a symbol of his new status. Used in public discourse, the fan is waved by a member to attract attention, impose silence, or seek approval for his pronouncements (Raponda-Walker and Sillans 1962: 154, 160).

Although fans with carved wooden handles and leather disk-shaped beaters are found in several cultures in Gabon and the Congo-Brazzaville region, the fan shown here was probably made by an artist from the Fang or neighboring peoples. It bears stylistic similarities to two other known examples attributed to this region (Perrois 1979: cat. no. 57; Fagg 1970b: cat. no. 42). The fan's carved wooden handle features two pairs of Janus faces depicted somewhat abstractly. The faces near the top of the handle, which seem to emerge from coils carved out of the wood, have wide-set, rounded eyes, while the larger faces at the base have heavy, arching brows and compressed features. The leather beater, attached to the handle by thonging, bears traces of gold paint.

The identity of the figures represented by these faces remains unknown. A closely related example with a similar face has been published by William Fagg (Fagg 1970b: cat. no. 42). Fagg proposed that the carving is a representation of a bushbaby, a small mammal found largely in thickly forested regions of sub-Saharan Africa. Although the wide face, exaggerated eyes, and small mouth are features characteristic of the bushbaby, this identification is unlikely, as the animal has rarely been represented in the visual or oral artistic traditions of any African culture (Allen Roberts, personal communication, January 2000). CC

Provenance:
Sotheby's, London, July 11, 1972
Lawrence Gussman, New York, 1972–99

Publication history:
Vogel 1980: cat. no. 123

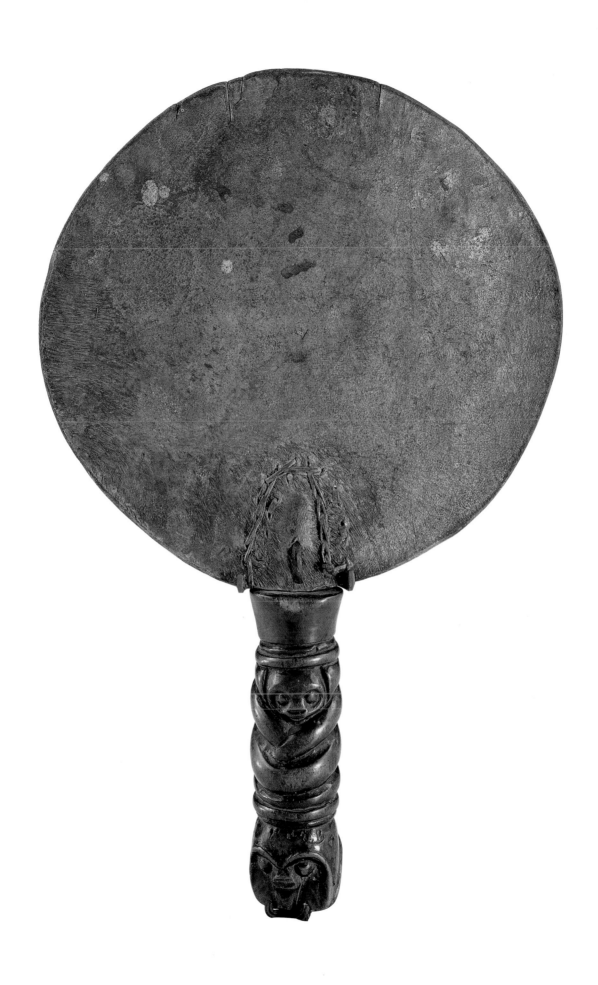

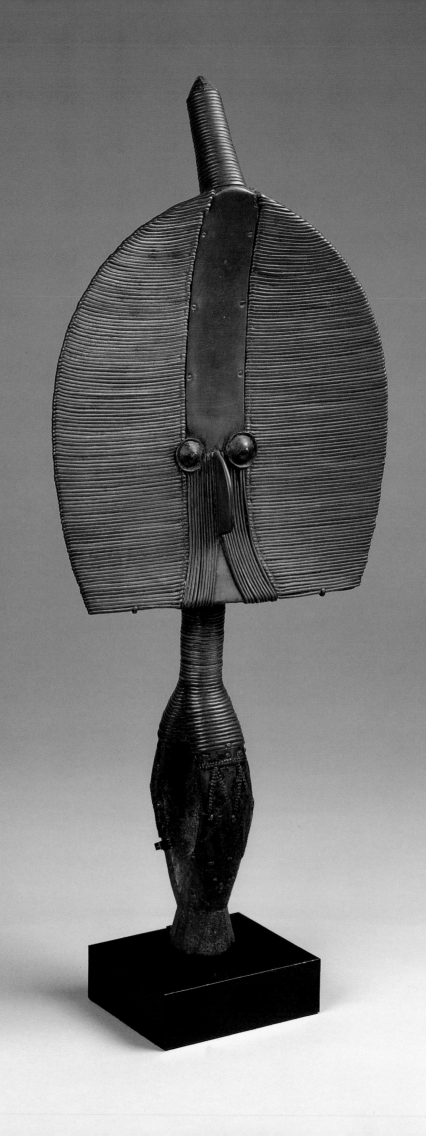

Reliquary Guardian Figure *(bwiti)*
Hongwe peoples, Gabon

19th–early 20th century
Wood, copper-alloy sheet and wire, iron
58.4 x 24.8 x 7.6 cm (23 x 9 3/4 x 3 in.)
Collection The Israel Museum, Jerusalem,
gift of Lawrence Gussman, New York,
to American Friends of the Israel Museum in
memory of Dr. Albert Schweitzer, B97.0009

Several cultures known collectively as Kota live around tributaries of the upper Ogowe River in eastern Gabon, to which they migrated from the northeast about four hundred years ago. The Hongwe (or Mahongwe), the most northern of these groups, live in northeastern Gabon. Like other Kota, including the Shamaye peoples, they practiced a cult of ancestral worship called Bwiti, preserving bones of important persons in basketry reliquaries topped with wood figures (also called *bwiti)* covered in sheet-metal and wire.

The style of such Hongwe reliquary guardian figures is the least naturalistic of all Kota styles. The principal element of each guardian figure is a shieldlike form shaped like a lancet arch. Despite its considerable abstraction, one can perceive "eyes," a "forehead" consisting of a copper strip, and what looks like moustaches on either side of a "nose." Extending from the top of this "face," and tilted slightly back, is a small, pointed, cylindrical projection that may represent some kind of coiffure. In complete figures, the "face" rests on a base resembling an inverted, angular tennis-racket frame, which may represent the guardian figure's arms, as is the case with the Kota figures from groups further south. DN

Provenance:
Possibly Olivier Le Corneur, Paris
Ralph Nash, London
Lawrence Gussman, New York, before 1980 to 1997

Publication history:
Vogel 1980: cat. no. 129
Center for African Art 1987: 55

Reliquary Guardian Figure
Possibly Shamaye or northern Obamba
peoples, Gabon

19th–early 20th century
Wood, copper-alloy sheet and strips, bone
39.4 x 10.2 x 5.1 cm (15 1/2 x 4 x 2 in.)
Collection Neuberger Museum of Art,
Purchase College, State University of New York,
gift of Lawrence Gussman in memory of
Dr. Albert Schweitzer, 1999.06.59

The reliquary guardian figure shown here is in a style character-istic of the northern part of Kota territory. More specifically, it belongs to a small body of works from that region which share similar formal elements, including a narrow, elongated oval face, a protruding pyramidal forehead, and a spade-shaped flange. On this figure, the wooden support has been embellished with nar-row bands of metal attached to the flange and with thin metal strips that wrap around the face and slender, cylindrical neck. The spiral coiffure made of copper alloy and the curved, open-triangular base are both unusual features. Works in this distinctive style have been previously attributed to the Shamaye or northern Obamba peoples (Chaffin and Chaffin 1979: 96), although this provenance is inadequately documented (Siroto 1981: 85).

Like the other reliquary guardians used in the Kota-speaking area (see cat. nos. 14, 16), a figure such as this one would be attached to a container holding the bones of a deceased individual of importance. Among those honored in this way are individuals who wielded political power, such as chiefs and judges, or those with a particular talent, including artists and unusually fertile women. Their bones, especially the skull, were believed to retain the power of the individual after his or her death and were employed as protective devices by the ancestor's descendants. The reliquary's power safeguarded primarily the family of the ancestor but occasionally extended to the community as a whole when brought together with other reliquaries in village-wide ceremonies (Siroto 1968: 22, 27).

Reliquary guardian figures were not intended as representa-tions of the individuals whose bones they guarded. However, they were given specific names, and the individual's high status in the community was conveyed through the material and formal aspects of the figure. The sheathing of the figure with copper alloy, among the most costly of metals, most clearly demon-strates its relation to wealth (ibid.: 86). The copper alloy for such figures was obtained from thin basins, called neptunes, that were imported from Europe and also served as a form of currency among the Kota. Leadership qualities are also alluded to in the formal resemblance of the figure to knives that are owned and displayed as a marker of status (ibid.). In this example, the blade-like outline of the flange and the metal-wrapped, cylindrical neck recall the form of weapons of authority commonly found in the region (see, for example, cat. no. 18). CC

Provenance:
Possibly Paul Guillaume, Paris
Henri Kamer, Paris, 1971
Lawrence Gussman, New York, 1971–99

Publication history:
Chaffin and Chaffin 1979: cat. no. 23

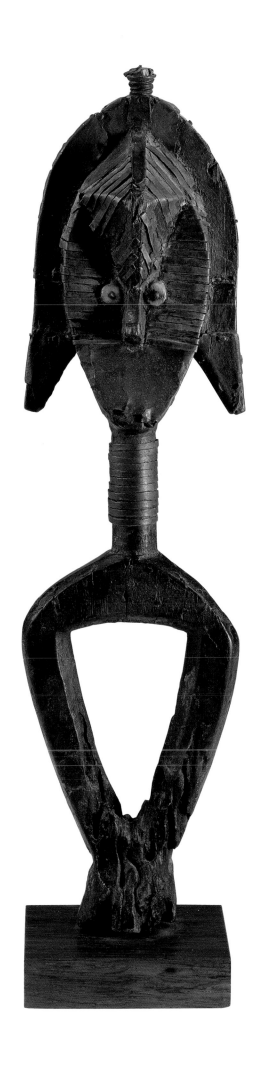

Reliquary Guardian Figure
(mbulu ngulu)
Kota peoples, Franceville district,
Gabon

19th–early 20th century
Wood, copper sheet, copper-alloy sheet and
wire, iron, bone
53.3 x 27 x 2.9 cm (21 x 10 5/8 x 1 1/8 in.)
Collection The Israel Museum, Jerusalem,
gift of Lawrence Gussman, New York,
to American Friends of the Israel Museum in
memory of Dr. Albert Schweitzer, B98.0052

The use of metal-covered figures to protect the skulls and other bones of ancestors, a common practice among the Hongwe peoples and their neighbors in northern Kota territory (see cat. nos. 14, 15), is also found among other Kota groups further south in Gabon. Reliquaries composed of plaited containers are surmounted by flat wood carvings of heads above a transverse open diamond, their upper parts transformed into faces by attached copper or copper-alloy sheets and strips. Housed on a shelf usually outside the village, the reliquary guardian figure *(mbulu ngulu)* was carefully polished with sand to maintain its shining surface.

There are at least seven major styles of these heads, each including several substyles. The powerful image with which this *mbulu ngulu* presents us is a variant of the Obamba and Mindumu groups in southeastern Gabon. It has a dramatic, almost menacing, forcefulness due to the interpretations of the design elements with which it is composed, and the interplay among them. The elegance of the flat, curved upper crescent, the sweeping side panels, and the slender neck and arms contrasts with the massive bulging brow, with its strong central ridge and arched eyebrows. The pale, protruding eyes, with their lowering gaze, add a finishing stroke of vigorous immediacy.

Although examples of reliquary guardian figures were first collected by explorers as early as 1883 and presented to the Trocadero Museum in Paris, they attracted little attention for a quarter of a century. Then, partly owing to the interest that contemporary artists took in them, they gained a place among the icons of African art that they have retained ever since. DN

Provenance:
Alain Schoffel, Paris, 1971
Lawrence Gussman, New York, 1971–99

Publication history:
Vogel 1980: cat. no. 25

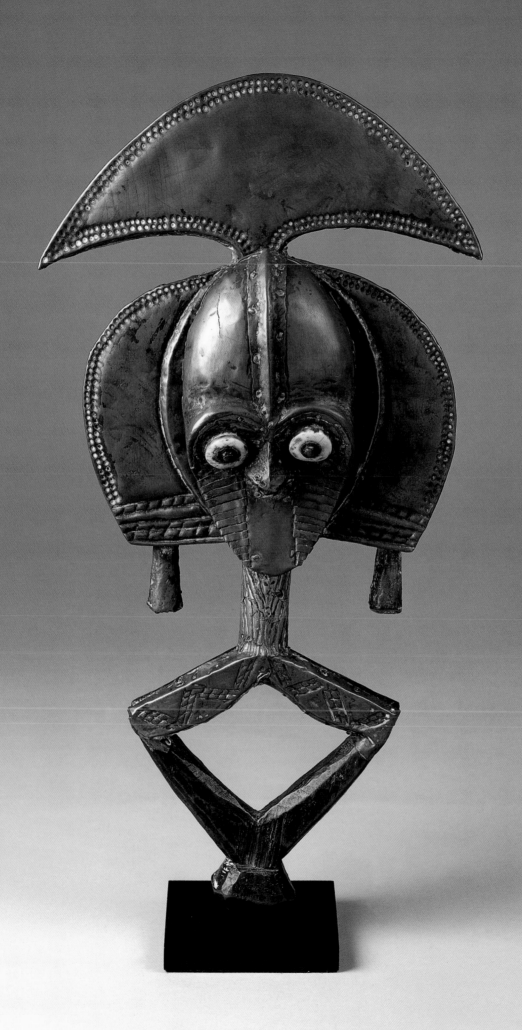

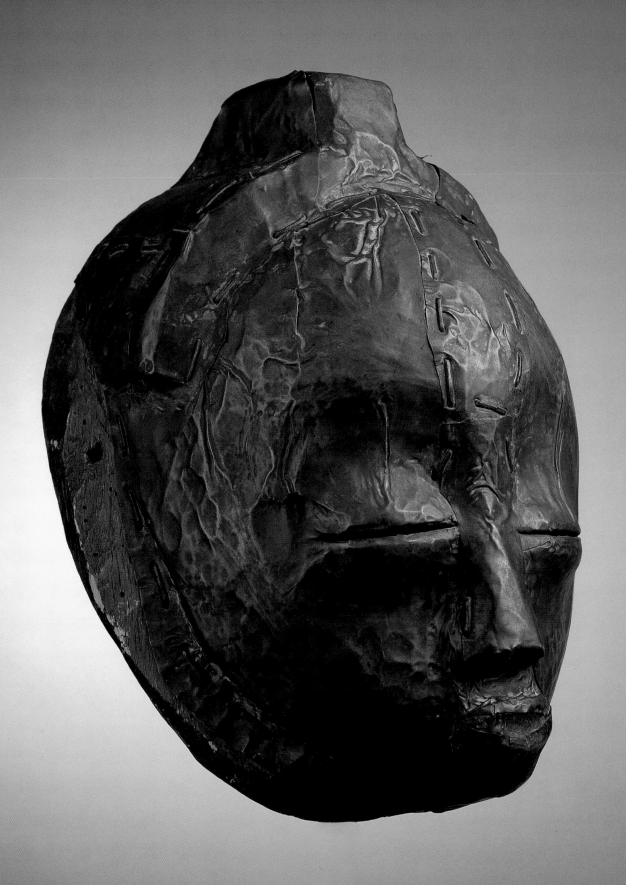

Mask
Possibly Kota peoples, Gabon

19th–20th century
Wood, copper-alloy sheet
16.2 x 15.9 x 25.4 cm (6 3/8 x 6 1/4 x 10 in.)
Collection The Israel Museum, Jerusalem,
gift of Lawrence Gussman, New York,
to American Friends of the Israel Museum in
memory of Dr. Albert Schweitzer, B98.1060

The exact origin of the rare mask shown here is uncertain, but an attribution to a Kota artist is strongly supported by its having been made of sheet metal attached to a light wooden base using prominent staples—a Kota and Hongwe technique, unusual elsewhere in Africa. Here, the result is a rounded, three-dimensional surface rather than the essentially flat planes of the reliquary figures. The facial features, set in the lower half of the face below a large forehead, include a bulging brow, a short nose, and a small, protruding mouth, which are consistent with those of some Kota reliquary figures. A flange runs down each side, and on top of the head a crest runs from side to side and a rectangular block projects upward at the middle. Since this work's ethnographic context is unrecorded, one cannot be sure that it was actually used as a face mask at all, even though the slit eyes are pierced through the wood. In fact, its depth is almost equal to its height, and very little of the wood has been removed in the back to accommodate a wearer's face.

Very few other works of this type are known. Another was formerly in the collection of Pierre Verité, Paris; it was attributed to the Kota by William Fagg (Elisofon and Fagg 1958: 182; Leuzinger 1971: 255, R5). A third, in the Paul Tishman Collection, New York, is illustrated in *Arts connues et arts méconnues de l'Afrique noire* (Paris, Musée de l'Homme, 1966: cat. no. 87). Those two masks, which are nearly identical in form, have been carved with somewhat more precisely defined details than the one shown here. DN

Provenance:
John J. Klejman, New York, before 1974
Lawrence Gussman, New York, 1974–98

Ritual Knife *(musele)*
Kota peoples, Gabon

19th–20th century
Iron, wood, copper alloy
27.3 x 27.3 x 3.5 cm (10 3/4 x 10 3/4 x 1 3/8 in.)
Collection Neuberger Museum of Art,
Purchase College, State University of New York,
gift of Lawrence Gussman in memory of
Dr. Albert Schweitzer, 1999.06.58

Despite the distinctive social position of metalworkers in many African cultures, the varied weaponry they create is often overshadowed by the Western emphasis on figurative sculpture. Kota knives *(musele)* are emblems of dignitaries in the Mungala association. They are wielded during acrobatic dances in which the dance chief *(nganga-mungala)* "crawls along on the ground, uttering raucous cries, brandishing the *musele*, and attempting to hurt the initiates who must jump above him as energetically as possible" (Perrois 1986: 30).

Such knives were often displayed along with spears and swords on the tombs of deceased chiefs as markers of status. The ancestral context of the knife suggests a functional relationship with the metal-wrapped reliquary guardian figures for which the Kota are renowned. This affinity is reinforced by its formal properties, including both the use of metal and the design motifs employed, such as lozenges, ovals, and triangles (Spring 1993: 14). Although the distinctive form of the blade suggests the shape of a bird—described as a horn raven (Fischer and Zirngibl 1978: 186) or a toucan (Perrois 1986: 187)—such an identification has not been conclusively proven. CC

Provenance:
André Fourquet, Paris, 1971
Lawrence Gussman, New York, 1971–99

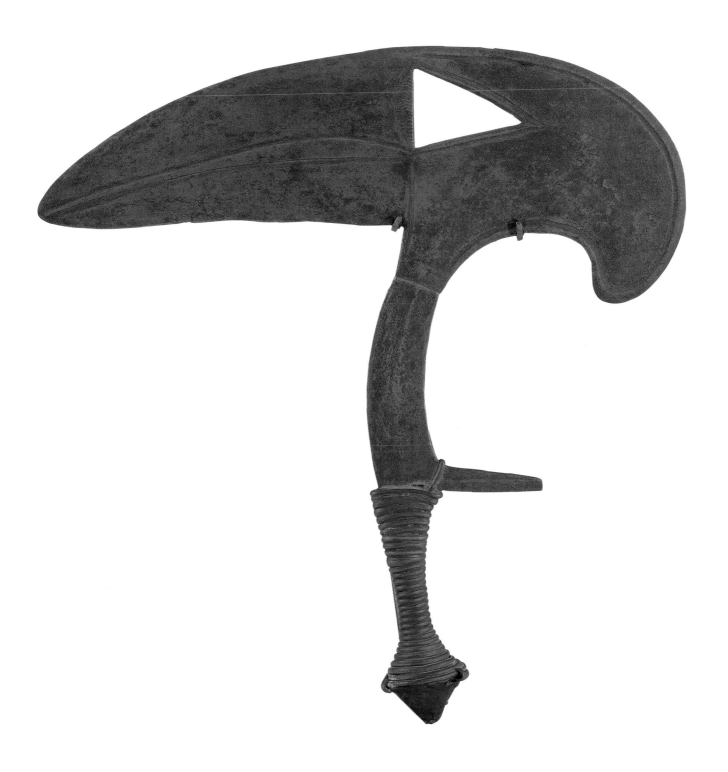

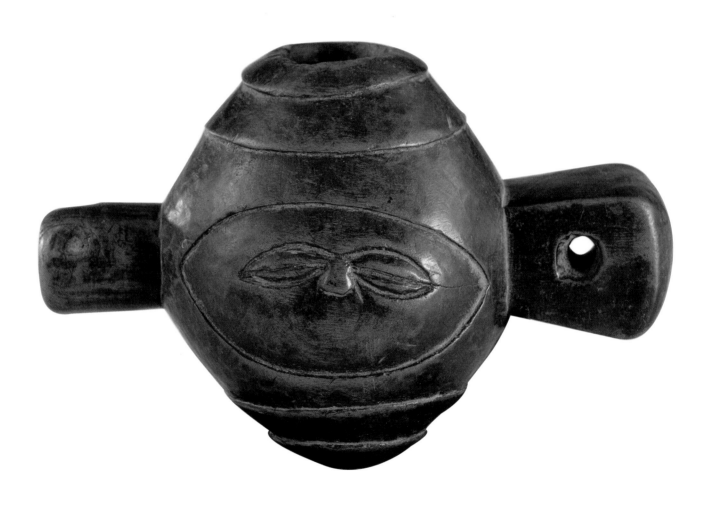

Whistle
Possibly Kwele peoples, Gabon and
Republic of the Congo

20th century
Wood
9.5 x 14.6 x 7.6 cm (3 3/4 x 5 3/4 x 3 in.)
Collection Neuberger Museum of Art,
Purchase College, State University of New York,
gift of Lawrence Gussman in memory of
Dr. Albert Schweitzer, 1999.06.53

Unlike other musical instruments in central Africa, the whistle functions less as a vehicle for the creation of melody than as a means of sending messages. In contrast to flutes, which are often played at performances together with other musical instruments, whistles are primarily used in hunting and in the past were used in warfare, and are often associated with secret societies (Laurenty 1974: 3).

In this example, design and utility are cleverly combined, resulting in an aerophone resembling a human face. The spherical body of the whistle, enclosing a large central cavity, is embellished with design elements sculpted in low relief and incised on its surface. Incised circles surround the round mouthpiece hole on top and are repeated on the bottom register. Across the middle of the body (and repeated on the opposite side), the wide, downward-tilting eyes and small, triangular nose of a stylized "face" are incised within an ellipse. Completing the face are two side projections that resemble ears, which are also functional. On one side is a pierced hole through which a cord could be threaded to suspend the whistle around the neck; the other cylindrical projection houses a modulation hole that emerges from the central hollow.

Other whistles of similar form have been attributed to cultures in the eastern forest region of the Democratic Republic of the Congo (see, for example, Laurenty 1974: pl. 10; Kreamer 1986: 69; Brincard 1989: cat. no. 144). Collection data for this example, however, suggests a provenance among the Kwele in Gabon and the Republic of the Congo. Stylistically, the wide, downward-tilting, coffee bean-shaped eyes and small, triangular eyes are in keeping with Kwele artistry. CC

Provenance:
Eric de Kolb, Gallery d'Hautbarr, New York, 1969
Lawrence Gussman, New York, 1969–99

Mask *(mvudi)*
Aduma or Mbete peoples, Gabon and
Republic of the Congo

19th–20th century
Wood, pigment
36.2 x 10.2 x 8.9 cm (14 1/4 x 4 x 3 1/2 in.)
Collection The Israel Museum, Jerusalem,
gift of Lawrence Gussman, New York
to American Friends of the Israel Museum in
memory or Dr. Albert Schweitzer, B97.0007

Although some masks of the type shown here, known as *mvudi*,
are known to date from the late nineteenth century, little else is
known about them. They are among the most abstract, geometric
representations of the human visage in all African art. The long,
shieldlike panel, which narrows to a point at the lower end or
"chin," is divided into four quadrants, two painted red and the
other two white. The "facial" features are restricted to the upper
third of the panel, and consist almost entirely of a beetling brow
and a long, narrow "nose," with eyes and mouth only indicated
by small slits.

These formal characteristics demonstrate the shared stylistic
elements found among the Aduma, the Mbete, and other cul-
tures of the Ogowe River area. Some of the metal-covered reli-
quary figures of the Kota and Hongwe, for instance, show very
much the same minimalist treatment of the face, while some
Fang masks are similarly divided into quadrants of contrasting
colors. DN

Provenance:
Possibly George Oltay, Cannes, before 1957
Henri Kamer, Paris, 1976
Lawrence Gussman, New York, 1976–96

Publication history:
Werth 1970
Center for African Art 1987: 54

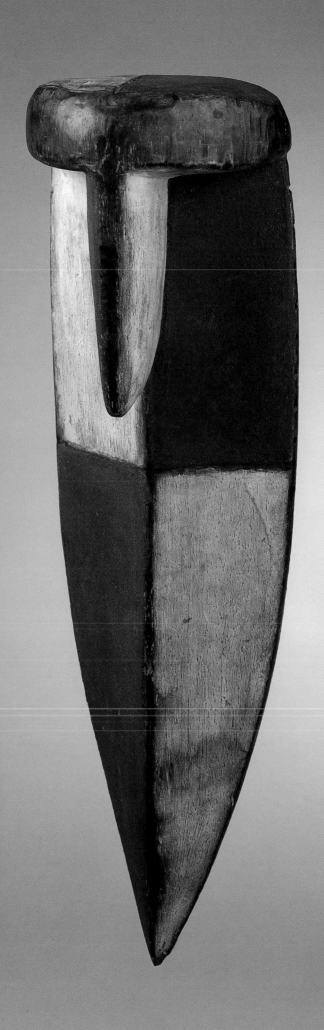

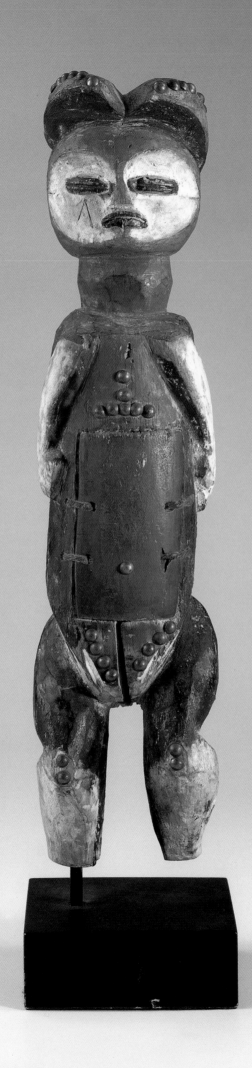

Reliquary Figure
Mbete peoples, Gabon

19th–20th century
Wood, pigment, copper-alloy strips, fiber,
brass tacks
49.5 x 12.7 x 10.2 cm (19 1/2 x 5 x 4 in.)
Collection Neuberger Museum of Art,
Purchase College, State University of New York,
gift of Lawrence Gussman in memory of
Dr. Albert Schweitzer, 1999.06.54

Unlike other reliquary figures found throughout Gabon, Mbete figures contained the relics of the deceased within the body of the figure. Inside rested the bones of notable men, many of whom belonged to organizations concerned with hunting and other activities considered to be masculine (Siroto 1995: cat. no. 30). On the example shown here, the elongated stomach has been hollowed out to serve as a receptacle and then covered with a hinged lid.

Stylistically, Mbete reliquaries demonstrate the artistic complexity of a regional tradition with links to sculptural styles from the Atlantic coast to the Congo (Perrois 1986: 54). Standing on flexed legs, this figure has an elongated trunk with short arms carved in low relief. The recessed, heart-shaped face—a design element found throughout the Ogowe River region—is carved with prominent slit eyes and a rectangular mouth. Brass tacks embellish the centrally parted coiffure and the body of the figure, similar to metal adornment of figures in Kota artistic traditions. The use of red, black, and white pigments for different areas of the figure is visually striking, and may also refer to a conceptual system shared by the many cultures in the region. According to Anita Jacobson-Widding, these three colors correspond to basic principles of cosmic and social order (Jacobson-Widding 1979). CC

Provenance:
Sotheby's, New York, 1983
Lawrence Gussman, New York, 1983–99

Gong *(mokenge)*
Tsogo peoples, Gabon

Early 20th century
Iron, wood, pigment, copper alloy
43.4 x 12.5 x 8.4 cm (17 1/16 x 4 15/16 x 3 5/16 in.)
Collection National Museum of African Art,
Smithsonian Institution, Washington, DC,
gift of Lawrence Gussman in memory of
Dr. Albert Schweitzer, 98-15-14

In Tsogo culture, the sound of an iron gong *(mokenge)* is regarded as that of a man's heartbeat (Gollnhofer 1975: 37–38), and gongs themselves are associated with the Evóvi (literally, "the judges"), a combination of bar association and religious group. The name "Evóvi" derives from the verb *vóvó,* "to speak" (Raponda-Walker 1962: 154). When an individual undergoes initiation into this society, the gift of "the word" is conferred by the spirit of the word itself, physically represented by the skull of a great past Evóvi. As a way of honoring an esteemed predecessor, this revered object serves a function similar to that of the ancestral relics (skull and other bones) protected by Tsogo reliquary guardian figures (see cat. nos. 23, 24). Initiates also receive the society's distinguishing emblems: red cotton hats, wooden staffs, iron spears, fans, and gongs. The fan (see cat. no. 13) serves to enhance the new judge's gestures, and the gong announces his presence and demands attention for his pronouncements. The gong also acts as a representative of the judge's authority: the Evóvi can delegate a town crier to make public announcements at dawn and dusk, using the Evóvi gong (ibid.: 159–60).

The gong's carved wooden handle represents Kombe, the mythical male being who is likened to the sun, the source of life, and the "supreme judge" (Perrois 1986: 203, 205). A gong's handle can be in the form of a full figure, a single face, or a double-faced head. Here, the heart-shaped face, emphatic brow, and coiffure are typical of Tsogo carving style, but, ironically, the sounding portion of the gong—the emblem of this Tsogo association—was not made locally. Iron gongs were acquired from the Tsangui people, who reside to the south near the border of Gabon and the Republic of the Congo (ibid.: 203). This and other aspects of regional trade among the various peoples of west-central Africa have received relatively little attention by scholars, being overshadowed by interest in white-faced masks, reliquary guardian figures, social-religious associations, and other objects and social phenomena of these cultures. BF

Provenance:
Georges Vidal, Paris, before 1969
Alain Schoffel, Paris, 1969
Lawrence Gussman, New York, 1969–98

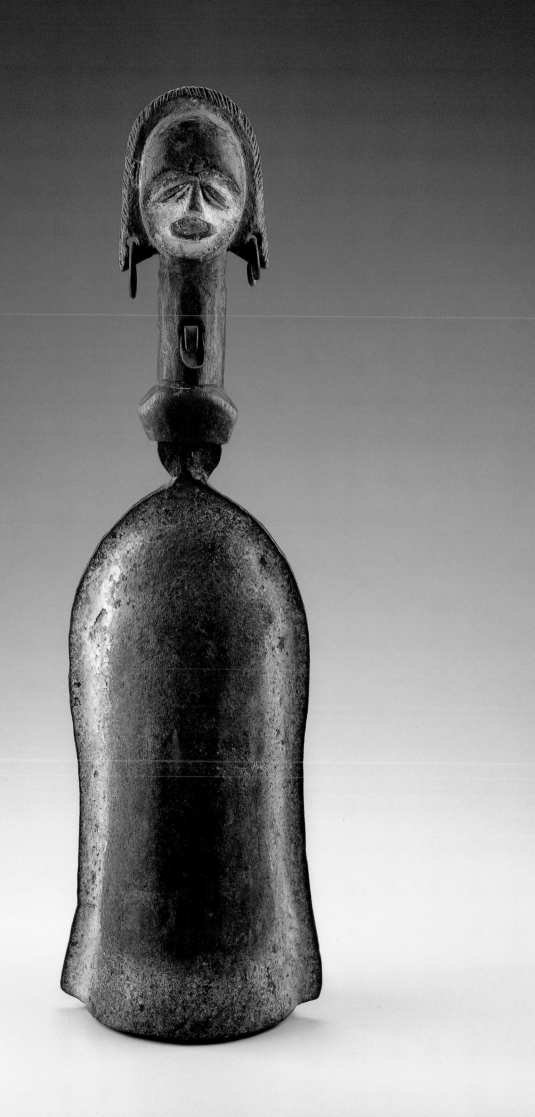

Reliquary Guardian Half-Figure
(mbumba bwiti)
Tsogo peoples, Gabon

20th century
Wood, pigment, copper alloy
40 x 8.9 x 10.8 cm (15 3/4 x 3 1/2 x 4 1/4 in.)
Collection Neuberger Museum of Art,
Purchase College, State University of New York,
gift of Lawrence Gussman in memory of
Dr. Albert Schweitzer, 1999.06.72

With rounded shoulders and clenched fists held tightly against the abdomen, this figure *(mbumba bwiti)* exudes the sense of contained energy necessary for the role of a guardian. Among the Tsogo, such sculptures are employed by members of Bwiti, the intercultural association that fosters communication between the deceased and their descendants (see cat. nos. 9, 11–12, 14 for discussion of Bwiti among neighboring cultures). They serve either as guardians of ancestral relics or, when displayed on the floor of the main cult's temple, as a focal point in dramatic evening rituals (Siroto 1995: cat. no. 36).

When employed as a reliquary guardian, the figure shown here would be only the sculptural component of a larger assemblage. The lower part of the body, deliberately left unfinished, is concealed within a receptacle called *bumba bwiti*. Consisting of either a sack made of antelope skin or a fiber basket, this receptacle would contain various relics, including human and animal bones, brass rings, grain, shells, coins, and jewelry (Perrois, in Vogel 1981: 196, cat. no. 116).

This particular example displays the restrained naturalism characteristic of Tsogo figurative sculpture. The large, rounded head has strongly defined features, with a broad, oval mouth and a flattened, square nose. Below the strong, arching brows, two diamond-shaped metal attachments serve as eyes, their shiny surface believed to have the ability to deflect negative forces. Another strip of metal bisects the forehead. The body of the figure is colored with camwood powder, while white kaolin has been applied in the recesses of the oval mouth. The use of red (a color that alludes to life, beauty, and prosperity) in combination

with white (associated with spirits and the ancestral realm) has significant cultural meaning. CC

Provenance:
Sotheby's, New York, 1983
Lawrence Gussman, New York, 1983–99

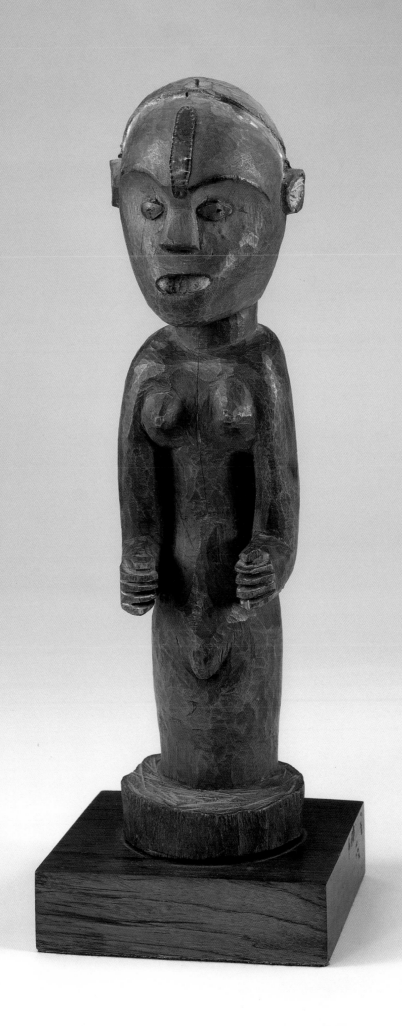

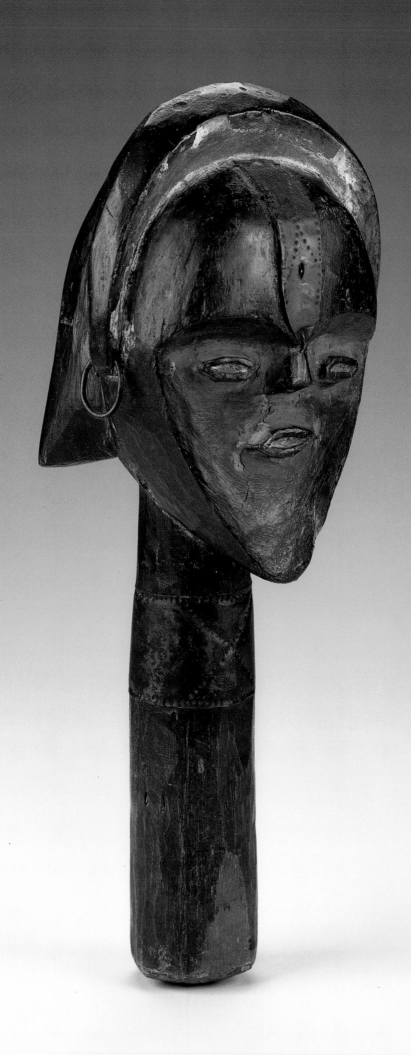

Reliquary Guardian Head
(mbumba bwiti)
Vuvi or Tsogo peoples, Gabon

Early 20th century
Wood, pigment, copper alloy
30.5 x 11.6 x 10.2 cm (12 x 4 9/16 x 4 in.)
Collection National Museum of African Art,
Smithsonian Institution, Washington, DC,
gift of Lawrence Gussman in memory of
Dr. Albert Schweitzer, 98-15-12

Stylized wooden heads have been attributed both to the Vuvi and the Tsogo peoples of central Gabon. Such heads were probably used as reliquary guardian figures, created to protect the relics of individual ancestors, as was the custom among Fang peoples. Little has been published about Vuvi sculptural traditions, except for a few images of flat-faced, white masks that share the small, stylized features of this head. More firmly attributed are the rare Tsogo reliquary guardians in the form of relatively naturalistic, carved half-figures *(mbumba bwiti)* rather than heads (see, for example, cat. no. 23). The red pigment, copper-alloy forehead strip, and arched eyebrows are traits shared by those figures and this type of head. The head's convex-concave face, triangular nose, almond-shaped eyes and mouth, and transverse crest coiffure are also found on Tsogo objects such as gongs and harps. BF

Provenance:
André Fourquet, Paris, 1971
Lawrence Gussman, New York, 1971–98

Publication history:
Hudson River Museum 1971: cat. no. 168

Face Mask *(mukudj)*
Punu or Lumbo peoples, Gabon

First half of 20th century
Wood, pigment, kaolin
32.1 x 17.8 x 15.2 cm (12 5/8 x 7 x 6 in.)
Collection The Israel Museum, Jerusalem,
gift of Lawrence Gussman, New York
to American Friends of the Israel Museum in
memory of Dr. Albert Schweitzer, B97.0008

The "white masks" of southern Gabon have long been among the most famous of all African sculptures. They are carved by the Lumbo and Punu peoples along the coast and, further inland to the east, in a slight variant of the style, by the Tsangui in northern Congo. Small in size, these masks have naturalistic human features, painted white with kaolin, framed below by a collar and above by a thick helmetlike coiffure (described as a "bivalve" form) that rises to a peak, with short braids on either side of it. Collar and hair are painted in a contrasting black. The face is notably delicate, with a small nose and mouth, and a somewhat pointed chin. The most expressive features are the strongly arched eyebrows and large, closed eyelids, which give the masks a strikingly meditative, almost dreamy look. Some have a diamond pattern in relief on the forehead, indicating scarifications, and are therefore masks of women (see cat. no. 26).

Mukudj are worn by male dancers at funerary rites. In contrast to the stillness of the mask's appearance, the dancer's actions are vigorous. He typically wears a cloth cloak and trousers, carries flywhisks in each hand, and walks on stilts (Perrois 1986: 62), parading through the village on them and performing acrobatic feats. DN

Provenance:
Gallery 43, London, 1969
Lawrence Gussman, New York, 1969–96

Publication history:
Hudson River Museum 1971: cat. no. 156
Walker 1976: 51, fig. 41

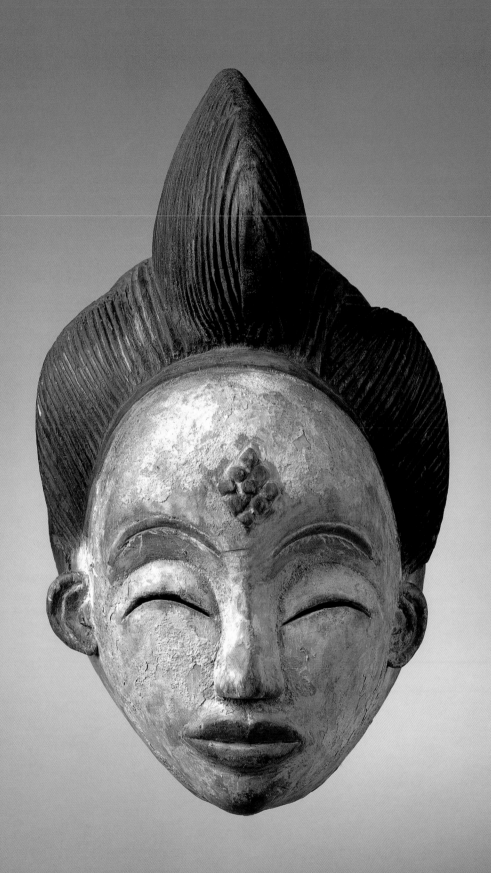

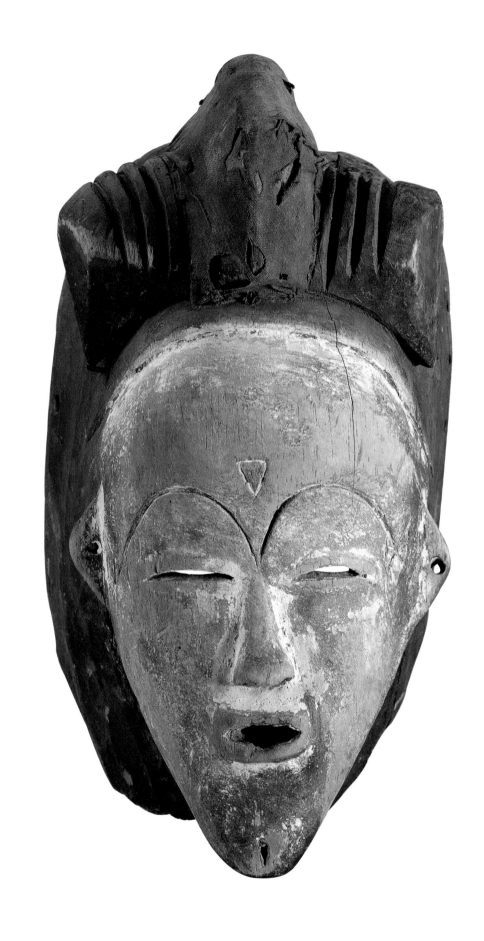

Face Mask *(mukudj)*
Undetermined attribution, southern
Gabon

19th–early 20th century
Wood, textile, kaolin, pigment
29.2 x 14 x 15.9 cm (11 1/2 x 5 1/2 x 6 1/4 in.)
Collection Neuberger Museum of Art,
Purchase College, State University of New York,
gift of Lawrence Gussman in memory of
Dr. Albert Schweitzer, 1999.06.61

The mask shown here is a regional variant of the white-faced genre, known as *mukudj*, found throughout the Ogowe River area (see also cat. no. 25). Masks of this type depict an idealized vision of womanhood; among the Punu, they were portraits of local women renowned for their beauty, although increasingly their representation has become more generalized (LaGamma 1996: 52). The mask would be worn by a particularly skilled male dancer who demonstrated his artistic mastery by performing on stilts.

The classic tri-lobed, blackened coiffure with high, central shell on this example was a popular hairstyle throughout coastal and southern Gabon during the precolonial and colonial era (Alisa LaGamma, personal communication, January 2000). Here, the central shell has been further embellished with a fabric covering. Although the mask itself is rounded and volumetric, the facial features are rather flat, carved in low relief. The narrow oval face, with high, arching brows and slit eyes, has a serene expression counterbalanced by the open, rectangular mouth.

The surface of the mask was once covered with white kaolin, traces of which remain, particularly around the nose and eyes and in the recesses of the engraved scarification on the forehead and at the temples. Throughout much of Gabon, the color white is associated with the ancestral realm. The artist, in applying the color to the face of the mask, has elevated the mortal woman whose face is represented here to the status of a spiritual entity (ibid.).

The performance executed by a dancer wearing a *mukudj* mask is in startling contrast to the mask's calm visage. Balanced on high stilts, the dancer demonstrates a varied repertoire of choreographic movements, regaling the audience with his wild acrobatics and daring feats of artistry. In southern Gabon, among the Punu, the attainment of such spectacular skills is believed to come at a price. It is widely perceived that *mukudj* performers have entered into spiritual transactions that grant them mystical powers known as *muyama*. Access to *muyama*, however, requires the depletion of the vital forces of a human victim. As a result, these masked dancers, while admired, are also believed to be witches *(balosi)* (LaGamma 1996: 101–02).

Since the beginning of Western interest in the white-faced mask form, scholars have attempted a classification based on details of coiffure and scarification. Recent research, however, suggests that, to a certain degree, such differences reflect individual aesthetic preferences rather than cultural distinctions (ibid.: 9). It is therefore difficult to determine this example's cultural origin in a specific ethnic subgroup based on formal attributes alone. A tag on the back of the mask reads "M'pongwe ca. 1850," a reference not to its origin but to the coastal culture that served as trade intermediary at its point of collection. A southern Gabon origin is more likely, given the distinctive coiffure and deep, rounded shape of the mask, although its facial features are more austere than those found on other masks from the region. CC

Provenance:
Julius Carlebach, New York
Eric de Kolb, Gallery d'Hautbarr, New York, 1969
Lawrence Gussman, New York, 1969–99

Female Figure *(kosi)*
Punu or Lumbo peoples, Gabon

19th–20th century
Wood, metal bell, fiber, pigment
24.1 x 10.2 x 5.1 cm (9 1/2 x 4 x 2 in.)
Collection Neuberger Museum of Art,
Purchase College, State University of New York,
gift of Lawrence Gussman in memory of
Dr. Albert Schweitzer, 1999.06.65

The miniature size of this delicately carved female figure belies its tremendous power. Such a figure, known as a *kosi*, is a device used by a ritual specialist *(nganga)* to exact retribution on behalf of a wronged client. Through the medium of the *kosi*, whose investigative powers have no geographic limitations, an *nganga* can determine the identity of the culprit who is causing pain or distress. Once identified, the responsible person is afflicted with sickness by the *kosi*, and his or her subsequent symptoms are seen as evidence of guilt (LaGamma 1996: 119–20).

This *kosi* takes the form of a smoothly patinated female figure with a crested coiffure and delicately carved scarification marks between and below her breasts. While reflecting local standards of beauty, the figure is also intended to depict a specific person, whose identity remains unclear. According to one Punu artist, a figurative *kosi* is intended to be a portrait of an individual who has been sacrificed in order to endow the sculpture with the life force *(muyama)* necessary to perform effectively. As Alisa LaGamma has observed, "The fact that the preponderant number of *kosi* that take the form of figurative sculptures are female reflects the idea . . . that most of the victims surrendered to *muyama* appear to be women" (ibid.: 122).

Here, the figure is given attributes that suggest the powerful forces that lie within the sculpture. She is represented grasping in her left hand a gourd, typically used as a container for powerful "medicines." Around her waist is fastened a crescent-shaped iron bell, an instrument associated with ritual performance pertaining to healing. Armed accordingly, this tiny figure stands ready to dispense swift and merciless justice on her patron's behalf. CC

Provenance:
Ralph Nash, London, 1972
Lawrence Gussman, New York, 1972–99

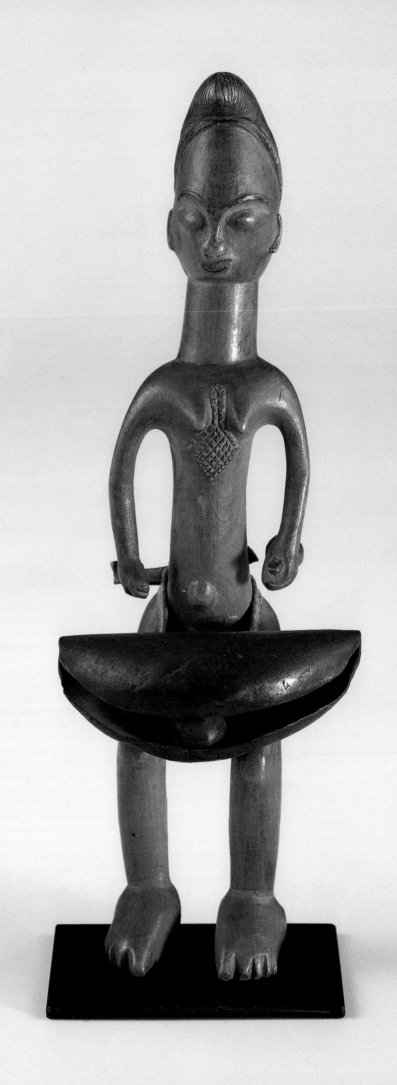

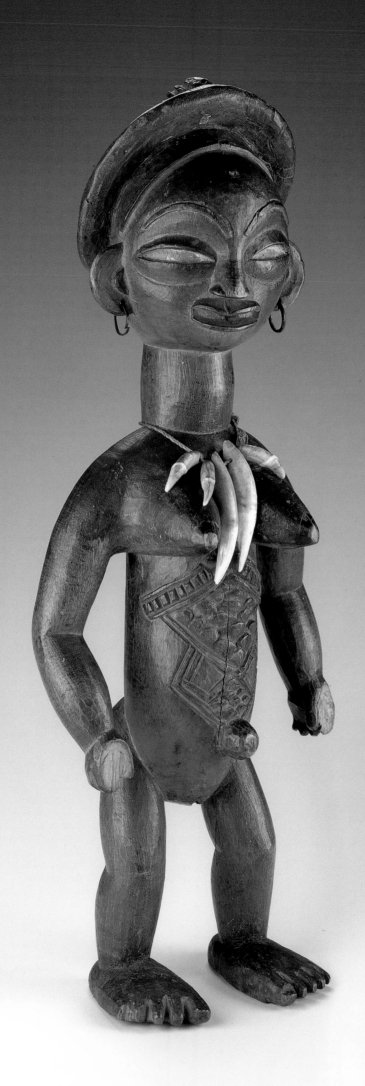

Female Figure *(kosi)*
Lumbo peoples, Gabon

Early 20th century
Wood, leopard's teeth, copper alloy, pigment
42.1 x 16.5 x 11.4 cm (16 9/16 x 6 1/2 x 4 1/2 in.)
Collection National Museum of African Art,
Smithsonian Institution, Washington, DC,
gift of Lawrence Gussman in memory of
Dr. Albert Schweitzer, 98-15-3

The figure shown here exemplifies regional ideals of beauty, high status, and spiritual power. The calm, composed expression and attention to carved details of scarification and hairstyle are identical to those of the better-known white-faced spirit masks from the Lumbo and neighboring peoples (see, for example, cat. nos. 25, 26). This figure's beauty was considered by its owner, a diviner, as a baited trap for wrongdoers (LaGamma 2000: 30). The earrings and leopard's-tooth necklace have been added as emblems of rank.

Other elements of the figure display the commonalities of belief and imagery between the Lumbo and the Kongo peoples of the Loango region (now the Republic of the Congo). The eyes, perhaps once inlaid with glass, retain traces of white pigment or kaolin (a fine, white clay). The practice of using white around the eyes, or inlaid mirrors, is well documented among the Kongo as a means of emphasizing the ability to see into the spiritual realm (MacGaffey, in MacGaffey and Harris 1993: 51, 54, 65, 101). Just as a Kongo *nkisi* (see cat. no. 35) was used by a ritual specialist *(nganga)* in the Loango region, a *kosi* was used by a diviner *(nganga kosi)* in the Ogowe River region to investigate the cause of an illness. It may represent a victim, or an ideal representation of the helping spirit (LaGamma 2000: 29–30; see also cat. no. 27, above).

Comparisons with other Lumbo figures (Felix 1995: 143; Sieber and Walker 1987: 82) suggest that the hands of this *kosi* once held carved European bottles or gourds, which would have represented ritual "medicine" containers. Indeed, it is possible that, originally, packets of herbal and magical substances were attached to the figure (Felix 1995: 143). Among the Kongo, such vessels would take the form of mirror-covered resin boxes, which were often anchored over a hole in the figure's chest or elsewhere on the body. Although fewer figures have been documented in collections from the Gabon region, some figures with containers, or at least with small cavities, do exist. On this figure, a shallow hole has been carved in the lower buttocks. Today, its "medicines" have been lost, but the figure retains the particular aspects that make it beautiful, which both the carver and the *nganga* considered essential to its effectiveness. BF

Provenance:
Baron Robert de Rothschild, Paris, collected in Gabon on African Citroën
 expedition, 1926–ca. 1945
Cécile de Rothschild, Paris, ca. 1945–ca. 1978.
Alain de Monbrison, Paris, before 1984 to 1987
Lawrence Gussman, New York, 1987–98

Publication history:
Bastin 1984: 262, cat. no. 273

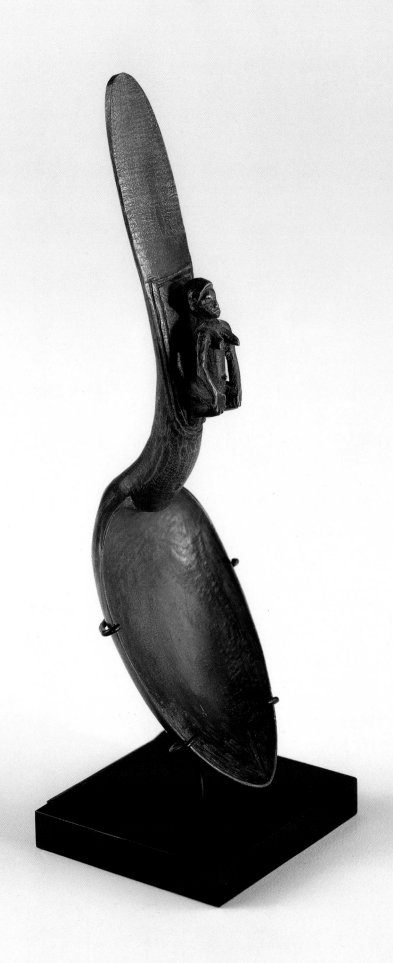

Spoon with Female Figure
Undetermined attribution,
southern Gabon

20th century
Wood
17.8 x 5.1 x 5.1 cm (7 x 2 x 2 in.)
Collection Neuberger Museum of Art,
Purchase College, State University of New York,
gift of Lawrence Gussman in memory of
Dr. Albert Schweitzer, 1999.06.71

The elegant form of the spoon shown here, with its miniature carved figure, suggests a use more ornamental than functional. According to Leon Siroto, small spoons similar to this one are most likely to have been owned by men and may have had a ceremonial role (Siroto 1991: 66). Toward the base of the handle, a nude female figure is carved lying prone, with hands resting lightly on bent knees. Among the Eshira and Punu peoples, female figures are frequently carved on spoons and may serve as a metaphor for abundance (ibid.: 68). The shape of the spoon, with its tapering ovoid bowl offset at an angle to the gently curved handle, suggests that it was created in southern Gabon; however, due to extensive cultural exchange in the region, any attribution to a specific society is uncertain (ibid.: 63). CC

Provenance:
H. Reasor
Alain de Monbrison, Paris, 1978
Lawrence Gussman, New York, 1978–99

Publication history:
Robbins and Nooter 1989: cat. no. 1258

Female Figure
Kuyu peoples, Republic of the Congo

19th–20th century
Wood
56 x 19 x 13 cm (22 x 7 1/2 x 5 1/8 in.)
Collection The Israel Museum, Jerusalem,
gift of Lawrence Gussman, New York
to American Friends of the Israel Museum in
memory of Dr. Albert Schweitzer, B98.0058

The Kuyu, a subgroup of the Mboshi, live on the east and west sides of the Kuyu River, a tributary of the Congo. Their sculpture appears to be limited to two forms: human heads and human figures; the latter are either large (up to nearly life-size) or relatively small, as in this example. Both forms share the same characteristics.

Both the eastern and western Kuyu groups hold initiations in which the powers of mythological animals are revealed. For the western Kuyu, the animal is the panther, the personification of the chief. For the easterners, it is the serpent Ebongo, shown as a carved head mounted on a long pole concealed by draperies, manipulated to mime the serpent's writhing (Nicklin 1983: 59). The heads are ovoid and crowned with feathers. During a later part of the initiation ritual, the Kuyu bring on small male and female figures representing the primordial couple, Joku and Ebotita, of which this is probably an example. Larger figures are said to depict male and female ancestors of chiefs, and at least one is janiform, showing both sexes. To add to the complex effect, the figures sometimes stand on other human heads, or are topped with small figures of animals—animals that perhaps were taboo to certain clans.

The hands of the figure shown here are held to the breasts, probably implying the nurturing role of the female ancestor. This figure exemplifies the Kuyu style, remarkable for the squatness of the body configuration, which is emphasized by its proportion of breadth to height, its barrel-shaped head, torso, and legs (with the head nearly as wide as the shoulders), and its lack of a neck. The face of such figures has slit eyes, a broad nose, and a diamond-shaped mouth with parted lips that reveal the teeth.

The face and torso are covered with relief bands, usually rows of small, raised squares, representing body scarification. Both sexes wear short skirts and ankle rings. All these details are usually enhanced with vivid polychrome; the surface of this figure, however, is entirely blackened. DN

Provenance:
Jay C. Leff, Uniontown, Pennsylvania, before 1959 to 1975
Lawrence Gussman, New York, 1975–99

Publication history:
Segy 1952: 190, fig. 182
Carnegie Institute 1959: cat. no. 353
University of Florida 1967: cat. no. 47
West Virginia University 1969: cat. no. 23D
Carnegie Institute 1969: cat. no. 258

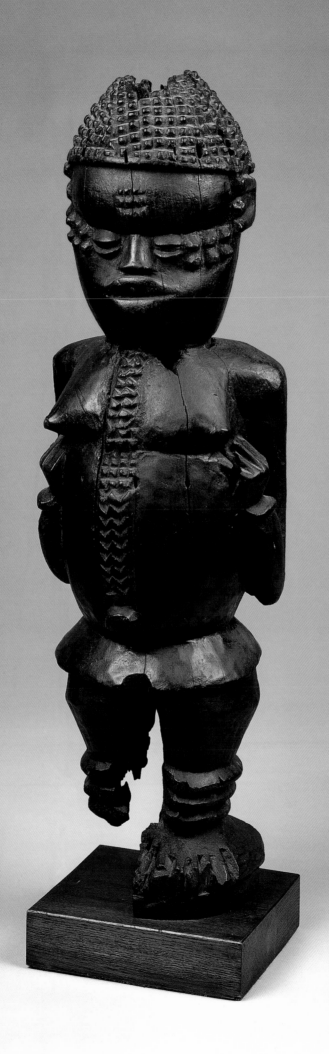

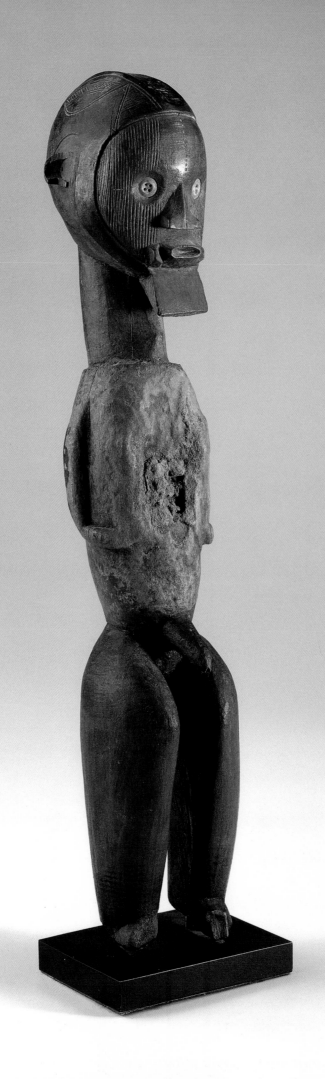

Male Figure *(buti)*
Teke peoples, Republic of the Congo

Late 19th–early 20th century
Wood, buttons, encrustation
43.2 x 8.3 x 10.2 cm (17 x 3 1/4 x 4 in.)
Collection Neuberger Museum of Art,
Purchase College, State University of New York,
gift of Lawrence Gussman in memory of
Dr. Albert Schweitzer, 1999.06.77

The male figure shown here is closely related to a series of Teke works collected in and around Pangala, a former colonial administrative village northwest of Brazzaville, in the early decades of the twentieth century (Féau 1999: 132–33; see also Lehuard 1996). Characteristic features include the incised, broad oval face; flared nostrils; flat, projecting beard; vertical lines of facial scarification; and, most notably, the use of European shirt buttons as eyes. This example, however, lacks the distinctive double coiffure, consisting of a circular crown surmounted by a transverse crest, seen on many examples from this region. Instead, the hairline is defined through low-relief sculpting and embellished with curvilinear incisions.

Residual layers of encrustation around the trunk of this figure suggest that it was once associated with a magical entity called *buti*, whose actions are considered by the Teke to be powerful yet ambiguous. Such figures are designed to be activated by a ritual specialist *(ngàà)* through the insertion of various symbolic "medicines" *(bonga)* into its abdominal cavity. According to Robert Hottot, who visited the Teke region in 1906, each *bonga* has a specific function, such as success in hunting, protection against disease, divination, or revenge. The nature of the empowering ingredients is determined by the intended function and may include plantain leaves, the beard bristles of an important elder, parts of totemic animals, or albino hairs (Hottot 1956: 29–30). Lacking a specific identification of the symbolic ingredients encrusted on this figure, however, it is impossible to know its original use. CC

Provenance:
Gallery Khepri, Amsterdam, 1969
Lawrence Gussman, New York, 1969–99

Figure *(nkira ntswo)*
Teke peoples, Republic of the
Congo and Democratic Republic
of the Congo
19th–20th century
Wood, encrustation
21.5 x 3.8 x 7.6 cm (8 1/2 x 1 1/2 x 3 in.)
Collection Neuberger Museum of Art,
Purchase College, State University of New York,
gift of Lawrence Gussman in memory of
Dr. Albert Schweitzer, 1999.06.78

The distinctive coiffure of this figure, with its backswept chignon, suggests that it is a representation of a deceased chief *(ntswo e mpuu)*. Among the Teke peoples, ancestor figures are used in a religious ritual concerned with the worship of nature spirits *(nkira)*. According to Lema Gwete, "the *nkira* define positive ritual functions that emerge from the will of the ancestors to assure the well-being of their descendants" (Gwete, in Royal Museum for Central Africa 1995: 299).

Great care is taken in the creation of an *nkira* figure. Teke sculptors use a specially chosen kind of wood, called *ngasu*, which has mystical importance. Its reddish color may be glimpsed beneath the layers of encrusted matter on the example shown here. Although there is some regional variation, Teke artists tend to conform to a standard style that is more homogeneous than that of neighboring cultures. This figure's three distinct parts exemplify the way Teke sculptors apparently conceptualize the human body: as head, torso, and legs. The head is a marker of ethnic identity, with parallel lines of facial scarification called *mabina*. The torso—here elongated, and with arms clutching the abdomen—is considered the source of magical forces. The one remaining leg (the other is missing) is bent at the knees, replicating a posture assumed by men in ritual dances (Hottot 1956: 27–28).

Once the carving is complete, the figure is coated with sand or clay and wrapped in cloth, resulting in the burnished effect seen here. An *nkira* ancestor figure is believed to possess intrinsically only *kiba*, the lesser of the two elements that the Teke believe are necessary to produce life. The other, *mpiele*, is a superior and indestructible force that must be actively applied. Each morning, the owner of the figure must invest it with *mpiele* by first blowing on it and then spitting on it in a ritual manner. The ancestor-spirit figure is then able to work effectively, protecting the well-being of the community from potentially dangerous forces. After the death of the owner, the *nkira* figure is no longer considered powerful and is buried with the deceased, along with his other belongings (ibid.: 31, 35). CC

Provenance:
Jef Vander Straete, Brussels, 1971
Lawrence Gussman, New York, 1971–99

Publication history:
Cornet 1971: 29
Robbins and Nooter 1989: cat. no. 973

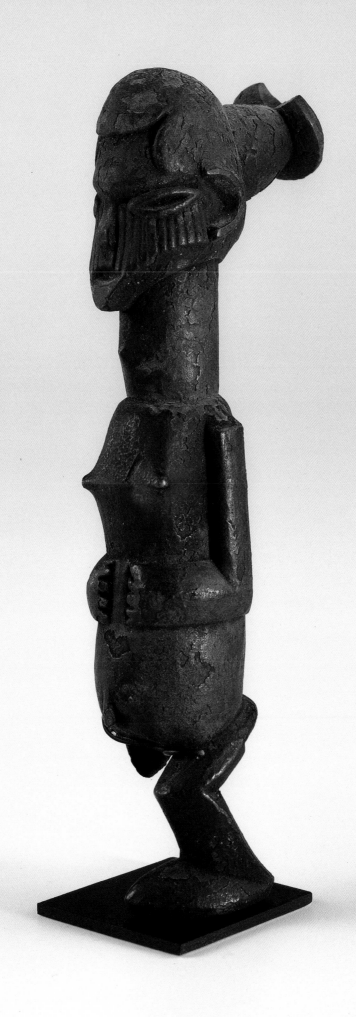

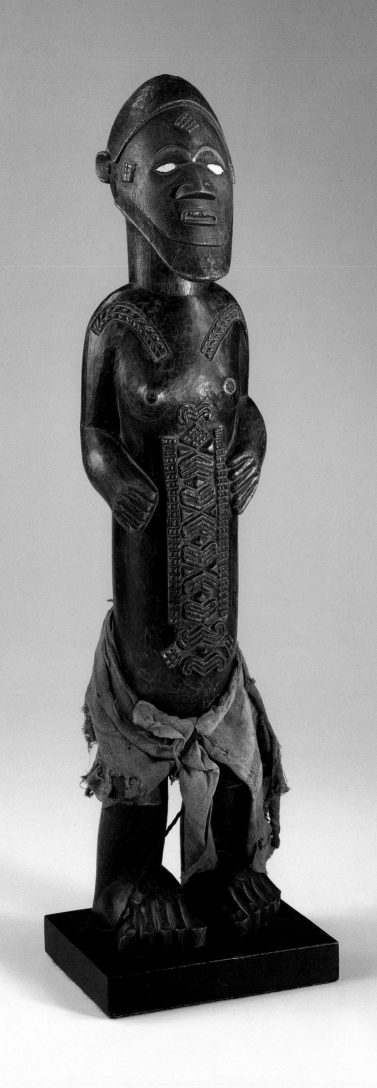

Male Figure
Bembe peoples, Republic of
the Congo

19th–20th century
Wood, textile, ceramic
50.8 x 11.4 x 12.1 cm (20 x 4 1/2 x 4 3/4 in.)
Collection Neuberger Museum of Art,
Purchase College, State University of New York,
gift of Lawrence Gussman in memory of
Dr. Albert Schweitzer, 1999.06.73

More known for their artistic mastery in miniature, Bembe sculptors also produce beautifully executed figurative works on a larger scale. Their center of artistic production is at or near Mouyondzi, the city considered by the Bembe to be the regional capital (Lehuard 1989: 327). Works created in this area follow standard stylistic conventions, of which the standing male figure shown here is a classic example.

Balancing naturalism with stylization, the figure stands erect with flexed legs and atrophied arms held tightly against the torso. The oval head has strongly modeled features, a smooth, rounded skull, and a thick beard extending from just below the chin. The eyes, inlaid with shards of porcelain, suggest an ability to see beyond the human realm. The most distinctive feature of this work, as in other examples of Bembe statuary, is its elongated trunk, which serves as a canvas for a rhythmic pattern of raised geometric scarifications. Such body designs would allow a local viewer to identify the individual represented as well as ascertain his status within the society (ibid.: 329).

Large Bembe figurative sculptures such as this standing male are fairly rare. Although its specific cultural context is unknown, it may represent an ancestor. Representations of ancestors are typically empowered by a diviner, who places various medicinal substances into a cavity near the rectum. The ancestor's life force is then considered to reside within the figure, offering protection to the surviving family as well as a connection between the living and the dead (Soderberg 1975: 21). This figure, however, though stylistically similar to consecrated images of ancestors, lacks such a cavity. CC

Provenance:
Harold Rome, New York, 1971
Lawrence Gussman, New York, 1971–99

Publication history:
Fagg 1970a: 75
Lehuard 1989: fig. G1-3-1

Figure *(nkisi)*
Bembe peoples, Republic of the
Congo and Democratic Republic of
the Congo

Late 19th–early 20th century
Wood, feathers, hide, textile, fiber, mirror,
ceramic, hair
43 x 5.1 x 19.4 cm (16 15/16 x 2 x 7 5/8 in.)
Collection National Museum of African Art,
Smithsonian Institution, Washington, DC,
gift of Lawrence Gussman in memory of
Dr. Albert Schweitzer, 98-15-10

The stylistic characteristics of the rare figure shown here—specifically, its facial features, beard, and inlaid ceramic eyes—suggest that it was created by a Bembe artist. The materials added to this figure, especially the mirror-covered resin box, identify this figure as an *nkisi* (see cat. no. 35), linking the Bembe with their Kongo neighbors. Museum X-radiographs were not definitive in revealing the concealed body of the figure, except for its well-defined shoulders and buttocks. It is possible that only the upper arms were carved next to the body and that the legs are actually more of a staff bottom. While there was an indication that some kind of matter had been added beneath the mirror, no clearly defined metal, bone, or other large solid additions could be seen.

Bembe figures such as this one receive their power from a strong breath contained in a cavity in the body (Anderson and Kreamer 1989: 84). A comparable "breath as power" metaphor can be found among the Kongo peoples. For the Kongo, the fluttering *(vevila)* of the feathers atop an *nkisi* figure in performance refers to a breeze or spirit, known as *mpeve* (MacGaffey, in MacGaffey and Harris 1993: 76). BF

Provenance:
Maurice Nicaud, Paris, July 1970
Lawrence Gussman, New York, 1970–98

Publication history:
Hudson River Museum 1971: cat. no. 175
Anderson and Kreamer 1989: 84, cat. no. 6

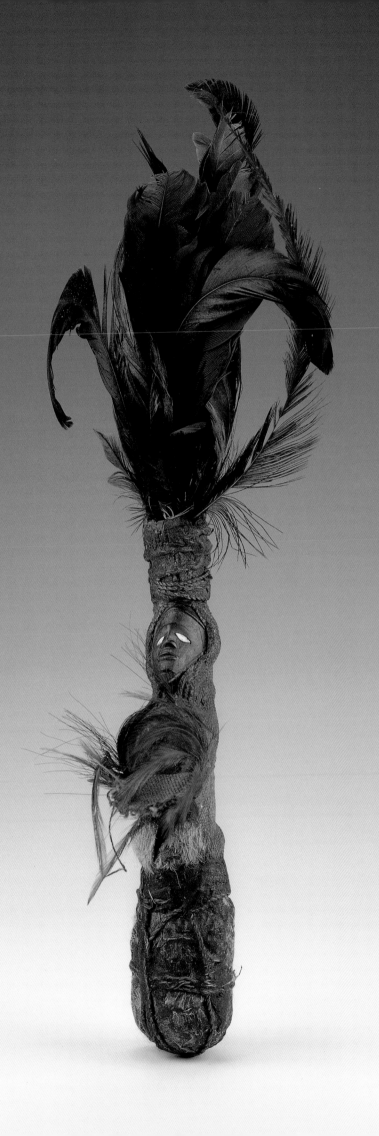

Dog Figure *(nkisi kozo)*
Kongo peoples, Democratic Republic
of the Congo

Late 19th–early 20th century
Wood, resin, mirror, ceramic
7.8 x 13.5 x 5.3 cm (3 1/16 x 5 5/16 x 2 1/16 in.)
Collection National Museum of African Art,
Smithsonian Institution, Washington, DC,
gift of Lawrence Gussman in memory of
Dr. Albert Schweitzer, 98-15-8

In Kongo thinking about the world of spirits, dogs possess a dual symbolism. As domestic animals, they belong in the village, home of the living; as hunting dogs, they travel into the forest, land of the dead (MacGaffey, in MacGaffey and Harris 1993: 42). Because of the hunting skills that dogs have in common with the ritual specialist *(nganga)*, they became symbolically associated with each other. Through the *nganga's* ability to activate the forces of the spirit realm, he could hunt down those who harmed others by stealing, lying, or causing illness. The *nganga* used medicinal or magical substances, including special herbs and earths, which were gathered into containers to form powerful instruments known as *minkisi* (singular, *nkisi)*. While some materials were contained in ordinary clay pots, woven baskets, or even snail shells, more dramatic were the sculpted human or—as in this case—canine figures that had "medicines" inserted in or attached to the body. Such figures added visual interest to the public-performance aspect of the *nganga's* invocation of a spirit from the world of the dead, which would be summoned for its particular abilities, its powers to help or harm, cure or kill, protect or punish (ibid.: 21, 32, 42). Unfortunately, there is no adequate English term to convey the meaning of *nkisi*. Of the two English-language terms used in the past to stand for *nkisi*—"fetish" and "power figure"—the word "fetish" originally communicated the concept of making something but does not convey the labor involved, and now has negative denotations; and the term "power figure" suggests a conduit for spiritual forces, but is subject to misinterpretation.

The figure shown here still retains the resin- and mirror-covered medicinal material on its back, with traces of additional material under the tail. Its open mouth may also have been used to hold substances. The shining ceramic-inlaid eyes symbolized the ability to see into the spirit realm. The articulation of the ribs apparent on this example is rare in Kongo sculptures, and particularly unusual on dog sculptures; on human figures, it may be a reference to the association of the *nkisi* with chest diseases (MacGaffey, in Royal Museum for Central Africa 1996: 144). While live hunting dogs are always kept trim, a starving hunting dog could be a subtle metaphor for the increase in illness and hunger caused by European colonization and its disruption of community life. BF

Provenance:
Edgar Beer, Brussels, 1965
Lawrence Gussman, New York, 1965–98

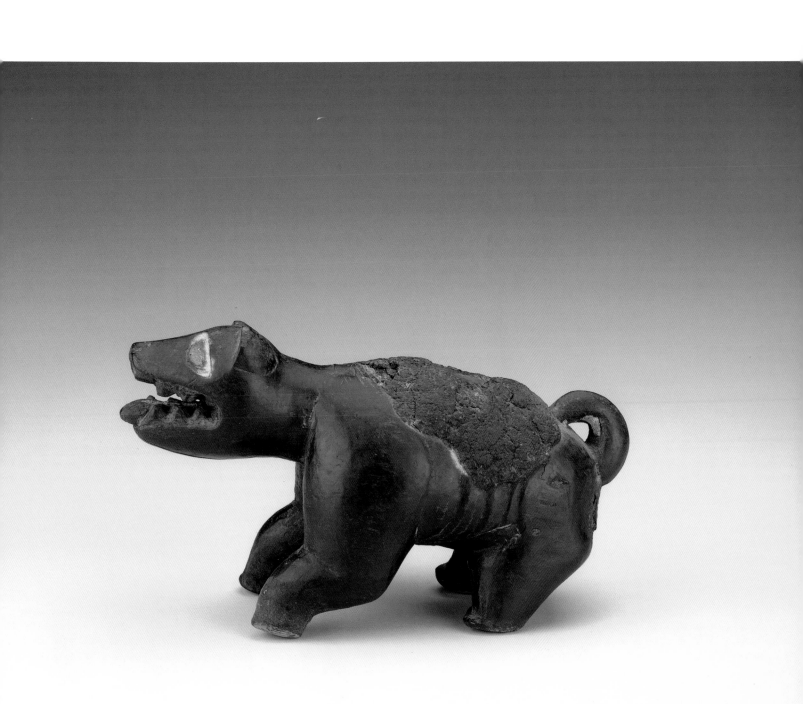

Bell *(dibu)*
Kongo peoples, Democratic Republic
of the Congo

Late 19th–early 20th century
Wood, stone
21.8 x 12.1 x 10.5 cm (8 9/16 x 4 3/4 x 4 1/8 in.)
Collection National Museum of African Art,
Smithsonian Institution, Washington, DC,
gift of Lawrence Gussman in memory of
Dr. Albert Schweitzer, 98-15-9

In Kongo cultures, bells are associated with hunting. Since Kongo hunting dogs cannot bark, hunters put undecorated wooden bells on them so they can be located when they run after prey. Until the early 20th century, an elaborately carved *dibu* was likely to be used by a different type of hunter: a ritual specialist *(nganga)*—a diviner or healer—who detects and pursues witches, individuals who harm people by occult means. The *nganga's* powers stem from his knowledge of spiritual forces and the materials that activate them.

In an *nganga's* public invocation of the spirits to heal or seek justice, he would wear a striking costume, jewelry, and regalia and would dance to music from whistles, gongs, rattles, and bells (MacGaffey, in MacGaffey and Harris 1993: 49–57). The sounds from such bells came from the action of a projecting wood clapper, which is now missing from the bell shown here.

The figure carved in a seated position at the top of this bell, which serves as its handle, conveyed a message for those immersed in Kongo ritual culture. While today the exact significance of the combination of turned head, upraised knees, and crossed arms is uncertain, one meaning of the arm gesture is clear: "I have no more to say" (Thompson and Cornet 1981: 167–68). BF

Provenance:
René Vander Straete, Brussels, 1972
Lawrence Gussman, New York, 1972–98

Publication history:
MacGaffey and Harris 1993: 57, cat. no. 35

Kneeling Figure *(ntadi)*
Kongo peoples, Democratic Republic
of the Congo

16th–19th century

Steatite

34.3 x 13 x 16.2 cm (13 1/2 x 5 1/8 x 6 3/8 in.)

Collection The Israel Museum, Jerusalem,

gift of Lawrence Gussman, New York,

to American Friends of the Israel Museum

in honor of Sarita Gantz, B97.0018

The Kongo peoples, who live in the territory around the mouth of the Congo River, including northern Angola, founded a kingdom on the banks of the river about the end of the fourteenth century and established a thriving trade in ivory and other commodities. After the arrival of the Portuguese in 1483, Kongo communities profited greatly from the expanded outlets for trade, providing Europe and the colonies with valuable goods, including slaves. The contacts grew even closer: ambassadors from Europe presented themselves at the Kongo king's court; when missionaries arrived, he and other rulers became converts to Christianity. These relationships, and the kingdom itself, collapsed after a decisive battle with the Europeans in 1665.

In Kongo culture, a stone *ntadi* (literally "watchman"; plural *mintadi)* was placed on the grave of a chief or other distinguished person. The tradition of carving *mintadi* in soft stone may have begun about the sixteenth century, gained impetus in the nineteenth century, and ended early in the twentieth century (Cornet 1971: 28, 30). Every *ntadi* consists of a single figure wearing a cylindrical cap and set on a plinth. The majority of them represent male adults, but some are of female children. Positions vary; most figures are seated cross-legged, or with one raised knee. Often the head is leaning on one hand or a knee, but sometimes other gestures are represented. This example is unusual: the kneeling pose with upraised hands suggests an attitude of prayer or imploring, but has also been interpreted as indicating the generosity of a ruler. DN

Provenance:

Julius Carlebach, New York, 1969

Lawrence Gussman, New York, 1969–96

Whistle *(yisoledi)*
Yaka peoples, Democratic Republic
of the Congo

19th–20th century
Wood
11.1 x 3.8 x 4.4 cm (4 3/8 x 1 1/2 x 1 3/4 in.)
Collection Neuberger Museum of Art,
Purchase College, State University of New York,
gift of Lawrence Gussman in memory of
Dr. Albert Schweitzer, 1999.06.80

Ingeniously, this miniature figure with stylized face and rounded body disguises its function as a whistle. A mouthpiece is hidden at the base of the figure, while the modulating hole projects from the side of the spherical form like an inverted navel. The finely carved head on top has features characteristic of northern Yaka sculpture: a large, crested coiffure; coffee-bean eyes in deep sockets; and, most distinctive of all, an upturned nose.

Whistles such as this one, called *yisoledi*, are used by Yaka men in ancestral cults and in hunting. The singular sound of the whistle is believed to enable traditional practitioners, such as healers and diviners, to communicate with the benevolent forces represented by ancestors (Niangi Batulukisi, personal communication, December 1999). On a more mundane level, a whistle is blown by the owner of a hunting dog to alert village men to an upcoming hunt (Bourgeois 1984: 87). Here, too, however, they may be associated with the spiritual realm. Certain whistles— those with a sculpted head, such as this example—are believed to offer hunters protection against malevolent forces that might attempt to ruin a hunt (ibid.: 88). CC

Provenance:
Mattias Lemaire, Galerie Lemaire, Amsterdam, 1989
Lawrence Gussman, New York, 1989–99

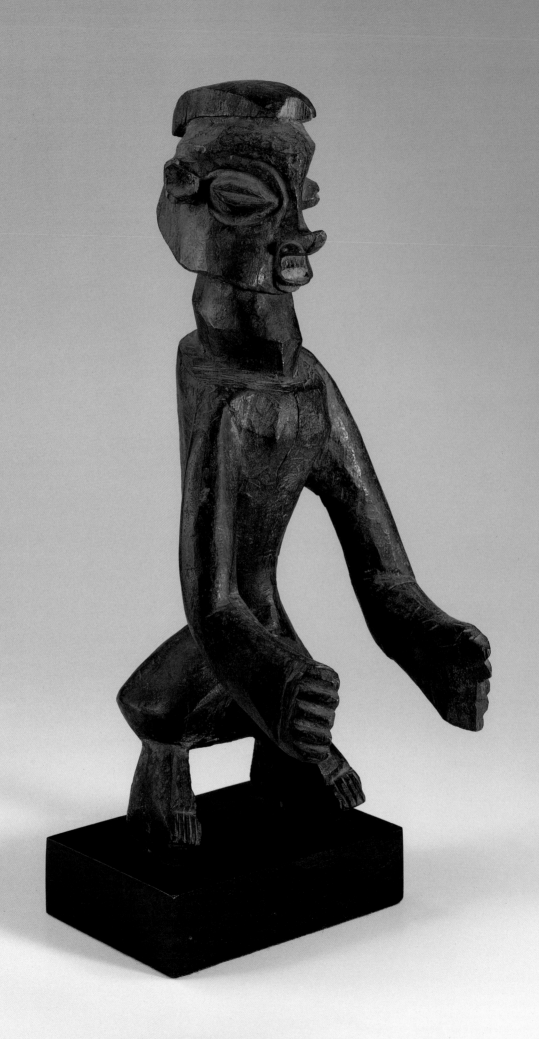

Figure *(khosi)*
Yaka peoples, Democratic Republic
of the Congo

19th–20th century
Wood
48.3 x 20.3 x 22.9 cm (19 x 8 x 9 in.)
Collection Neuberger Museum of Art,
Purchase College, State University of New York,
gift of Lawrence Gussman in memory of
Dr. Albert Schweitzer, 1999.06.79

The powerfully carved figure shown here belongs to a category of objects known as *khosi*, which serve a therapeutic ritual function. Found among the Yaka and the neighboring Suku and Holo peoples, *khosi* are employed on behalf of individuals and clans to restore and maintain harmony between living people and ancestors. *Khosi* are owned and manipulated by a ritual specialist *(nganga)*, who provides treatment to a patient suffering from ailments attributed to an offended spirit. To activate the figure, the *nganga* puts various medicinal ingredients in an animal horn or small packet and ties it to the figure's waist or neck (Bourgeois 1985: 6). The therapy session ends with the installation of the *khosi* spirit within the patient's family and the placement of the *khosi* figure on the lineage altar, where it is regularly consulted in order to maintain its protective function (Niangi Batulukisi, personal communication, December 1999).

This work is among the most expressive examples of Yaka figurative sculpture. The long, outstretched arms convey a sense of movement that is countered by the weightiness of the squat, widely spread legs and broad hips. Rising from a slender waist, the torso swells into a massive chest that juts forward forcefully. The large, oval eyes with half-closed lids extend from deeply carved sockets, framed on either side by stylized ears. The nose is gently upturned, a feature most characteristic of Yaka statuary, while the open mouth reveals bared teeth. In its original context, this figure probably supported a bundle of attached medicinal ingredients, now missing.

The pose of this figure is unusual. Typically, the hands of a Yaka figure are placed on the chest. Niangi Batulukisi interprets the gesture of the outstretched arms as an embrace that suggests

"the ancestor is ready to interpose between the living and the dead [while] the lowered eyes, half-closed, symbolize profound meditation" (ibid.). According to Niangi, the style of this figure is characteristic of the northern Yaka, whose sculptures tend toward extreme dynamism of form (ibid.) A similar example is in the collection of the Royal Museum for Central Africa in Tervuren, Belgium. CC

Provenance:
Julius Carlebach, New York
Eric de Kolb, Gallery d'Hautbarr, New York, 1969
Lawrence Gussman, New York, 1969–99

Publication history:
Vogel 1980: cat. no. 146

Female Figure *(biteki)*
Suku peoples, Democratic Republic
of the Congo

19th–20th century
Wood
48.9 x 12.4 x 12.7 cm (19 1/4 x 4 7/8 x 5 in.)
Collection The Israel Museum, Jerusalem,
gift of Lawrence Gussman, New York,
to American Friends of the Israel Museum
in honor of James Shasha, B97.0011

The Yaka and the main group of the Suku peoples live in adjacent areas between the Kwango and Kwilu rivers in southern Congo. They are surrounded by smaller ethnic groups, among which are scattered enclaves of minor Suku communities. The close proximity of the Yaka and Suku peoples has led to their sharing a number of cultural traits, including religious beliefs and art styles. Both have male initiation rites that include circumcision rituals, and both have experts in religious affairs who have also undergone special initiations.

As in other parts of Africa, these two peoples believe in the existence of a creator god, but when confronting life's problems and dangers, they invoke the ancestors to come to their aid. Here as elsewhere, carved figures are the vehicles through which such appeals for intervention are made. These figures serve as containers of protective magical power exercised by the experts against illness, to avenge sorcery, and for supernatural assistance in hunting. To activate the figures' powers, diviners place "medicines" (sacred formulas of natural materials) into small pouches and attach them to the figures; however, such pouches are now often missing in collected examples.

Suku and Yaka sculptures display great similarities in their proportions and stances. The most prevalent distinguishing feature is the Yaka figures' greatly exaggerated turned-up nose (said by some to represent an elephant's trunk), which appears less commonly in Suku figures; the latter are marked by the very distinctive articulation of firmly defined sections of the body visible in the female figure *(biteki)* shown here. The gesture of the hands raised to the chest is said to express sorrow or mourning. Some figures of this type are believed to be associated with fertility rites, as this example's protruding abdomen (possibly indicating pregnancy) might suggest. DN

Provenance:
Julius Carlebach, New York, before 1968
Eric de Kolb, Gallerie d'Hautbarr, New York, 1968
Lawrence Gussman, New York, 1968–96

Publication history:
Palais Miramar 1957: fig. 236
Museum of African Art 1970: cat. no. 363
Hudson River Museum 1971: cat. no. 237

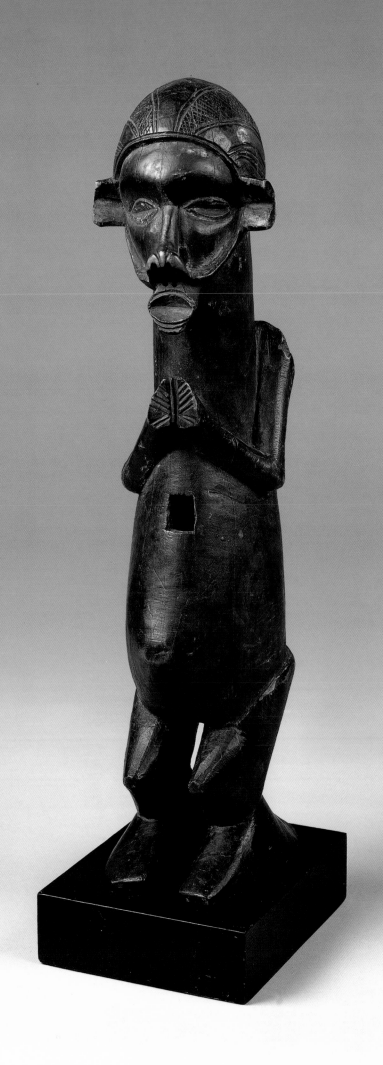

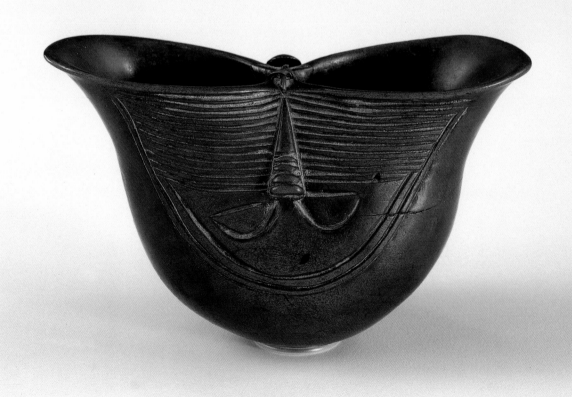

Cup *(kopa)*
Suku peoples, Democratic Republic
of the Congo

19th–20th century
Wood, brass tack
8.9 x 13.3 x 6.4 cm (3 1/2 x 5 1/4 x 2 1/2 in.)
Collection Neuberger Museum of Art,
Purchase College, State University of New York,
gift of Lawrence Gussman in memory of
Dr. Albert Schweitzer, 1999.06.81

Among the Suku, cups such as the one shown here are owned by a matrilineage headman *(leemba)*—the chief of the region—and are a symbol of his authority. The cup *(kopa)* is used in a highly ritualized ceremony in which the headman, in the presence of his respectful associates, first offers libations to the ancestors and then himself drinks from the vessel (Bourgeois 1984: 56).

The distinctive form of the cup derives from the shape of a gourd that has been halved vertically, resulting in a double-mouthed opening, which in this example is decorated with a brass tack. On one side of the cup there are several motifs of symbolic significance framed by a graceful pattern of incised lines that echo the cup's curves. The narrow cone-shaped form in the middle represents an antelope horn, which the Suku frequently use as a container for powerful "medicines." Below it, two semicircles suggest the eyelids of a human face, a possible reference to the *hemba nkisi*, a northern Suku charm (Bourgeois, in Philips 1995: cat. no. 4.22). These motifs are considered powerful enough to frighten away anyone intending to touch the vessel without authorization (Bourgeois 1978: 77).

The smoothly patinated surface suggests its long history of use. Such cups are usually passed on from generation to generation; on his deathbed or in declining health, the village headman bestows the cup on his *mwana khasi* or titular nephew (ibid.: 76). The transfer of the cup, accompanied by a recitation of the names of all the previous owners, signifies that the successor now holds the office of *leemba* (Bourgeois 1984: 56). CC

Provenance:
Lawrence Gussman, New York, 1973–99

Publication history:
Robbins and Nooter 1989: cat. no. 1105

Stringed Instrument *(kalumbeti* or *kakosha)*
Holo peoples, Luremo region, Angola

20th century
Wood, nylon strings
48.3 x 15.2 x 9.5 cm (19 x 6 x 3 3/4 in.)
Collection Neuberger Museum of Art,
Purchase College, State University of New York,
gift of Lawrence Gussman in memory of
Dr. Albert Schweitzer, 1999.06.84

Although historically the Holo had close contact with Portuguese Capuchin missionaries in the seventeenth century, little was known in the Western world about their art and culture until Albert Maesen's research during the 1950s. While doing field work among the Holo, Maesen collected a two-stringed musical instrument, described variously as a harp or violin, that is now in the Royal Museum for Central Africa in Tervuren, Belgium. That one and the example shown here are among the few such objects currently in museum collections.

In form, the instrument bears a close resemblance to the cylindrical slit drums used in Holo divination rituals. It differs, however, in the addition of the two strings that extend from the base to the handle, which is sculpted in the shape of a head. There, the strings pass through the mouth, where they are fastened to two wooden pegs inserted into the head behind the ears. According to Niangi Batulukisi, the head is sculpted in a style that is specific to the region of Luremo in Angola (Niangi Batulukisi, personal communication, December 1999). The lowered, crescent eyes are inscribed on the convex surface of a heart-shaped face adorned with three dotted lines of scarification: a vertical that bisects the forehead from below the hairline to the top of the nose, and two curved lines above the arching brows Below each eye are incised two vertical lines of scarification. The coiffure is represented as rows of small, tight knots covering the skull.

This type of musical instrument, called either *kalumbeti* or *kakosha*, is played by a professional musician or court storyteller, using an arched bow with fiber cord. It is held by the musician either perpendicularly to the ground or horizontally across the chest (Biebuyck 1986, vol. 1: 217). The music is played to accompany the tales of storytellers and local historians (Niangi Batulukisi, personal communication, December 1999). CC

Provenance:
Alain Schoffel, Paris, 1971
Lawrence Gussman, New York, 1971–99

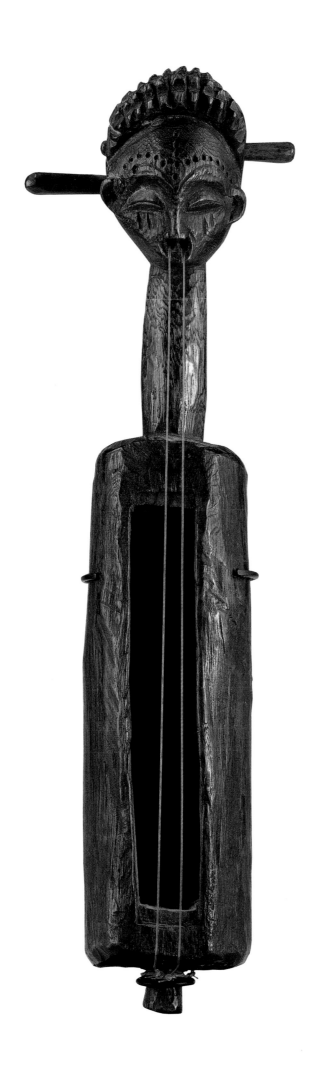

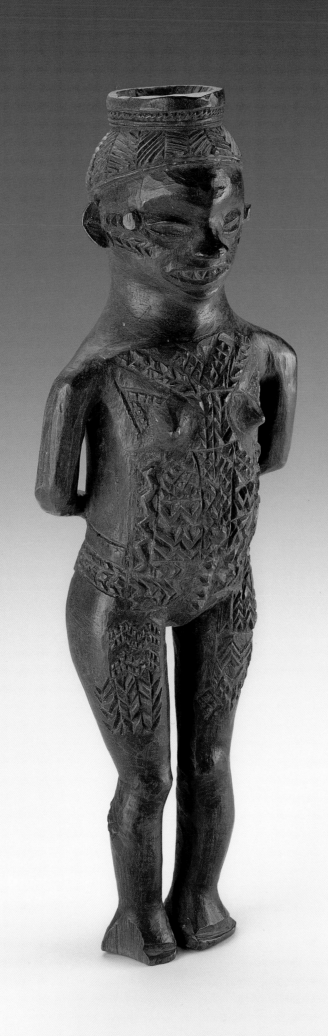

Vessel in Form of Female
Wongo peoples, Democratic Republic
of the Congo

Early 20th century
Wood
27.5 x 9 x 7.5 cm (10 13/16 x 3 9/16 x 2 15/16 in.)
Collection National Museum of African Art,
Smithsonian Institution, Washington, DC,
gift of Lawrence Gussman in memory of
Dr. Albert Schweitzer, 98-15-4

Among many central African peoples, elaborate scarification on a woman was considered both beautiful to the eyes and appealing to the touch. It can be assumed that the decorated palm wine cup shown here, shaped in the figure of a woman, was meant to convey both pleasure and status. It also exemplifies two historic influences on Wongo art and life: the Kuba and Pende cultures.

In 1906, Emil Torday field-collected Wongo cups for the British Museum and was the first to point out the cultural relationship between the Wongo and the neighboring Kuba peoples (Mack, in Phillips 1995: 271). While such wine cups are not the most important artistic artifacts of either culture, both peoples do create a variety of finely carved cups—some figural, and others in simpler shapes ornamented with geometric motifs. Most Kuba examples are in the form of a head rather than the full figure of this Wongo vessel. Here, moreover, the facial features—the pointed jaw line, angled eyes, triangular nose—are unlike Kuba faces but recall the stylized motifs on Pende masks and ivory pendants. The artistic exchange represented by these similar tendencies resulted from a series of migrations of the Wongo and Pende peoples into the same territory (Felix 1987: 188). However, this figure's relatively slender proportions, the extent and high relief of the scarification, and the intensity of expression conveyed by the wide mouth are different from both Kuba and Pende styles, whether because of the particular artist or the dictates of the little-known Wongo style. BF

Provenance:
Harvey Menist, Amsterdam
Ernst Anspach, New York
Eric de Kolb, Gallery d'Hautbarr, New York, 1970
Lawrence Gussman, New York, 1970–98

Publication history:
Walker 1976: 42, fig. 29

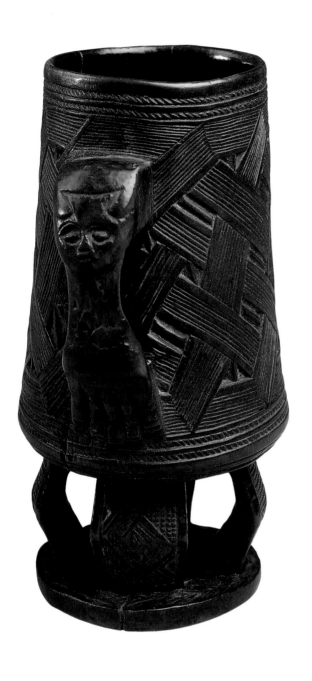

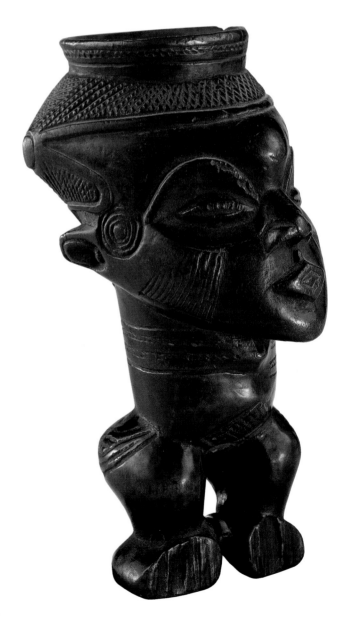

Vessel in Form of Drum
Kuba peoples, Democratic Republic
of the Congo

19th–20th century
Wood
22.5 x 11.7 x 11.7 cm (8 7/8 x 4 5/8 x 4 5/8 in.)
Collection The Israel Museum, Jerusalem,
gift of Lawrence Gussman to American
Friends of the Israel Museum in memory of
Dr. Albert Schweitzer, B97.0021

Vessel in Form of Female Figure
Kuba peoples, Democratic Republic
of the Congo

19th–20th century
Wood
21.6 x 10.2 x 14 cm (8 1/2 x 4 x 5 1/2 in.)
Collection Neuberger Museum of Art,
Purchase College, State University of New York,
gift of Lawrence Gussman in memory of
Dr. Albert Schweitzer, 1999.06.90

Vessels Figures 44–46

The Kuba produce a variety of vessels used for drinking palm wine. Palm wine is a naturally alcoholic beverage that exudes from the core of the raffia palm tree when it is tapped. The liquid is collected in large pottery or gourd containers in the early morning and late afternoon. Today, palm wine vendors offer this beverage in a plastic cup or drinking glass; but in the nineteenth and early twentieth century, Kuba men could purchase a decorated wooden palm-wine container for their personal use.

Carved wooden palm-wine vessels were created in a variety of distinctive forms. There are three decorated, carved wooden vessels in the Gussman Collection. The first example (cat. no. 44), a beaker form, is a representation of a Kuba drum supported by four broad, curved legs that attach the drum to a circular base. Also typical of Kuba decorated drums is the addition of a carved wooden handle that suggests a human body in abbreviated form: a head and neck that merge into a wrist and hand. The curved form of the wrist and hand stylistically echoes the shape of the drum's legs. The incised surface decoration on this beaker resembles the elaborate carved or beaded surface decoration on some Kuba drums.

The second vessel (cat. no. 45) is carved in the form of a female figure featuring an enlarged head supported on a small torso, with abbreviated legs that terminate in large feet. The stylistic features of the face—including a stylized hairline ridge, crescent-shaped eyebrows, and facial decorations that represent tear lines on the cheeks—suggest those found on Kuba masks. The carved surface decorations on the torso and legs of the cup recall jewelry and elaborate scarification patterns worn by many Kuba women in the nineteenth and twentieth century.

Bowl

Kuba peoples, Democratic Republic of the
Congo
19th–20th century
Wood
7.9 x 15.9 x 15.2 cm (3 1/8 x 6 1/4 x 6 in.)
Collection Neuberger Museum of Art, Purchase
College, State University of New York, gift of
Lawrence Gussman in memory of Dr. Albert
Schweitzer, 1999.06.91

The third Kuba palm-wine container (cat. no. 46) is in the form of a handled bowl that displays finely detailed surface decoration consisting of a central panel of interlace pattern. DB

Provenance:
Cat. no. 44:
 Genevieve Rodier, Paris, before 1972
 Harold Rome, New York, 1972–73
 Lawrence Gussman, New York, 1973–96
Cat. no. 45:
 Arthur Spingarn, New York
 Merton Simpson, New York, 1972
 Lawrence Gussman, New York, 1972–99
Cat. no. 46:
 Lawrence Gussman, New York, 1972–99

Publication history:
Cat. no. 44:
 Hôtel Drouot, Paris 1972: pl. VIII, cat. no. 104
Cat. no. 45:
 Vogel 1980: cat. no. 157

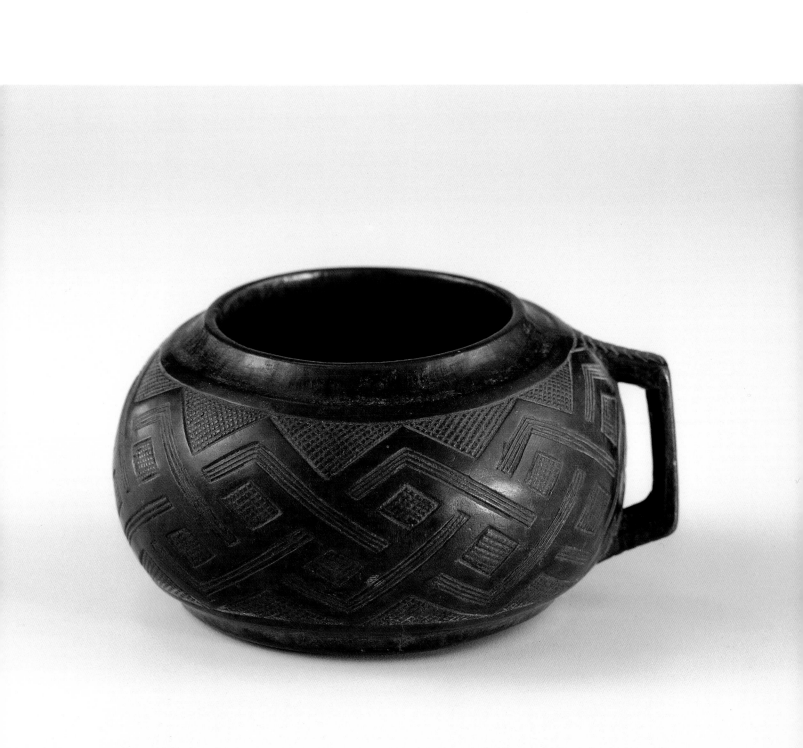

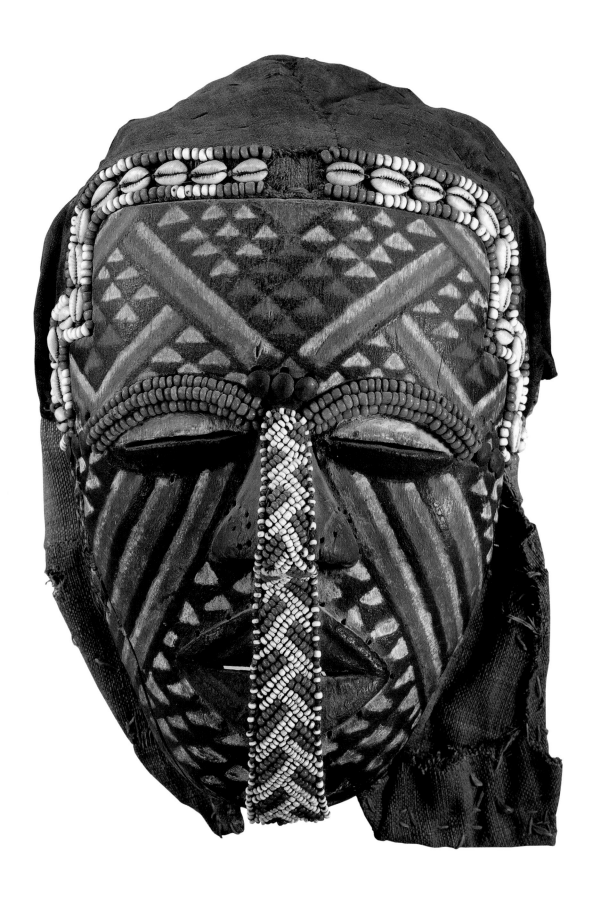

Ngady amwaash Mask
Kuba Peoples, Democratic Republic
of the Congo

19th–20th century
Wood, textile, pigment, beads, cowries
26.7 x 17.8 x 21.6 cm (10 1/2 x 7 x 8 1/2 in.)
Collection Neuberger Museum of Art,
Purchase College, State University of New York,
gift of Lawrence Gussman in memory of
Dr. Albert Schweitzer, 1999.06.92

Among the most well known of all Kuba masks, Ngady amwaash is a more elaborately decorated version of a mask type called *mukasha ka muadi* (literally, "female mask"), produced in the southern Kuba region among northern Kete peoples. The northern Kete mask is usually painted with red pigment and minimal surface decoration, whereas the Ngady amwaash mask is completely covered with painted geometric patterns. In addition, the hairline of the Ngady amwaash is decorated with parallel rows of colorful beads and cowrie shells; two arched bands of beaded decoration define the eyebrow ridges; and another band of beaded decoration is attached vertically over the mask's nose, mouth, and chin.

Ngady amwaash masks are worn by male dancers during ceremonial events. The top, sides, and back of the mask shown here are covered with undecorated blue cloth; but before a performance, a tricornered hat and feather decoration are attached at the top. The masked dancer also wears a distinctive costume that includes a shirt decorated with geometric patterns and a woman's long, embroidered raffia skirt. A woman's embroidered overskirt is worn over the longer skirt and is secured around the waist with a belt. Other elements of regalia, such as beaded necklaces, are also worn.

The Ngady amwaash mask is used most often by dancers at funerals, accompanied by a dancer wearing the Bwoom mask. The performance style of the Ngady amwaash dancer is restrained, with movements that mimic the dancing style of a woman. This is in sharp contrast to the extroverted style of the performer wearing the Bwoom mask, who carries a parade knife in his gloved hand and makes short jabbing motions toward the assembled onlookers. DB

Provenance:
Jef Vander Straete, Brussels, 1972
Lawrence Gussman, New York, 1972–99

Publication history:
Walker 1976: fig. 72

Female Figures 48–49

Among the Lulua, female figures bearing a cup in the hand are associated with Bwanga Bwa Bwimpe, an organization concerned with issues of fertility and the protection of newborns, and the figures themselves are called *bwanga bwa bwimpe* or *lupingu lwa bwimpe.* They are owned by mothers who have borne healthy and beautiful children, particularly those with pale or "red" skin. After the birth of such a child, a white *mwabi* tree is usually planted near the mother's house and dedicated to the spirits of the deceased. The ancestral spirits are believed to be contained within the sculpted figures, providing the special protection needed by these exceptional children. The sculptures also perform a variety of other services, including treating children who suffer from skin diseases and eye infections as well as ensuring the success of farmers and hunters (Petridis, in Koloss 1999: cat. no. 148).

The two names for the cup-bearing figures both contain the term *bwimpe*, which conveys in a single word the inextricably linked concepts of "goodness" and "beauty" in Lulua thought. This ideal union of moral and physical beauty is most directly expressed through the figures' exaggerated details of anatomy and patterns of intricate scarification that cover the body. Intelligence, will power, and common sense are symbolized by their large heads and high foreheads, while a capacity for hard work is indicated by their sturdy calves (Petridis 1997: 193). Large, bulging eyes suggest a supernatural vision that can detect and avert harmful forces, and the protruding navel alludes to both the source of life and the connection with the ancestors.

These exaggerated formal elements are further accentuated by symbolically meaningful patterns of scarifications. Concentric circles ringing the navel and protruding from the backs of the knees refer to certain celestial bodies and also convey the positive concepts of life, birth, and growth (ibid.: 194). Undulating double grooves on the forehead and temples (as in cat. no. 49) symbolize a growing life and beating heart in a mother's womb (Petridis, in Royal Museum for Central Africa 1995: 333).

For the Lulua, attaining the aesthetic ideal represented by such figurative sculptures is not mere vanity but rather regarded as necessary to maintain one's well-being. In their culture, physical imperfections, particularly those affecting the skin, are viewed as evidence of bewitchment or sorcery (ibid.: 134). As a preventive measure, newborns are lavished with special care and handling, a treatment that is replicated on the sculptures: both the babies and the figures are regularly massaged with a mixture of camwood powder and palm oil and then washed with warm water (Timmermans 1966: 20). On these examples, evidence of this can be seen in the rounded forms of the polished wood surfaces and the traces of red pigment left in the crevasses. CC

Provenance:
Cat. no. 48:
 Marcel Le Maire, Brussels
 Merton Simpson, New York, 1970
 Lawrence Gussman, New York, 1970–96
Cat. no. 49:
 J. F. Gustav Umlauff, Hamburg, Germany
 Merton Simpson, New York, 1970
 Lawrence Gussman, New York, 1970–99

Publication history:
Cat. no. 48:
 Hudson River Museum 1971: cat. no. 233
Cat. no. 49:
 Hudson River Museum 1971: cat. no. 232

Female Figure *(bwanga bwa bwimpe*
or *lupingu lwa bwimpe)*
Lulua peoples, Democratic Republic
of the Congo

19th–20th century
Wood
25.4 x 5.1 x 5.1 cm (10 x 2 x 2 in.)
Collection The Israel Museum, Jerusalem,
gift of Lawrence Gussman, New York,
to American Friends of the Israel Museum
in honor of Herbert Gussman, B97.0012

Female Figure *(bwanga bwa bwimpe*
or *lupingu lwa bwimpe)*
Lulua peoples, Democratic Republic
of the Congo

19th–20th century
Wood
29.8 x 6 x 6.3 cm (11 3/4 x 2 3/8 x 2 1/2 in.)
Collection Neuberger Museum of Art,
Purchase College, State University of New York,
gift of Lawrence Gussman in memory of
Dr. Albert Schweitzer, 1999.06.96

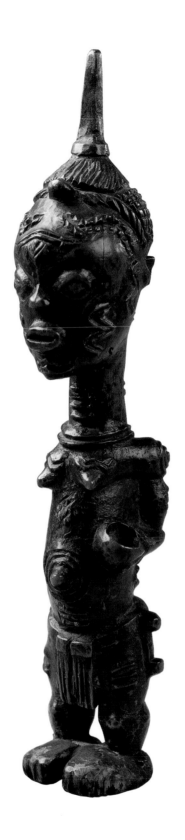

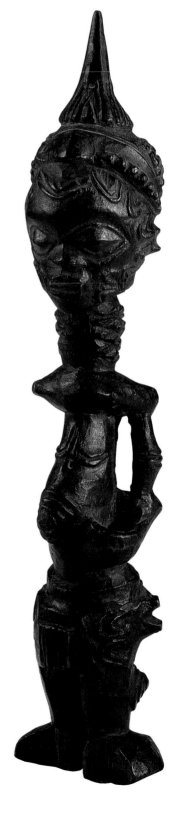

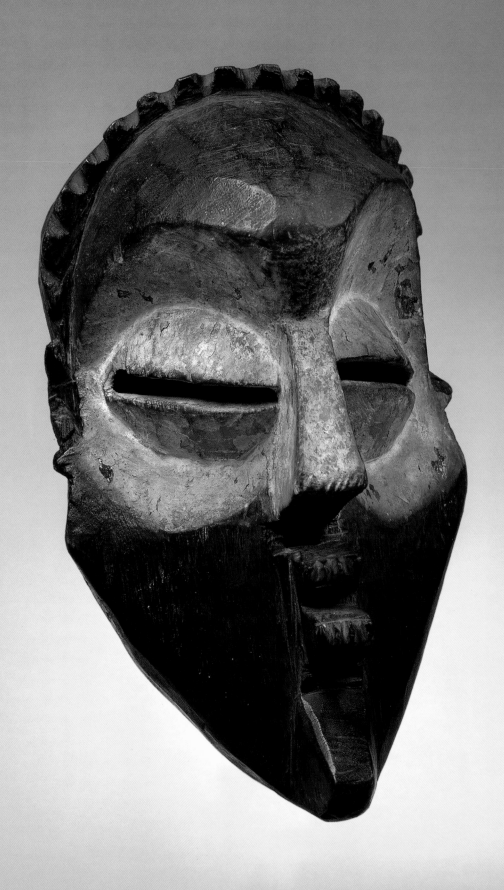

Mask *(kibwabwabwa)*
Kete or Mbagani peoples, Democratic
Republic of the Congo

19th–20th century
Wood, kaolin, pigment
28.3 x 18.7 x 17.1 cm (11 1/8 x 7 3/8 x 6 3/4 in.)
Collection The Israel Museum, Jerusalem,
gift of Lawrence Gussman, New York,
to American Friends of the Israel Museum in
memory of Dr. Albert Schweitzer, B97.0017

The Mbagani (also known as Binji) and Kete were groups of agricultural people who, like other indigenous Congolese peoples, were largely dispersed by Luba invasions. The masks of both groups are notable for their concise, geometric forms. In the example shown here, the upper half of the face is defined by a rounded brow, in outline, and the lower half tapers down to a pointed chin. The relatively enormous eyes—protruding ovals in relief, with horizontal eye slits—are set in rounded, concave areas painted white. Between the eyes, the nose is a rectangular block; below it, a smaller block forms the mouth, notched to denote the lips. The style is related to the masks of the neighboring Lwalu and the Salampasu.

The masks are used by the Kete in circumcision rituals. Among the Mbagani, the huge eyes are associated with the ancestral spirits they worship, and the masks are worn at rites to promote successful hunting or female fertility. DN

Provenance:
Harold Rome, New York, 1972
Lawrence Gussman, New York, 1972–96

Mother and Child Figure
Lwena peoples, Democratic Republic
of the Congo, Angola, and Zambia

19th–20th century
Wood
19.4 x 5.7 x 5.1 cm (7 5/8 x 2 1/4 x 2 in.)
Collection The Israel Museum, Jerusalem,
gift of Lawrence Gussman, New York,
to American Friends of the Israel Museum in
memory of Dr. Albert Schweitzer, B98.0059

The Lwena are a matriarchal society consisting of a group of chiefdoms, in which both men and women can be chiefs. As a people, the Lwena originated in the sixteenth century, when a brother of a Lunda queen, after a dispute over the royal authority arising from her marriage to a Chokwe, migrated from Angola and established his own state. Given the importance of women in their society, it is not surprising that most Lwena figure sculptures are female—small standing figures representing female ancestors or spirit guardians. When they are shown as pregnant, or holding a baby, they are linked to the quest for fertility.

The sculpture shown here is of a woman with a graceful torso, small conical breasts, a narrow waist, and thin arms bent at right angles, holding a full-faced figure of a baby before her, just above the engraved pubic scarifications. In contrast to her upper body's slender proportions, the buttocks, bent legs, and the feet are sturdy, even massive. Her head demonstrates the strong influence of Chokwe sculpture on Lwena art, in spite of the often-hostile relations with the Chokwe, which resulted in Lwena migrations to Congo and Zambia about a century ago. This influence is evident in Lwena chairs following Chokwe models, anthropomorphic pottery, and the facial conventions of masks. Here the broad, almost flattened face, with its sunken, elliptical eyes and its other features given summary treatment, is clearly based on Chokwe models, as is the shallow, disk-shaped cap. DN

Provenance:
Ernst Anspach, New York
Eric de Kolb, Galerie d'Hautbarr, New York, 1969
Lawrence Gussman, New York, 1969–98

Publication history:
Hudson River Museum 1971: cat. no. 162

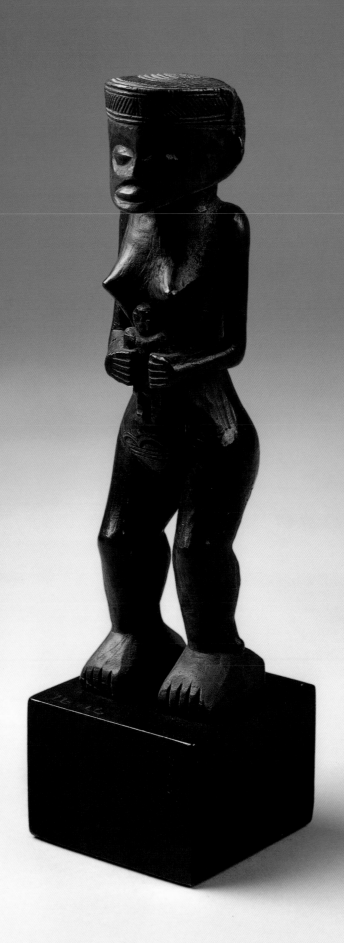

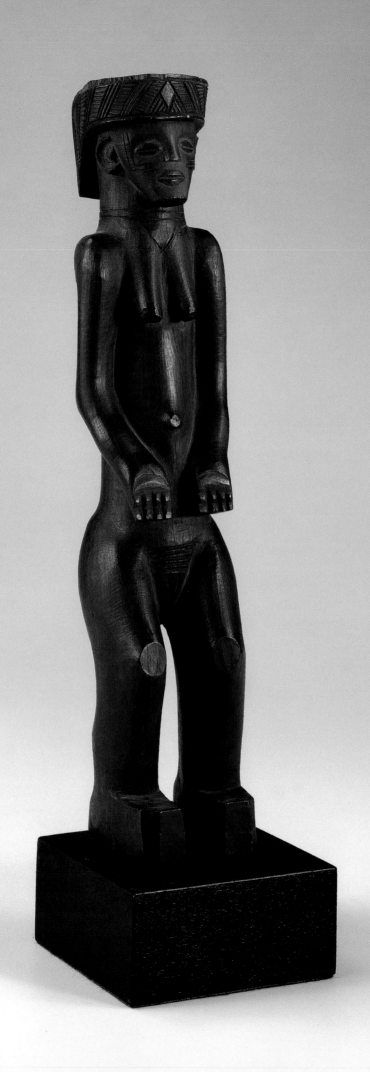

Female Figure
Lwena peoples, Democratic Republic
of the Congo, Angola, and Zambia

20th century
Wood
36.8 x 7 x 7.6 cm (14 1/2 x 2 3/4 x 3 in.)
Collection Neuberger Museum of Art,
Purchase College, State University of New York,
gift of Lawrence Gussman in memory of
Dr. Albert Schweitzer, 1999.06.100

The Lwena figure shown here presents a sculptural image of an ideal woman. Standing erect, with head held high, she embodies the physical and social characteristics of a desirable wife and future mother. Her arms cradle her abdomen—the future source of life—while her legs are slightly flexed, suggesting her youthful energy. The smoothly polished and rounded forms of her body contrast with and highlight the darker, finely incised lines of her coiffure and scarification.

Elisabeth Cameron, in her research among the related Lunda and Luvale cultures, describes the sculpting of an ideal female as a mutable process, the result of ongoing negotiations between women and the male sculptors that create such works. For the female teachers that organize women's initiations, the ultimate goal is the transformation of a girl into an ideally socialized woman. This ideal female is then rendered into sculptural form by male artists who focus on the physical attributes of a woman who has recently completed initiation. "Women, however, exercise great control within the initiation context over ideals portrayed by male sculptors. They either incorporate or change the ideals that sculptors portray, and they select those qualities that they find attractive themselves. All these interactions contribute to the constant redefinition of the ideal female form" (Cameron 1998: 77–79).

The sculptor of this figure has emphasized her scarifications and extended labia, both of which are bodily manipulations associated with the process of female initiation. Incised on either side of the face are double L-shaped lines, called *tukone*, Lwena body marks that have also been adopted by the neighboring Chokwe peoples. The vertical line of raised cicatrices down her back is

called *kangongo*, a reference to a small species of mouse that has a black stripe down its back. Above the labia are five horizontal rows of incised lines *(mikonda)*, which are made when a girl begins puberty (Bastin 1961: 113; Bastin 1982: 72–73). CC

Provenance:
Julius Carlebach, New York
Eric de Kolb, Gallery d'Hautbarr, New York, 1969
Lawrence Gussman, New York, 1969–99

Staffs of Office 53–55

In the precolonial period, a staff of office *(kibango)* was an important artifact in Luba rituals of investiture. A newly appointed king was first ritually purified in holy river water, then rubbed with white chalk, freshly clothed, and adorned with the regalia of his new office. Holding the *kibango*, the chief's sister or first wife preceded the ruler during these investiture rites and then placed it next to the royal throne. The staff was held by the ruler as he took the oath of office, and later, placed upright in the ground during important public ceremonies and when the Luba were at war; he also carried it wherever he went and prominently displayed it. Such staffs were also owned by chiefs and titleholders, local governors and village heads, and female spirit mediums.

The *kibango*, more than any other type of royal insignia, functions as a mnemonic text. Its forms and designs constitute a "sculptural map" that evokes the Luba landscape and historical events in a way that can be read by their owners (Roberts and Roberts 1996: 162). The sculpted female figures that often adorn the staffs represent founders of specific royal lines. On the shaft, the broad, diamond-shaped section *(dibulu)* identifies the administrative center of a royal capital and is embellished with low-relief geometric patterns that have symbolic significance. The shaft itself, frequently wrapped with copper coiling, represents uninhabited savannas or roads leading to administrative centers of a kingdom. At the bottom, an iron spike signifies the material wealth of a kingdom or the strength of a chiefdom (ibid.: 166).

Despite the large number of *kibango* that exist, no two are identical. According to Mary Nooter Roberts and Allen F. Roberts, "Each represents the history of a particular chief or titleholder, and the migrations of his ancestors, his genealogy, and the location of tutelary spirits and natural resources. Like witnesses to the past, these emblems chronicle the local political histories that constituted the web of relations within the Luba sphere of influence" (ibid.: 162–63).

At the top of the staff in cat. no. 53, for example, is a kneeling female figure ornamented with blue and white beads that may refer to a lineage founder. Below the metal-wrapped shaft, an openwork oval panel ends in a paddle-shaped base, an allusion to the staff's riverine origin near the Luluaba. The staff in cat. no. 54 has a long shaft bound with copper coils and ending in a long metal spike at the bottom end. At the top, extending above a small sculpture of a human head, is a flat panel with curved sides and decorated with a plaited pattern that alludes to the prohibitions of kingship *(bizila)*. In the middle, the *dibulu* includes a relief carving of four duiker horns and two groups of concentric circles. The depiction of these small antelope horns, typically used by Luba healers to hold powerful "medicines," refers to the curative abilities of the staff itself, while the circular pattern may indicate the ruler's seat of power (Mary Nooter Roberts, personal communication, December 1999). Cat. no. 55 has a short, unadorned shaft and a plain tip at the bottom end. Just above the shaft is a small Janus head and a flat panel with a plaited pattern similar to the one in cat. no. 54; above that is a small sculpted head with a cruciform coiffure, and there is another Janus head just below the shaft in the lower part of the staff, which resembles a spear. This third head is carved in high relief in a panel that is shaped like a feather or leaf and decorated with the same plaited pattern. Both sculpted Janus heads probably represent the twinned tutelary spirits of Luba kingship, Mpanga and Banze. CC

Staff of Office *(kibango)*
Luba peoples, Lualaba River region,
Democratic Republic of the Congo

19th–20th century
Wood, iron, copper alloy, beads, cord
150.4 x 12.7 x 6.4 cm (59 1/4 x 5 x 2 1/2 in.)
Collection The Israel Museum, Jerusalem,
gift of Lawrence Gussman, New York,
to American Friends of the Israel Museum in
memory of Dr. Albert Schweitzer, B97.0013

Provenance:
Cat. no. 53:
 Brussels Museum, until 1924
 Mrs. W. A. Creath, London (?), 1924–72
 Ralph Nash, London, 1972
 Lawrence Gussman, New York, 1972–99
Cat. no. 54:
 Brussels Museum, until 1931
 Mrs. W. A. Creath, London (?), 1931–72
 Lawrence Gussman, New York, 1972–99
Cat. no. 55:
 Mrs. W. A. Creath, London (?), before 1938 to 1972
 Ralph Nash, London, 1972
 Lawrence Gussman, New York, 1972–99

Publication history:
Cat. no. 53:
 Sotheby's, New York, 1972, pl. LIX, no. 261
 Vogel 1980: cat. no. 163

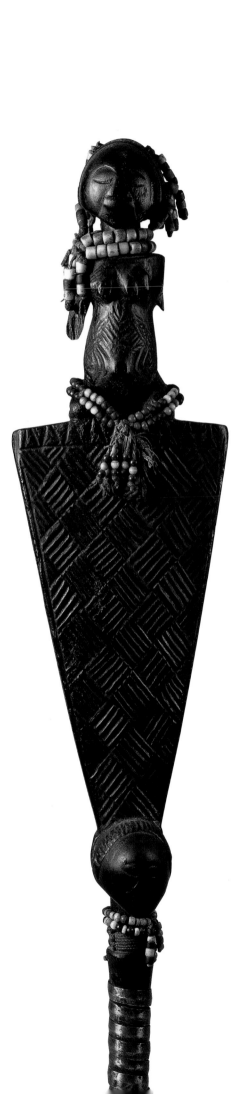
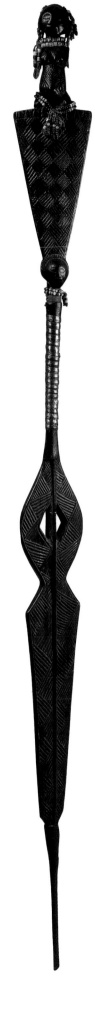

Staff of Office *(kibango)*
Luba peoples, Democratic Republic
of the Congo

19th–20th century
Wood, copper
148 x 14 x 5.7 cm (58 1/4 x 5 1/2 x 2 1/4 in.)
Collection Neuberger Museum of Art,
Purchase College, State University of New York,
gift of Lawrence Gussman in memory of
Dr. Albert Schweitzer, 1999.06.109

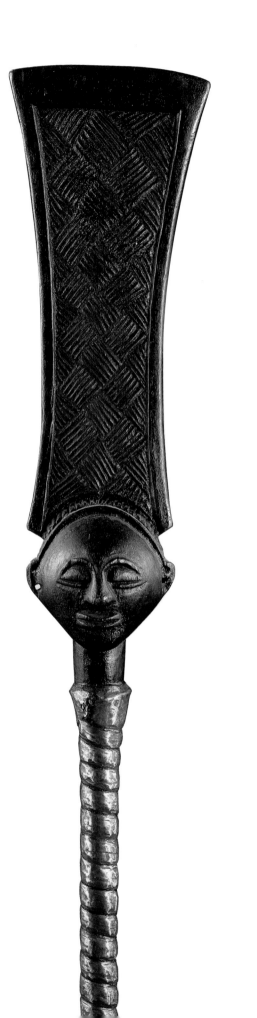
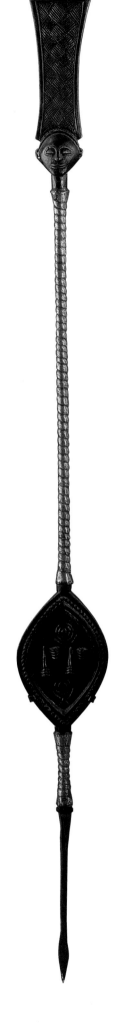

Staff of Office *(kibango)*

Luba peoples, Democratic Republic of
the Congo
19th–20th century
Wood
148.6 x 10.2 x 6.4 cm (58 1/2 x 4 x 2 1/2 in.)
Collection Neuberger Museum of Art, Purchase
College, State University of New York, gift of
Lawrence Gussman in memory of Dr. Albert
Schweitzer, 1999.06.110

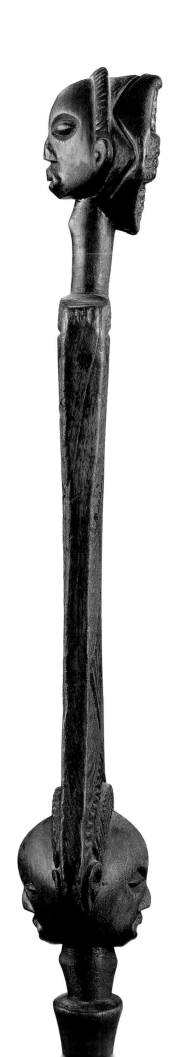

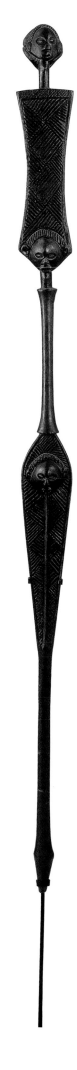

Ceremonial Axe *(kibiki* or *kasolwa)*
Luba peoples, Democratic Republic
of the Congo

19th century
Wood, iron, copper
31.1 x 22.9 x 6 cm (12 1/4 x 9 x 2 3/8 in.)
Collection The Israel Museum, Jerusalem,
gift of Lawrence Gussman, New York,
to American Friends of the Israel Museum in
memory of Dr. Albert Schweitzer, B98.1061

Ceremonial Axe and Adze 56–57

Finely crafted axes *(kibiki* or *kasolwa)* and adzes *(nseso)* with flared metal blades were among the regalia that a high-ranking Luba owned as an indicator of status. Worn over the shoulder, these ceremonial tools were considered an emblem of kingship, although they were also owned by other Luba of importance, including chiefs, secret-association members, and female spirit mediums. Luba court historians relate that the display of an axe or adze commemorates Kalala Ilunga, the culture hero who founded the institution of kingship among the Luba and who also introduced metalworking technology. However, the tradition might be considerably older than the Luba royal era, as recent archaeological excavations have revealed similar examples of ceremonial axes that date to at least as early as the eleventh century (Childs and de Maret, in Roberts and Roberts 1996: 57).

In the two examples shown here, the compositional elements have symbolic meanings that, in combination, present a richly textured and multivalent reading. The flared metal blades are adorned with delicately incised geometric designs, called *ntapo*, that refer to patterns of female scarification. The sculpted female heads that decorate the shafts allude in general to the importance of women's role in safeguarding the secrets of kingship. The presence of two female heads on the adze (cat. no. 57) probably refers more specifically to the twin spirit guardians of Luba kingship, Mpanga and Banze. Also on the adze are some of the more symbolically charged elements of Luba artistry. Small iron pins *(kinyundo)* adorn the plaited coiffure of each head. Wrought in the shape of a miniature blacksmith's anvil, the pins allude to the secret of blacksmithing and, by extension, to the power, strength, and transformative capacities of the king. According to Mary

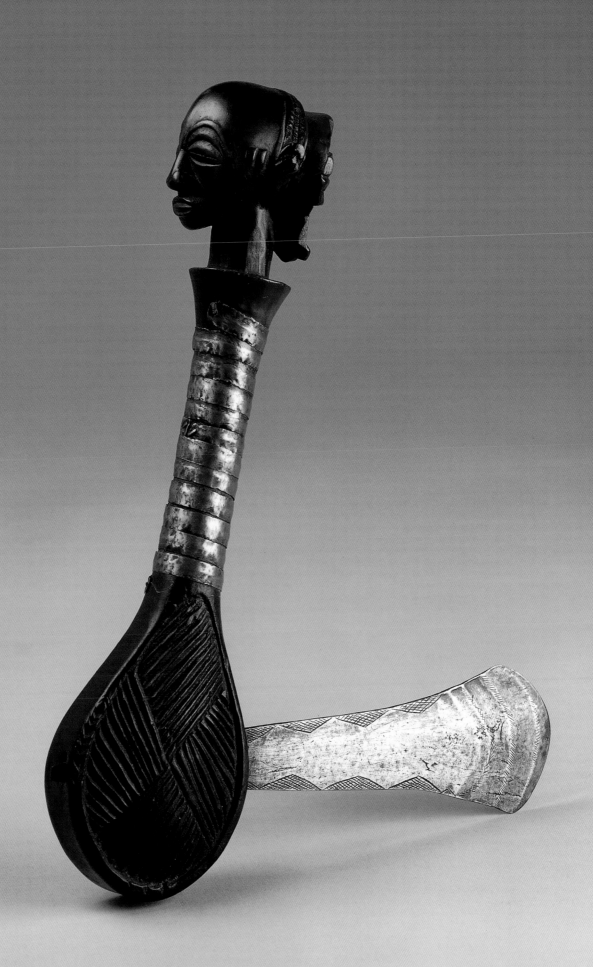

Ceremonial Adze *(nseso)*

Luba peoples, Democratic Republic of the
Congo
19th century
Wood, iron
34.3 x 40.6 x 3.2 cm (13 1/2 x 16 x 1 1/4 in.)
Collection Neuberger Museum of Art, Purchase
College, State University of New York, gift of
Lawrence Gussman in memory of Dr. Albert
Schweitzer, 1999.06.112

Nooter Roberts, the presence of the iron pins is understood by some Luba as an indication that the object's purpose is to safely contain and hold the power within (Mary Nooter Roberts, personal communication, December 1999). CC

Provenance:
Cat. no. 56:
 W. A. Creath, London (?)
 Sotheby's London, early 1970s
 Lawrence Gussman, New York, early 1970s to 1998
Cat. no. 57:
 Sotheby's, London, 1984
 Lawrence Gussman, New York, 1984–98

Publication history:
Cat. no. 56:
 Roberts and Roberts 1996: cat. no. 12
Cat. no. 57:
 Roberts and Roberts 1996: cat. no. 24
 LaGamma 2000: cat. no. 35

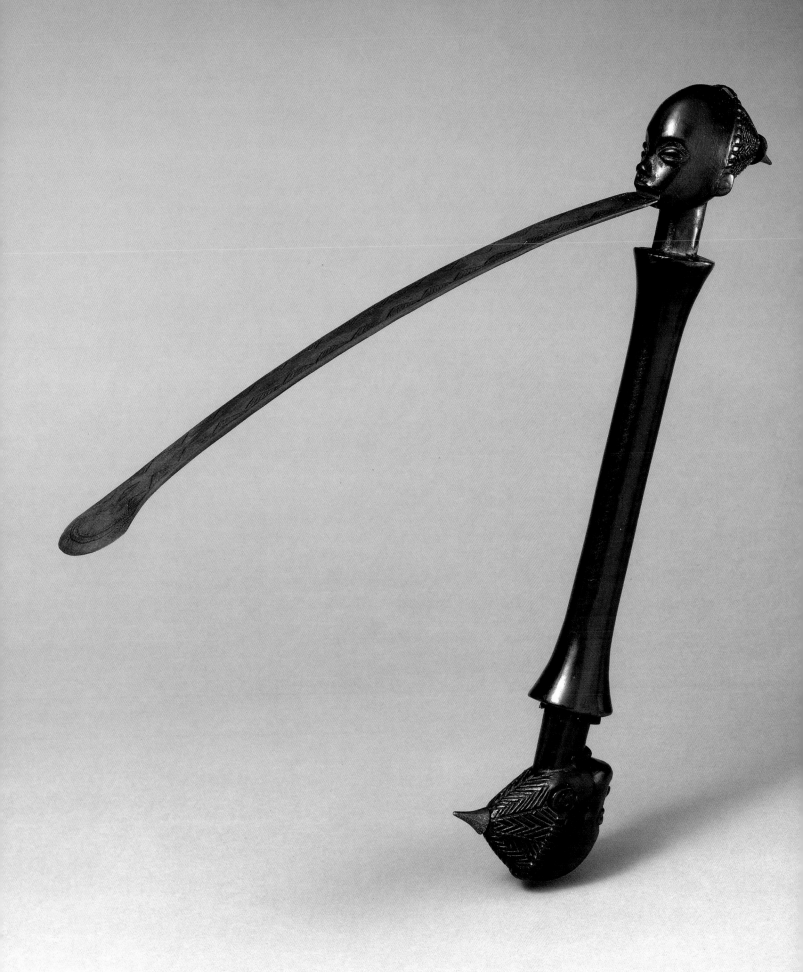

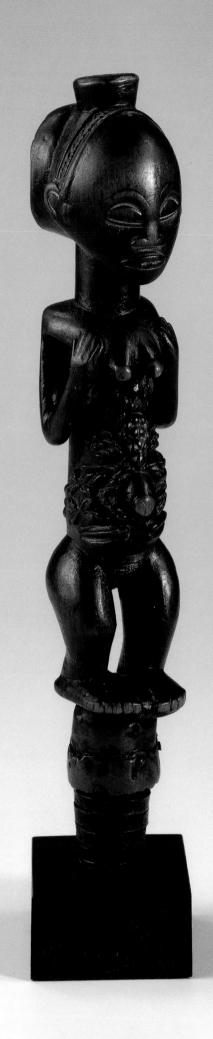

Female Figure
Luba peoples, Democratic Republic
of the Congo

19th century
Wood, copper, iron
28.6 x 3.8 x 5.1 cm (11 1/4 x 1 1/2 x 2 in.)
Collection Neuberger Museum of Art,
Purchase College, State University of New York,
gift of Lawrence Gussman in memory of
Dr. Albert Schweitzer, 1999.06.108

The serene expression of the female figure shown here, with her half-closed eyes and taut mouth, suggests the composure essential in her role as designated steward of secret knowledge pertaining to royalty. Her hands are placed firmly on the sides of her breasts, which are believed to contain the royal prohibitions upon which Luba kingship rests (Roberts and Roberts 1996: 111–12). The base is wrapped with strips of copper and iron, symbols of wealth, prosperity, and endurance, and a characteristic feature of Luba royal emblems. Once part of a larger object—a staff, spear, or bowstand—this sculpture probably served the same purpose that female figures generally do in Luba art: to symbolize the spiritual essence of a king or chief and to provide an effective receptacle for his powers (Mary Nooter Roberts, personal communication, December 1999).

Intricate scarification marks are carved in relief around the body of the figure, their raised surfaces still gleaming with traces of palm oil. Such marks, while considered beautiful and erotic by the Luba, may also be read as "a kind of personal biography inscribed on the skin, documenting a woman's experience and identity" (ibid.). Each pattern is named and conveys multiple levels of meaning. By selecting the designs she wishes to have replicated on her body, a woman chooses the messages that she communicates to others. On this female figure, the pattern of clustered marks on either side of the navel may be *kisanji*, an allusion to the music of a thumb piano, an instrument performed during the recitation of historic events (ibid.). Other identifiable designs include *milalo*, the horizontal parallel lines on the lower abdomen below the navel, and *meso a tete* ("grasshopper eyes"), which are raised, round protuberances above the buttocks. CC

Provenance:
Dr. Stephen Chauvet, Paris, before 1950
Jean Roudillon, Paris
Merton Simpson, New York
Lawrence Gussman, New York, before 1980 to 1999

Publication history:
Kunsthaus Zurich 1970: cat. no. W14
Roberts and Roberts 1996: cat. no. 34

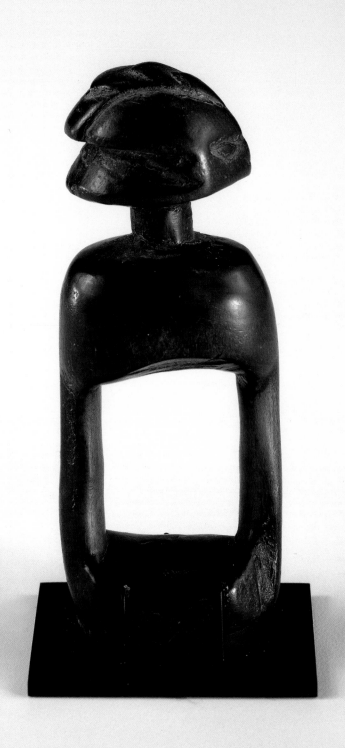

Divination Implement *(kakishi)*
Luba peoples, Democratic Republic
of the Congo

19th–20th century
Wood
12.7 x 5.1 x 3.1 cm (5 x 2 x 1 1/4 in.)
Collection Neuberger Museum of Art,
Purchase College, State University of New York,
gift of Lawrence Gussman in memory of
Dr. Albert Schweitzer, 1999.06.106

This type of small carved instrument, called a *kakishi*, is employed as an oracle by practitioners of *kashekesheke*, one of the oldest forms of divination among the Luba. In *kashekesheke*, a diviner invokes the ancestral forces known as *bafu* ("the dead") to understand and remedy a client's particular problems or misfortunes. The diviner first prepares the instrument with medicinal leaves, then begins an extensive dialogue with the spirit, asking numerous questions about the client's situation. The spirit responds by causing the device—held by both the diviner and the client—to move. The instrument rubs across the ground or a woven mat, making a "sheke-sheke" sound from which the name of the process is derived, and its motions are interpreted by the diviner (Roberts and Roberts 1996: 184–85).

The carved wooden *kakishi* is one of two types of oracles employed in *kashekesheke*, the other being a cup-shaped gourd more commonly used today. A wooden *kakishi* can be either abstract or figurative, its form determined by a diviner's consulting spirit, who visits in a dream. Regardless of its appearance, the *kakishi* is always considered female. On the instrument shown here, the stylized head has wide-set eyes and a backswept coiffure that imply a sense of motion even while still. The body of the sculpture forms a rectangular hollow, designed for grasping by the client and the diviner. The instrument would be washed only on the day of the rising of a new moon; and that night, it is rubbed with chalk to "express purity, loyalty, and gratitude to the spirit world" (ibid.: 182–84).

This example shows signs of extensive handling, particularly on the bottom, where the worn, slanted surface is the result of frequent rubbings on a mat or the ground. Likewise, the sides of the implement, held during a consultation, have been smoothed by use, reflecting the collaborative nature of the process. The success and integrity of *kashekesheke* depends on this joining of the client, who brings specific life experiences, with the diviner, who offers insightful interpretation, through the device of the *kakishi*. As a Luba proverb relates, "There is no liar in *kashekesheke* divination, because you are holding [the instrument], and so am I" (ibid.: 184). CC

Provenance:
René Vander Straete, Brussels, 1971
Lawrence Gussman, New York, 1971–99

Headrest with Female Figure
Luba peoples, Democratic Republic
of the Congo

Late 19th–early 20th century
Wood, beads
16.5 x 14 x 8.9 (6 1/2 x 5 1/2 x 3 1/2 in.)
Collection Neuberger Museum of Art,
Purchase College, State University of New York,
gift of Lawrence Gussman in memory of
Dr. Albert Schweitzer, 1999.06.105

By the late nineteenth century, Luba men and women had per-fected the art of coiffure to such an extent that Western visitors to the region referred to them as "the headdress people" (Roberts and Roberts 1996: 100, cat. no. 40). The need to protect their elaborate hairstyles, which required considerable time to create, resulted in the making of small wooden headrests used to elevate the head while sleeping (Nooter 1991: 238). The multi-tiered hor-izontal plaits of hair extending from the back of the figure's head on this headrest replicate the "cascade style," a well-known coif-fure popular in the Luba-Shankadi region until the 1920s.

The sculptor of the work shown here has translated the human body into a graceful play of geometric forms. The weight-iness of the thick columnar trunk is offset by the figure's deli-cately curving legs, which merge fluidly into the circular base. Her broad-shouldered arms support the gentle arch of the head-rest, creating a rectangular void that is punctuated by the compact head in the center. This distinctive style is seen on a number of Luba works attributable to a single artist or workshop, including a headrest in the Detroit Institute of Arts (Mary Nooter Roberts, personal communication, December 1999; see also Nooter Roberts, in Detroit Institute of Arts 1995: 154, cat. no. 79). CC

Provenance:
Mattias Lemaire, Galerie Lemaire, Amsterdam, 1968
Lawrence Gussman, New York, 1968–99

Publication history:
Hudson River Museum 1971: cat. no. 216
Walker 1976: cat. no. 102

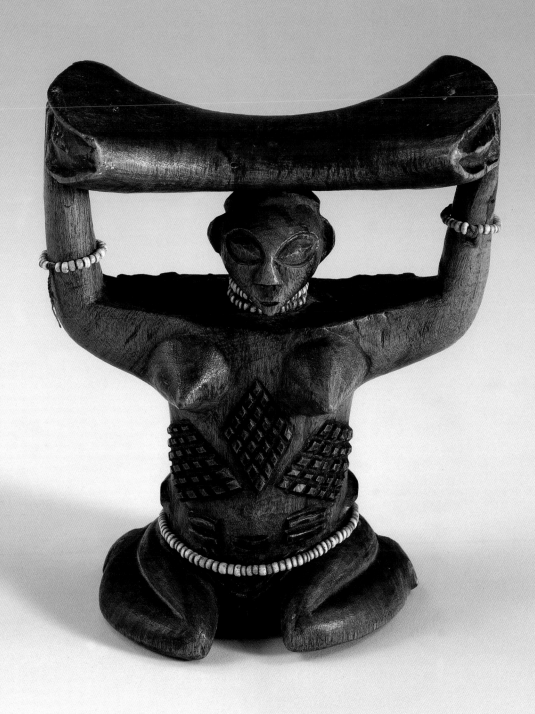

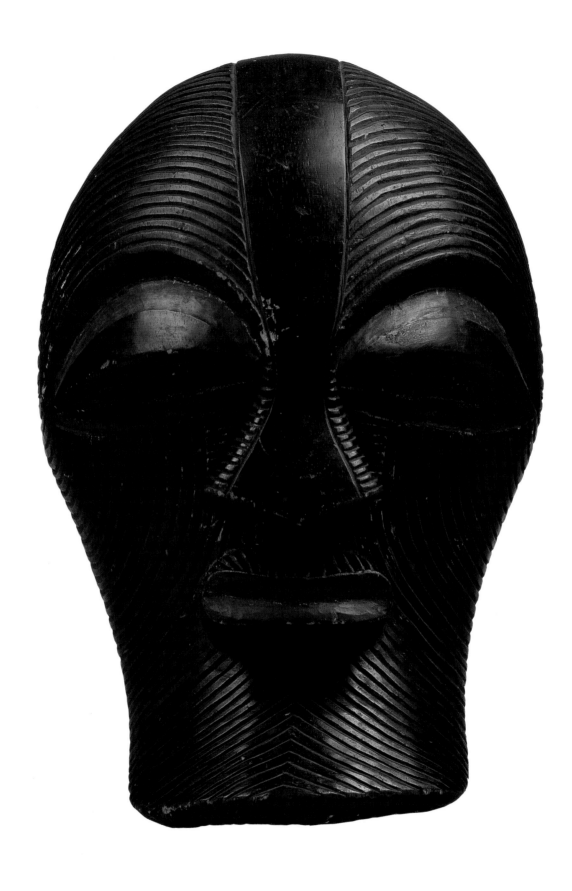

Mask *(kifwebe)*
Luba or Songye peoples, Democratic
Republic of the Congo

19th–20th century
Wood, pigment
38.1 x 25.7 x 18.4 cm (15 x 10 1/8 x 7 1/4 in.)
Collection The Israel Museum, Jerusalem,
gift of Lawrence Gussman, New York,
to American Friends of the Israel Museum in
memory of Rosaline Gussman, B97.0015

Among both the Luba and their northern neighbors, the Songye, there is a society called Bwadi bwa kifwebe, whose origin is obscure. Each of the two cultures attributes the origin of the society to the other, although it seems more likely that the Songye created it. In any case, the two branches of the society have very different functions.

The mask *(kifwebe)* used by Bwadi members has a domed forehead under which appear huge eyelids and a spatulate nose. The lower part of the face is elongated, with a protruding rectangular mouth. The whole surface is covered with parallel incised striations. Male *kifwebe* have a large crest running from front to back, while females have only a low ridge, if any.

The different elements of the Songye mask have specific symbolic meanings. The left side represents the moon, the right the sun, while the striations are their rays; the nose is the tree of life; the mouth is the beak of the bird, a sorcerer's fire, or the thick lips of a forceful speaker; and the chin or beard is a symbol of wisdom and strength (Hersak 1986: 60). Representing dangerous spirits with menacing powers of sorcery, the Songye *kifwebe* were instrumental in upholding the authority of the rulers.

Unlike the Songye *kifwebe* and their malevalent spirits, the Luba form of this mask embodies a myth of benevolent beings. The myth tells of three spirits who emerged from a ditch: the female went to live in a nearby village, while the two males elected to live in the bush; finally, all three danced together at the village and founded the Bwadi bwa kifwebe society. Luba *kifwebe* were regarded as performing the function of healers by expelling evil ghosts and sorcerers. They also appeared in male and female pairs at such important occasions as the deaths of chiefs, rites celebrat-

ing the new moon, and rituals in honor of the ancestors. Female Luba *kifwebe* are domed, while the male *kifwebe* follow Songye conventions, though with less prominent features; however, all of them are still covered with a similar system of concentric and parallel striations. Here, the striations represent scarification marks, emblematic of beauty and human culture, and also refer to the ditch from which the spirits come. DN

Provenance:
Maurice de Vlaminck, Paris, before 1937
Jay C. Leff, Uniontown, Pennsylvania, before 1959 to 1975
Lawrence Gussman, New York, 1975–96

Publication history:
Hôtel Drouot, Paris 1937: cat. no. 46
Carnegie Institute 1959: cat. no. 372
Carnegie Institute 1969: cat. no. 293
Sotheby's Park Bernet, New York 1975: cat. no. 53

Figure
Kusu peoples, Democratic Republic
of the Congo

19th–20th century
Wood, iron, encrustation
29.8 x 6.4 x 7 cm (11 3/4 x 2 1/2 x 2 3/4 in.)
Collection Neuberger Museum of Art,
Purchase College, State University of New York,
gift of Lawrence Gussman in memory of
Dr. Albert Schweitzer, 1999.06.118

The sculptor of the diminutive female figure shown here has utilized a spare geometry of form. The broad head, with facial features merely suggested in low relief, has a tapering triangular chin that projects sharply from the thick, columnar neck. Long, elegant arms flow from the squared shoulders, and the hands join together to grasp the protruding navel. A vertical line of raised scarifications runs the length of the torso from the small, rounded breasts to the navel. The truncated figure is set on an iron spike, which has a deep brownish encrustation.

Kusu figurative sculpture is relatively rare, and little is known about its use. This object, which has a cavity in the top of the head filled with symbolically charged ingredients, probably functioned as a power object. Inserted into the ground on the metal spike, such a figure may have been employed during initiatory proceedings or divination rituals. CC

Provenance:
Alain de Monbrison, Paris
Marc and Denyse Ginzberg, New York, 1983
Lawrence Gussman, New York, 1983–99

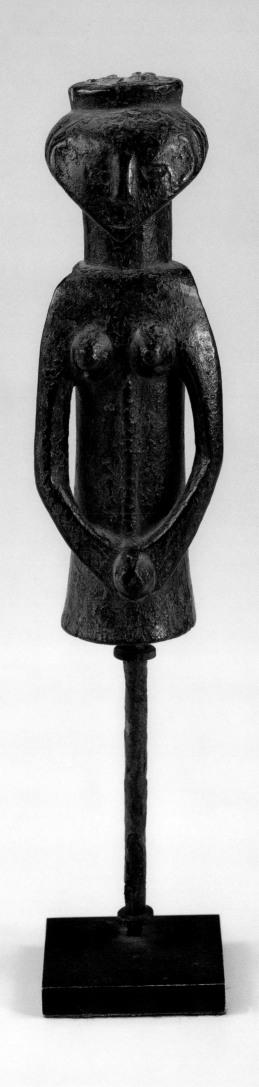

Male Figure
Hemba peoples, Democratic Republic
of the Congo

19th–20th century
Wood
69.9 x 17.8 x 16.5 cm (27 1/2 x 7 x 6 1/2 in.)
Collection Neuberger Museum of Art,
Purchase College, State University of New York,
gift of Lawrence Gussman in memory of
Dr. Albert Schweitzer, 1999.06.115

Although Hemba statuary represent specific, named ancestors, they do not purport to be a realistic representation of that person. Instead, the deceased individual is depicted as the embodiment of a youthful ideal, projecting such valued virtues as intelligence, composure, strength, energy, and fertility (Anderson and Kreamer 1989: cat. no. 20). An ancestor figure such as the one shown here would be kept in a small shrine, maintained by the chief or other men of importance, and would regularly be provided offerings by the extended families of the deceased.

This particular figure is a classic example of Hemba artistry. Symmetrical overall, it has a strong-shouldered torso that tapers and then swells into a rounded abdomen. The oval face is a study in serenity, with high, curving brows, almond-shaped eyes, an aquiline nose, and a composed mouth. The most characteristic formal element is the plaited, cruciform coiffure, a hair design that has symbolic significance. According to François Neyt, the four directions of the coiffure "evoke the universe and the place where the spirits assemble and part" (Neyt, in Royal Museum for Central Africa 1995: cat. no. 191, p. 367). CC

Provenance:
Georges Rodrigues, New York, 1971
Lawrence Gussman, New York, 1971–99

Publication history:
Vogel 1980: cat. no. 158
Anderson and Kreamer 1989: cat. no. 20
Robbins and Nooter 1989: cat. no. 1179

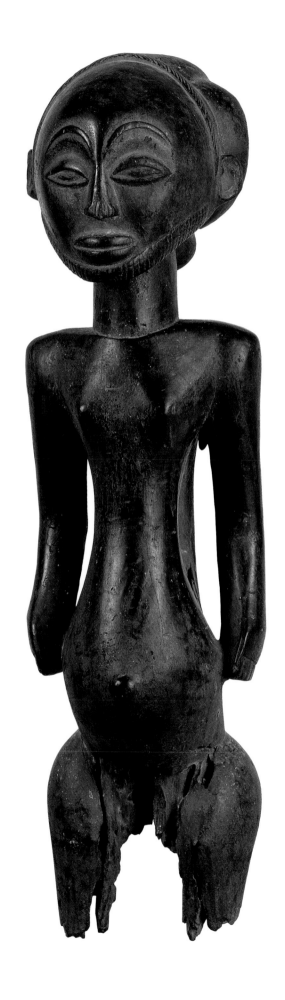

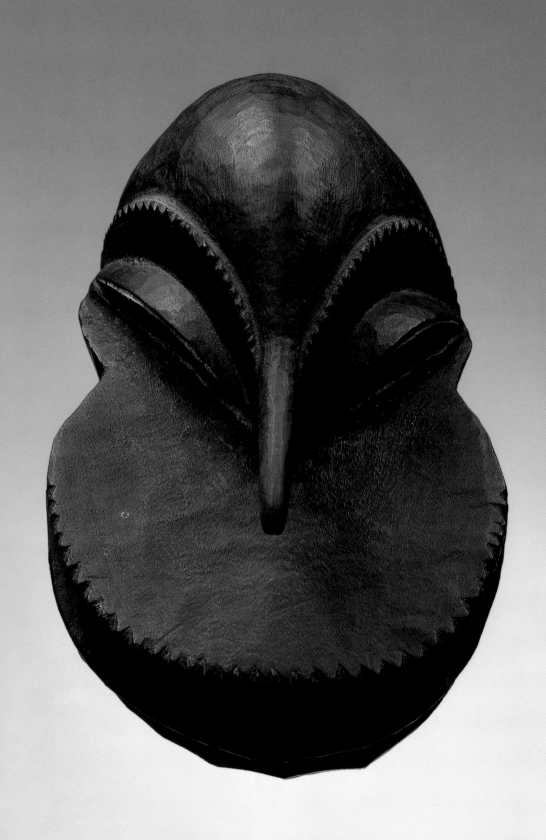

Mask *(misi gwa so'o)*
Hemba peoples, Democratic Republic
of the Congo

19th–20th century
Wood
19.7 x 14 x 20.3 cm (7 3/4 x 5 1/2 x 8 in.)
Collection The Israel Museum, Jerusalem,
gift of Lawrence Gussman, New York,
to American Friends of the Israel Museum in
memory of Dr. Albert Schweitzer, B97.0014

The *so'o* mask of the Hemba, a personification of death, has a prominent role at funerals (Blakely and Blakely 1987: 36). It is small and round, and its features are at the opposite pole from the noble faces of the ancestral statues: they are deliberately grotesque. It represents a menacing creature, half-man, half-chimpanzee, with the animal's aggressively toothy grimace—a being partly of the wild, partly of human culture (ibid.: 30, 32). At the same time, it may embody a deceased ancestor, and bear his name. In any case, it can be vengeful, likely to ruin the crops of someone who fails to join the society that reverse it.

The *so'o* seems to operate in several different contexts as well. At times other than funerals, it is said, the mask can be kept in the house to ward off evil, and it may also be carried by dancers on their belts. Like many spiritual beings, the *so'o* is capricious and ambivalent in its moods and intentions, and can be either dangerous or helpful. DN

Provenance:
René Rasmussen, Gallerie AAA, Paris, 1971
Lawrence Gussman, New York, 1971–99

Mask *(emangungu)*
Bembe peoples, southern part of
Nganza, Democratic Republic of
the Congo

19th–20th century
Wood, pigment
42.2 x 13.7 x 7.6 cm (16 5/8 x 5 3/8 x 3 in.)
Collection The Israel Museum, Jerusalem,
gift of Lawrence Gussman, New York,
to American Friends of the Israel Museum in
memory of Dr. Albert Schweitzer, B98.0056

The Bembe peoples are a forest-dwelling group formed when several others—most significantly the Lega—joined together sometime in the eighteenth century. They lived in small, widely scattered villages that they abandoned every few years, and their basic social unit was the patrilineal clan. Governance was managed through their adoption of a simplified form of the Lega peoples' Bwami society, with just two grades (see cat. no. 66 for explanation of Bwami).

The Bembe established several cults, for men and women alike. Some were ancestor cults, but most were devoted to spirits associated with nature. Figure sculptures were relatively rare and though small, were exquisitely made. Some were used for healing rites, or were owned by Bwami members and used to honor their ancestors. Several types of masks were made, some being kept as important secret objects only revealed to initiates. The most spectacular type is the *alunga*, the embodiment of a forest spirit. A barrel-shaped helmet, it has two Janus faces in which the human features are reduced to pairs of enormous oval "eyes," with small cylindrical pupils that are sometimes framed in star shapes.

A distinctive type of mask *(emangungu)*, made of wood, was used for one of the two types of circumcision rites ; no wooden masks were made for the other. A recently circumcized youth would wear this mask on the occasions when he ventured out, heavily disguised, to solicit offerings of food in nearby villages during his year-long period of seclusion in the bush. In outline, the mask is a flat plank with parallel sides, squared off at the foot and arched at the top, where a large face appears, with large circular eyes, a short nose, and a small cylindrical mouth. Below this face is another face, heart-shaped, with the same circular

eyes. The sides are bordered with strips of zigzags, and at the foot is a small panel with hourglass designs. This is clearly analogous to the *alunga* mask, especially the eye shapes, although here the eyes themselves are in relief. The Bembe probably acquired these masks from other groups; they are quite rare. DN

Provenance:
Professor Gossieaux, Liège, collected in the field before 1976
Henri Kamer, Paris, 1976
Lawrence Gussman, New York, 1976–98

Publication history:
Vogel 1980: cat. no. 175
Anderson and Kreamer 1989: 85, cat. no. 9

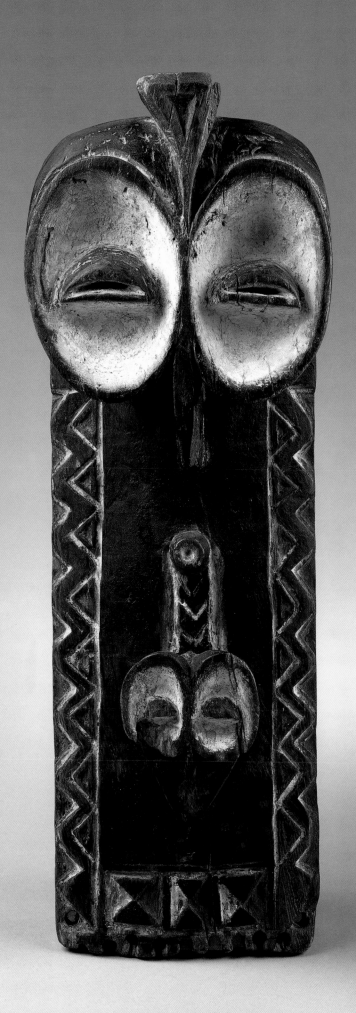

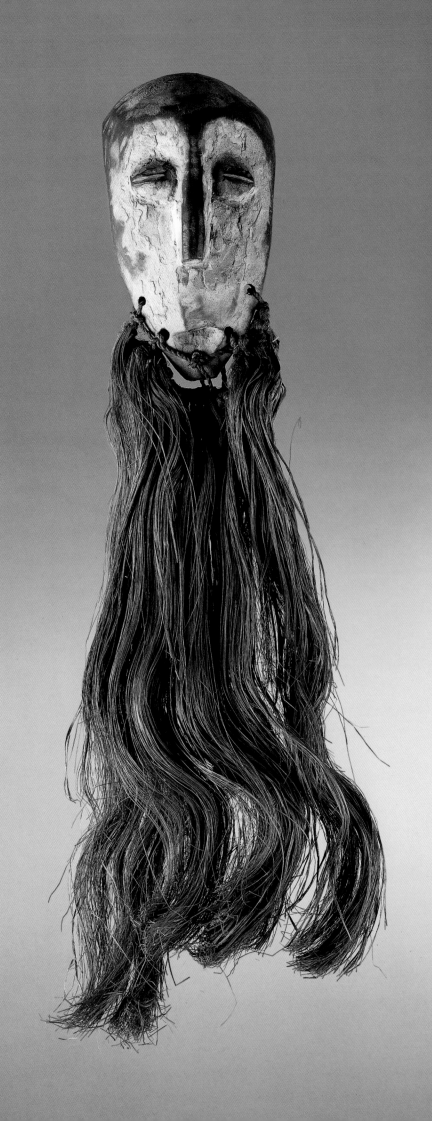

Mask *(lukwakongo)*
Lega peoples, Democratic Republic
of the Congo

19th–20th century
Wood, kaolin, raffia
43.2 x 9.1 x 4.6 cm (17 x 3 9/16 x 1 13/16 in.)
Collection The Israel Museum, Jerusalem,
gift of Lawrence Gussman, New York,
to American Friends of the Israel Museum in
memory of Dr. Albert Schweitzer, B 97.0016

The Lega, who live in the forested eastern part of the Democratic Republic of the Congo, are governed by an association called Bwami, to which all men and women seek to belong. The membership of Bwami is organized into a hierarchical series of grades, admission to which is achieved by passing through initiations. Bwami functions as the political structure of Lega society and as an educational system that advocates and upholds Lega values and morals.

Each grade has numerous objects associated with it, including stools, spoons, various items of dress, and certain types of small figures and masks made of wood, bone, or ivory. The masks *(lukwakongo)* are not intended to be worn on a person's face, although sometimes they are placed on the upper arm; they are usually displayed on racks, or carried in the hand by their raffia beards, during the rituals to which they pertain (Biebuyck 1973: 167–68). Masks made of wood, such as the one shown here, are among the paraphernalia used by male Bwami members of the second-highest grade. DN

Provenance:
Edgar Beer, Brussels, 1965
Lawrence Gussman, New York, 1965–98

Publication history:
Anderson and Kreamer 1989: 104, pl. 46

Female Janus Figure
Lega peoples, Democratic Republic
of the Congo

19th–20th century
Ivory
12.2 x 4.5 x 2.5 cm (4 3/4 x 1 3/4 x 1 in.)
Collection The Israel Museum, Jerusalem,
gift of Lawrence Gussman, New York,
to American Friends of the Israel Museum in
memory of Dr. Albert Schweitzer, B98.0060

Shown only in the Israel Museum exhibition

Bwami initiates (see cat. no. 66 for explanation of Bwami society) —including wives of men who have attained the highest grade in this association, and thus the highest grade in the parallel women's ranking—possess not only masks but also small figurative carvings in wood or ivory. Bwami is deeply involved with the ethical aspects of life; each object has attached to it an exemplary story or proverb, expressing moral virtues or vices, that is told to the initiate when the objects are handed over to him or her (Biebuyck 1973: 145–46, 148–49, 156–57). For instance, figures with more than one body or head often exemplify the farsightedness that is an ideal of high-level Bwami members. Such is probably the symbolic meaning of this Janus figure, although the specific proverb concerned seems not to be recorded. DN

Provenance:
Jean-Pierre Lepage, Brussels, 1971
Lawrence Gussman, New York, 1971–99

Publication history:
Hudson River Museum 1971: cat. no. 208
Anderson and Kreamer 1989: cat. no. 32

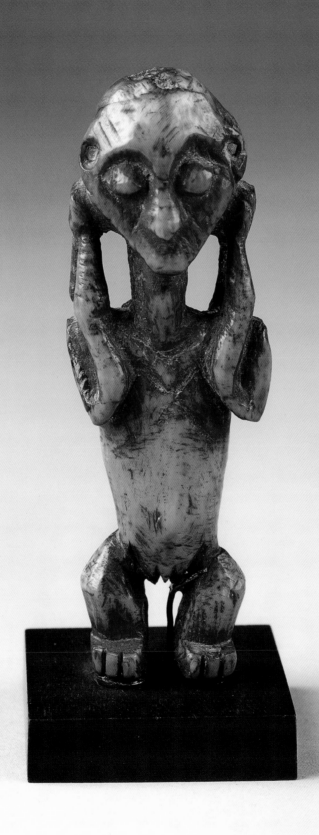

Head
Lega peoples, Democratic Republic
of the Congo

19th–20th century
Ivory, fiber, cowries
14.6 x 7.9 x 11.4 cm (5 3/4 x 3 1/8 x 4 1/2 in.)
Collection Neuberger Museum of Art,
Purchase College, State University of New York,
gift of Lawrence Gussman in memory of
Dr. Albert Schweitzer, 1999.06.135

Not shown in the Israel Museum exhibition

Ivory, prized by the Lega for its beauty, strength, and color, is the exclusive province of Bwami members (see cat. no. 66 for explanation of Bwami society)—specifically, male members of the highest two levels of *kindi* and, occasionally, of the highest-level female initiates, *kanyamwa*. Such high-ranking Bwami associates typically own one or more carved ivory sculptures as insignia of their status. The ivory head shown here belongs to the category of anthropomorphic sculpture known as *iginga*, defined as "objects that sustain the teachings and precepts of bwami" (Biebuyck, in Phillips 1995: 300). Viewed only by other high-ranking members during initiation rituals, these objects express the moral values, social principles, and legal code of the association (Biebuyck 1986, vol. 2: 61). The medium of ivory, associated with the hard, indestructible essence of the body, illustrates important Bwami concepts of permanence and continuity (Ezra 1984: 26).

Working under the direction of their Bwami patrons, Lega artists are usually unaware of the significance or function of their work unless they also happen to be a top-level initiate. The materials used by the sculptor are prescribed: he may use only the tops of the tusks, preferably the finer, lighter-shade ivory of female elephants. Artists prepare the fresh ivory by coating its surface with oil, which not only makes carving easier but also enhances the patina. This oiling process is then repeated frequently in Bwami rites by the owner of the object. The constant handling and oiling of the ivory over generations of use imparts a deep patination to the object, as seen in the rich reddish color of the head shown here (Biebuyck 1973: 228–29; Biebuyck 1986, vol. 2: 40).

Because the function and meaning of Lega sculptures can vary, it is difficult to determine the specific identity of such an object when it is removed from its original context. Here, one can say with assurance that the formal characteristics of this sculpted head refer to the highest levels of the Bwami association. The knotted fiber cap represents the Bwami skullcaps worn only by top-ranking initiates, and the bald skull and toothless mouth suggest their status as elders. Cowrie shells, in place of the eyes, symbolize the heightened vision of the initiate, while the smooth, shiny surface patina signifies the beauty and goodness that is Bwami (Biebuyck, in Vogel 1981: cat. no. 134). CC

Provenance:
Jean-Pierre Lepage, Brussels, 1971
Lawrence Gussman, New York, 1971–99

Publication history:
Ezra 1984: cat. no. 63, fig. 23
Preston 1985: cat. no. 93
Anderson and Kreamer 1989: cat. no. 59

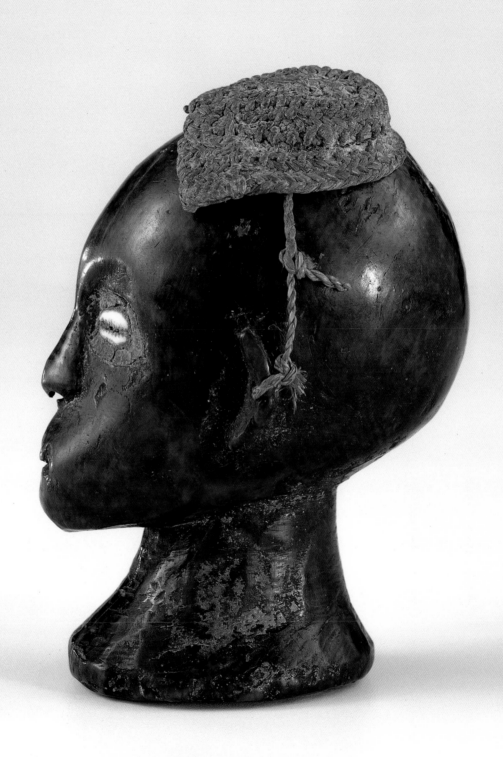

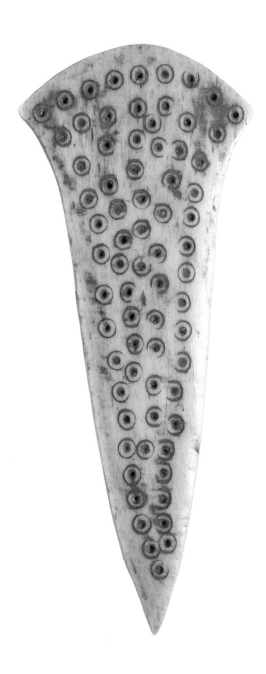

Ceremonial Blade
Lega peoples, Democratic Republic
of the Congo
19th–20th century
Ivory
13.3 x 5.7 x .6 cm (5 1/4 x 2 1/4 x 1/4 in.)
Collection Neuberger Museum of Art,
Purchase College, State University of New York,
gift of Lawrence Gussman in memory of
Dr. Albert Schweitzer, 1999.06.130

Not shown in the Israel Museum exhibition

Insignia of high-ranking Bwami members (see cat. no. 66 for explanation of Bwami society) can be non-figurative ivories as well as ivories in human or animal form. The thin ivory blade shown here may be part of the regalia of *kanyamwa* women, the top level of female Bwami initiates. The form of the blade is decorated with the circle-and-dot pattern typical of Lega sculpture. Hung from women's belts along with other small figurines, the blades symbolize the diligent work performed by initiated women (Biebuyck 1986, vol. 2: 184). CC

Provenance:
Nicolas De Kun, Brussels, before 1970
Lawrence Gussman, New York, 1970–99

Publication history:
Anderson and Kreamer 1989: cat. no. 48

Female Figure
Metoko peoples, Democratic Republic
of the Congo

19th–20th century
Wood, pigment
68.6 x 18.7 x 10.8 (27 x 7 3/8 x 4 1/4 in.)
Collection Neuberger Museum of Art,
Purchase College, State University of New York,
gift of Lawrence Gussman in memory of
Dr. Albert Schweitzer, 1999.06.138

Large figural sculptures, such as the one shown here, which represents a female, are employed by members of the Bukota society, a sociopolitical and religious organization related to the Lega peoples' Bwami association. Membership in Bukota, which includes both males and females, is based on secret initiations and is organized hierarchically. In addition to wooden sculptures, the Bukota society uses a variety of elements, including natural objects and assemblages. Members who attain the two highest ranks, *nkumi* and *kasimbi*, hold exclusive rights over some of these, although other individuals also own specific objects (Biebuyck 1976a: 52).

As with most examples of Metoko sculpture, the specific context for this example is unknown. Daniel Biebuyck, drawing upon extant ethnographic literature, details several functional categories for wooden sculpture, including initiation, funerary, peace-making, and circumcision (ibid.). These categories are not exclusionary, and many of the figures have multiple uses. Figurative sculptures usually have specific names that refer to various characters, such as a protagonist or a role model for positive behavior (ibid.).

The sculptural form of the figure shown here demonstrates an elegant play of angular and rounded lines in three dimensions. The sparely carved facial features—circular eyes and a long, slim nose—project from an elongated concave area that is rounded at the top and flat at the bottom. Dotted lines colored with white pigment, representing scarification, enhance the face, neck, and torso. The sculpture may represent Itea, a female figure that, when paired with her male counterpart Ntanda, is used in Bwami initiation rites for attaining the grade of *kasimbi*

(ibid.). As a pair, Itea and Ntanda may also serve as witnesses in peace-making discussions and as temporary receptacles for the souls of important deceased individuals during funeral rituals (Felix 1995 : 110). CC

Provenance:
Julius Carlebach, New York
Eric de Kolb, Gallery d'Hautbarr, New York, 1969
Lawrence Gussman, New York, 1969–99

Male Figure *(ofikpa)*
Mbole peoples, Democratic Republic
of the Congo

19th–20th century
Wood, pigment
50.8 x 12.7 x 10.2 cm (20 x 5 x 4 in.)
Collection Neuberger Museum of Art,
Purchase College, State University of New York,
gift of Lawrence Gussman in memory of
Dr. Albert Schweitzer, 1999.06.141

The figure shown here, with its oversize head and forward-thrusting shoulders, represents a person who was condemned to death by hanging for transgressing the rules of Lilwa, a male initiation association that plays an important role among the Mbole and neighboring cultures. Members of Lilwa oversee the education of boys aged seven to twelve in the physical, social, and moral responsibilities of adulthood. During the course of the long, arduous initiation process, the boys are shown figures such as this one, known as *ofikpa*, as examples of the fate of people who have transgressed the judicial and moral code of Lilwa.

Although there is no firsthand documentation of their exact use, it is thought that the sculptural figures are displayed at several occasions during the initiation process. During the first stage, the boys proceed through a narrow corridor, flanked by initiates who flagellate them. At the end of the corridor, the boys' initiation instructor *(isoya)* warns them to maintain the secrecy of the ritual and displays the *ofikpa* as a reminder of the consequences of disobedience. Later on, during the healing and instruction period, the youths again see the figures and learn the stories associated with each one. The figures are also used as a warning device to ensure that the initiates practice the principles of restraint and humility. Even after initiation, they must swear on the *ofikpa* if their behavior has been called into question (Biebuyck 1976b: 57–58).

Ofikpa, while identified as representing specific people, are not considered individual portraits. The figures—which may be either male (as in this example) or female—typically conform to a basic prototype. Characteristic of the sculptural genre, the figure here is carved in a hanging position, with hunched shoulders, loosely held arms, and slightly bent legs. In a particularly poignant detail, the lifeless body is suggested by the curving inward of one of the legs. The head is quite large, with a high forehead and crestlike coiffure. The facial features, barely suggested by narrow slits, have been interpreted as conveying a resigned sadness (Cornet 1971: 273). White pigment accents the heart-shaped, concave face, and contrasts with the rest of the body, which has been darkened.

Little is known about the symbolism of the form or color of these figures. Daniel Biebuyck has speculated that *ofikpa* might serve to house the spirits of criminals in order to prevent their rebirth, since the Mbole believe that the souls of the dead are reborn with their previous characteristics. In addition, Biebuyck associates the blackness of the figures with the burial practices of hanged people. He observed among the related Lalia peoples that Lilwa initiates cover parts of their body with a black substance made from palm oil and ashes to perform their dances after the burial of a hanged person (Biebuyck 1976b: 58). CC

Provenance:
Alain de Monbrison, Paris, 1978
Lawrence Gussman, New York, 1978–99

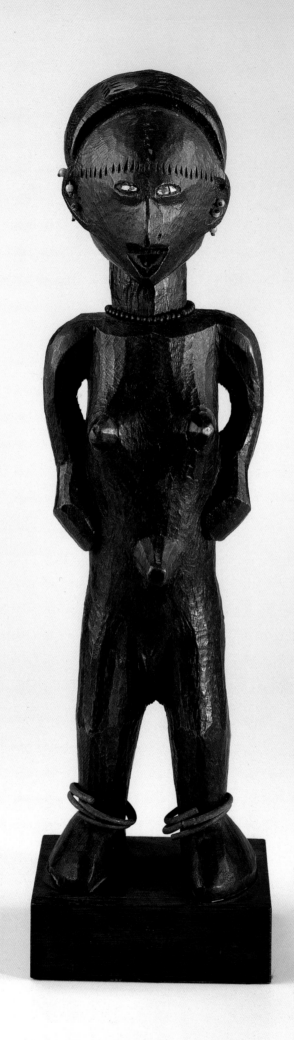

Female Figure
Possibly Ngala peoples, Democratic
Republic of the Congo

19th–20th century
Wood, beads, metal, shell
52.1 x 11.4 x 14 cm (20 1/2 x 4 1/2 x 5 1/2 in.)
Collection Neuberger Museum of Art,
Purchase College, State University of New York,
gift of Lawrence Gussman in memory of
Dr. Albert Schweitzer, 1999.06.145

The long history of migration, intermarriage, trade, and cultural exchange in the northwestern section of the Democratic Republic of Congo has resulted in a great diversity in artistic production. It is therefore often difficult to determine with any degree of certainty the cultural origin of a specific sculpture from this region. The female figure shown here exhibits stylistic traits that are characteristic of a number of area cultures, including the Ngala, Ngbaka, Ngombe, and Ngbandi. The rounded head has close-set eyes inlaid with shell; a long, thin nose; and an open, triangular mouth. The body is of overall blocky form, with stylized arms held closely to the sides of the torso and thick, slightly flexed, legs. Decorations added to the wooden sculpture include beaded earrings in the pierced ears, a necklace of blue beads, and two metal anklets on each leg.

Despite the culturally complex artistic traditions of the region, there are several elements of this figure that suggest it may be the work of an Ngala artist. The scarification marks on the face are similar to those observed by the Reverend John Weeks, a missionary of the Baptist Missionary Society who lived among the Ngala from 1890 to 1905. He reported seeing "a single line of elliptical punch-marks running from temple to temple just above the eyebrows" only on older Ngala men and women, as a marker of kinship (Weeks 1909: 101). Morever, the coiffure resembles hairstyling practices popular among the Ngala in the late nineteenth century, in which hair is drawn back and plaited in rows and also shaved from the front hairline to make the forehead appear larger (ibid.: 99). How this figure was used remains unclear, as Ngala figurative sculpture has not been the subject of extensive research to date. CC

Provenance:
Julius Carlebach, New York
Eric de Kolb, Galerie d'Hautbarr, New York, 1969
Lawrence Gussman, New York, 1969–99

Publication history:
Palais Miramar 1957: cat. no. 304
Hudson River Museum 1971: cat. no. 188

Knife with Sheath
Yakoma peoples, Democratic Republic
of the Congo

19th–20th century
Iron, copper wire, leather
45.7 x 15.2 x 5.7 cm (18 x 6 x 2 1/4 in.)
Collection Neuberger Museum of Art,
Purchase College, State University of New York,
gift of Lawrence Gussman in memory of
Dr. Albert Schweitzer, 1999.06.147

The Yakoma peoples are renowned for their abilities as smelters and metalworkers. Because they manufacture more than what is locally needed, they export much of their production to peoples living along the Ubangi River in exchange for iron (Westerdijk 1984: 31). Their expert blacksmiths produce decorative knives in several styles, but with common design elements that make their origin easily identifiable. On the example shown here, the distinctively shaped blade with its openwork areas is embellished with patterns of engraved dots, a design characteristic of Yakoma metalwork. The handle of the blade and the leather sheath are both covered with wrapped and braided copper wire. Iron cones embellish the projections, forming two small "handles" at one end of the sheath and another at its lower end; the bent cone at the lower end is a typical feature of Yakoma knives (Zirngibl 1983: 56). CC

Provenance:
André Fourquet, Paris, 1971
Lawrence Gussman, New York, 1971–99

Publication history:
Hudson River Museum 1971: cat. no. 173

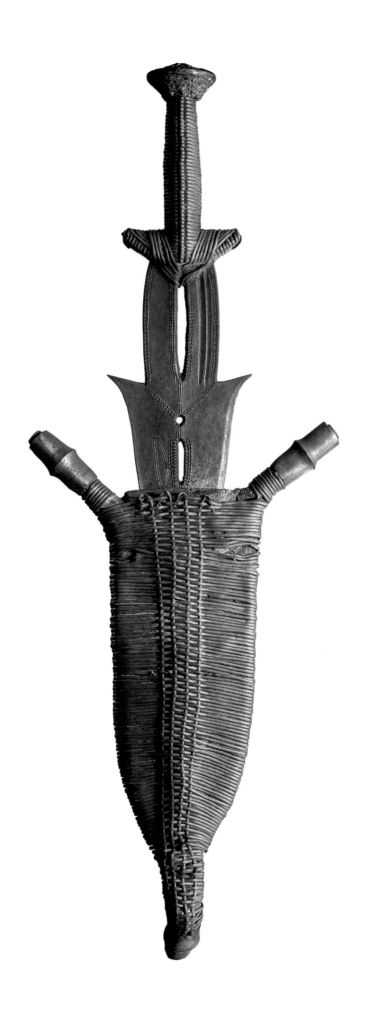

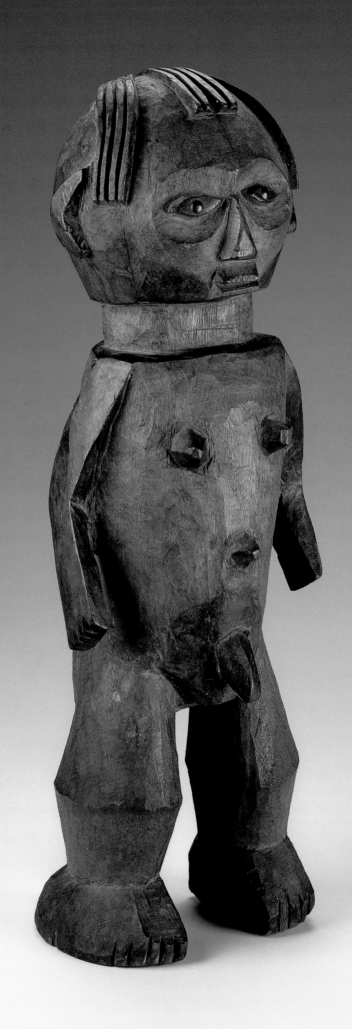

Male Figure
Ngbandi peoples, Democratic
Republic of the Congo

Late 19th–early 20th century
Wood, copper alloy
44.9 x 15.2 x 14 cm (17 11/16 x 6 x 5 1/2 in.)
Collection National Museum of African Art,
Smithsonian Institution, Washington, DC,
gift of Lawrence Gussman in memory of
Dr. Albert Schweitzer, 98-15-5

Figures such as the one shown here were owned by healer-divin-ers and by anti-sorcerers (men who combated witches). Ngbandi beliefs are complex and not fully documented, but a simplified explanation would be that the figure represents power over spirit forces, and that the figure's owner was a force for good who combated individuals possessed by malevolent spirits (Tanghe 1929: 122).

The size, pose, and simplified volumetric forms of this figure are typical of the art of several peoples in the Ubangi region, although the absence of scarification designs on the head is unusual. Sculpture from this region is attributed to the Ngbandi peoples relatively rarely; in this instance, it is based on the dis-tinctive W-form hairstyle (compare Burssens 1958: cat. nos. 26, 36, 39). Basiel Tanghe, a Capuchin priest who did fieldwork among the Ngbandi, took photographs of similar beaded hairstyles worn by Ngbandi boys and girls and collected descriptions given to him of adult hairstyles no longer in use (Tanghe 1929: 200–201). The W-form arrangement of this figure's carved strands is similar to the hairstyles recorded by Tanghe in the early 20th century. BF

Provenance:
Jef Vander Straete, Brussels, before 1962
Harold Rome, New York, 1962–70
Lawrence Gussman 1970–98

Publication history:
Syracuse University School of Art 1964: 29, cat. no. 43
Hudson River Museum 1971: cat. no. 189
Vogel 1980: cat. no. 185

Female Figure *(yanda: nazeze* type)
Zande peoples, Democratic Republic
of the Congo

19th–early 20th century
Wood
24.1 x 9.2 x 7.9 cm (9 1/2 x 3 5/8 x 3 1/8 in.)
Collection The Israel Museum, Jerusalem,
gift of Lawrence Gussman, New York,
to American Friends of the Israel Museum in
memory of Dr. Albert Schweitzer, B98.0061

Like the Mangbetu, the Zande peoples were invaders from the north who established their sovereignty over a large region. Although they were frequently at war with the Mangbetu, their cultures had much in common, including their aggressive character, their architecture, and the style of their art.

Sculptures created by the Zande include small figures *(yanda)* made for the Mani society, which are intended to promote the well-being of its members, especially their health, prosperity, safety from sorcery, and general success (Schildkrout and Keim 1990: 222). Most *yanda* are made of wood, and some are of pottery. The *nazeze*—one of several types of *yanda*—are human figures, usually armless, with large heads, torsos, and stumps of legs treated as somewhat abstract geometric forms, and often decorated with glass beads and brass rings. The figures are apparently meant to represent females but often have a markedly phallic appearance, as in this example. DN

Provenance:
Harold Rome, London, before 1964 to 1973
Lawrence Gussman, New York, 1973–98

Publication history:
Syracuse University School of Art 1964: cat. no. 31
Vogel 1980: cat. no. 181

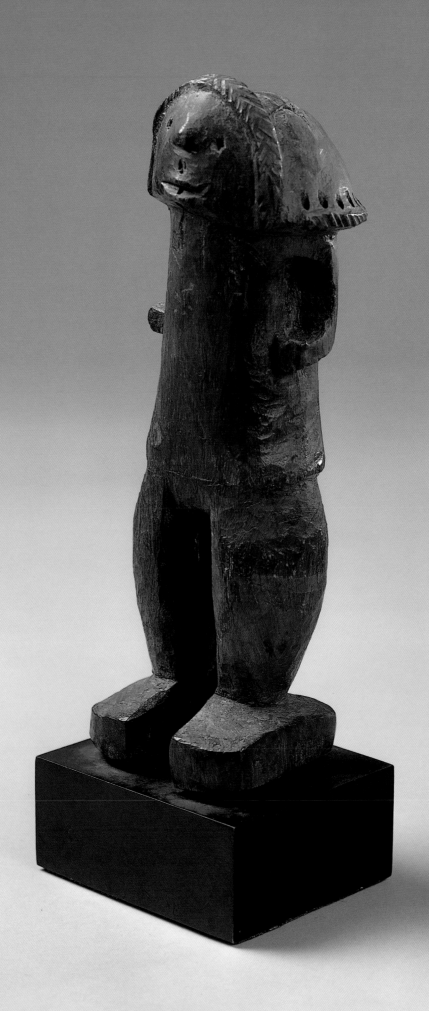

Selected Bibliography

Anderson, Martha G., and Christine Mullen Kreamer. 1989. *Wild Spirits, Strong Medicine: African Art and the Wilderness.* New York: The Center for African Art.

Bastin, Marie-Louise. 1961. *Art Decoratif Tshokwe.* Lisbon: Museu do Dundo.

———. 1982. *La Sculpture Tshokwe.* Trans. by J. B. Donne. Meudon: Alain and Françoise Chaffin.

———. 1984. *Introduction aux Arts d'Afrique.* Arnouville: Arts d'Afrique Noire.

Biebuyck, Daniel. 1973. *Lega Culture.* Berkeley: University of California Press.

———. 1976a. "Sculpture from Eastern Zaire Forest Regions: Metoko, Lengola and Komo," *African Arts* 10(1): 54–61.

———. 1976b. "Sculpture from Eastern Zaire Forest Regions: Mbole, Yela and Pere," *African Arts* 10(2): 52–58.

———. 1986. *The Arts of Zaire.* 2 vols. Berkeley: University of California Press.

Blakely, Thomas D. and Pamela A. R. Blakely. 1987. "So'o Masks and Hemba Funerary Festival," *African Arts* 21 (1): 30–37, 84–86.

Bourgeois, Arthur. 1978. "Suku Drinking Cups," *African Arts* 12(1): 76–77, 108.

———. 1984. *Art of the Yaka and Suku.* Meudon, France: Alain and Françoise Chaffin.

———. 1985. *The Yaka and Suku.* Leiden: Brill.

Brincard, Marie-Thérèse, ed. 1989. *Sounding Forms: African Musical Instruments.* New York: American Federation of Arts.

Burssens, Herman. 1958. *Les peuplades de l'entre Congo-Ubangi: Ngbandi, Ngbaka, Ngombe et gens d'eau.* London: International African Institute.

Cameron, Elisabeth. 1998. "Potential and Fulfilled Women: Initiations, Sculpture, and Masquerades in Kabompo District, Zambia." In *Chokwe! Art and Initiation among Chokwe and related Peoples.* Ed. by Manuel Jordan. Munich; New York: Prestel-Verlag.

Carnegie Institute, Department of Fine Arts. 1959. *Exotic Art from Ancient and Primitive Civilizations: Collection of Jay C. Leff.* Pittsburgh.

Carnegie Institute, Museum of Art. 1969. *The Art of Black Africa, Collection of Jay C. Leff.* Pittsburgh.

Center for African Art. 1987. *Perspectives: Angles on African Art.* New York.

Chaffin, Alain and Françoise Chaffin. 1979. *L'Art Kota.* Meudon: Alain and Françoise Chaffin.

Cornet, Joseph. 1971. *Art of Africa: Treasures from the Congo.* Trans. by Barbara Thompson. New York: Phaidon Press.

Delange, Jacqueline. 1967. *Arts et peuples de l'Afrique noire.* Paris: Gallimard.

Detroit Institute of Arts. 1995. *African Masterworks in the Detroit Institute of Arts.* Essays by Michael Kan and Roy Sieber. Washington and London: Smithsonian Institution Press.

DeVale, Sue Carole. 1989. "African Harps: Construction, Decoration, and Sound." In *Sounding Forms: African Musical Instruments.* Ed. by Marie-Thérèse Brincard. New York: The American Federation of Arts.

Elisofon, Eliot and William Fagg. 1958. *The Sculpture of Africa.* New York: Frederick A. Praeger.

Ezra, Kate. 1984. *African Ivories.* New York: Metropolitan Museum of Art.

Fagg, William. 1970a. *African Sculpture.* Washington, DC: International Exhibitions Foundation.

———. 1970b. *Miniature Wood Carvings of Africa.* Bath, England: Adams & Dart and Greenwich, CT: New York Graphic Society.

Féau, Etienne. 1999. *Batéké: Peintres et sculpteurs d'Afrique centrale.* Paris: Réunion des Musées Nationaux.

Felix, Marc L. 1987. *One Hundred Peoples of Zaire and Their Sculpture: The Handbook.* Brussels: Zaire Basin Art History Research Foundation.

———. 1995. *Art et Kongos: les peuples Kongophones et leur sculpture biteki bia bakongo.* Brussels: Zaire Basin Art History Research Center.

Fernandez, James W. 1982. *Bwiti: An Ethnography of the Religious Imagination in Africa.* Princeton: Princeton University Press.

Fernandez, James W. and Renate L. Fernandez. 1975. "Fang Reliquary Art: Its Quantities and Qualities," *Cahiers des Etudes Africaines* 60 (4): 723–746.

Fischer, Eberhard and Manfred Zirngibl. 1978. *African Weapons.* Passau: Prinz-Verlag.

Fry, Jacqueline. 1978. *Vingt-cinq sculptures africaines = Twenty-five African Sculptures.* Ottowa: National Gallery of Canada for the Corporation of the National Museums of Canada.

Gollnhofer, Otto, with Pierre Sallée and Roger Sillans. 1975. *Art et artisanat tsogho.* Paris: Office de la recherche scientifique et technique outré-mer.

Hersak, Djuna. 1986. *Songye Masks and Figure Sculpture.* London: Ethnographica.

Hotel Drouot. 1937. *Tableaux Modernes, Sculptures Africaines et Océaniennes; Collection de M. Maurice de Vlaminck.* Auction catalogue. Paris.

———. 1972. *Arts Primitifs, collection de Geneviève Rodier et appartenant à divers.* Auction catalogue. Paris.

Hottot, Robert. 1956. "Teke Fetishes," *The Journal of the Royal Anthropological Institute of Great Britain and Ireland.* 86 (1): 25–40.

The Hudson River Museum. 1971. *African Art in Westchester from Private Collections.* Yonkers, New York: the Hudson River Museum.

Jacobson-Widding, Anita. 1979. *Red-White-Black as a Mode of Thought: A Study of Triadic Classification by Colours in the Ritual Symbolism and Cognitive Thought of the Peoples of the Lower Congo.* Stockholm: Uppsala.

Koloss, Hans-Joachim, ed. 1999. *Afrika: Kunst und Kultur. 200 Meisterwerke afrikanischer Kunst.* Berlin: Museum fur Volkerkunde, Prestel.

Kreamer, Christine Mullen. 1986. *Art of Sub-Saharan Africa: The Fred and Rita Richman Collection.* Atlanta: The High Museum of Art.

Kunsthaus Zurich. 1970. *Die Kunst von Schwartz-Afrika.* Zurich: Kunsthaus Zurich.

LaGamma, Alisa. 1996. "The Art of the Punu *Mukudj* Masquerade: Portrait of an Equatorial Society." Ph.D. dissertation. Columbia University.

———. 2000. *Art and Oracle: African Art and Rituals of Divination.* New York: The Metropolitan Museum of Art.

Laurenty, Jean-Sébastien. 1974. *La systématique des aérophones de l'Afrique centrale.* Tervuren, Belgium: Musée Royale de l'Afrique Centrale.

Lehuard, Raoul. 1989. *Art Bakongo: Les Centres de Style.* Vol. 2. Arnouville, France: Arts d'Afrique noire.

———. 1996. *Les Arts Bateke: Congo–Gabon–Zaire.*

Leuzinger, Elsy. 1971. *The Art of Black Africa.* Trans. by R. A. Wilson. London: Studio Vista.

MacGaffey, Wyatt and Michael Harris. 1993. *Astonishment and Power.* Washington, DC: Smithsonian Institution for the National Museum of African Art.

Musée de l'Homme. 1966. *Arts connues et arts méconnues de l'Afrique noire.* Paris: Musée de l'Homme.

Museum of African Art. 1970. *The Language of African Art.* Washington, DC: Museum of African Art.

The National Museum of African Art. 1981. "Life...Afterlife, African Funerary Sculpture" (exh. booklet). Washington, DC: the National Museum of African Art, Smithsonian Institution.

Neyt, François. 1982. *L'Art Holo du Haut-Kwango.* Munich: Fred Jahn.

Nicklin, Keith. 1983. "Kuyu Sculpture at the Powell-Cotton Museum," *African Arts* 17 (1): 55–59.

Nooter, Mary H. 1991. "Luba Art and State Formation: Deconstructing Power in a Central African Polity." Ph.D. dissertation, Columbia University.

Norborg, Ake. 1989. *A Handbook of Musical and Other Sound-Producing Instruments from Equatorial Guinea and Gabon.* Stockholm: Musikmuseets Skrifter 16.

Palais Miramar. 1957. *Premiere Exposition Retrospective Internationale des Arts d'Afrique et d'Oceanie.* Cannes: Palais Miramar.

Perrois, Louis. 1973. "La Statuaire des Fang du Gabon," *Arts d'Afrique Noire* 22–42.

———. 1979. *Arts du Gabon.* Arnouville, France: Arts d'Afrique Noire.

———. 1986. *Ancestral Art of Gabon from the Collections of the Barbier-Mueller Museum.* Trans. by Francine Farr. Geneva: Barbier-Mueller Museum.

———. 1992. *Byeri Fang: Sculptures d'ancétres en Afrique.* Marseilles: Reunion des Musées Nationaux.

Perrois, Louis and Marta Sierra Delage. 1990. *The Art of Equatorial Guinea: The Fang Tribes.* New York: Rizzoli; Barcelona: Folch Foundation.

Petridis, Constantine. 1997. "Of Mothers and Sorcerers: A Luluwa Maternity Figure," *The Art Institute of Chicago Museum Studies* 23, 2: 183–200.

Phillips, Tom, ed. 1995. *Africa: The Art of a Continent.* London: Royal Academy of Arts; Munich: Prestel.

Preston, George Nelson. 1985. *Sets, Series, Ensembles in African Art.* New York: the Center for African Art and Harry N. Abrams.

Raponda-Walker, André and Roger Sillans. 1962. *Rites et croyances des peuples du Gabon.* Paris: Présence Africaine.

Robbins, Warren M. and Nancy Ingram Nooter. 1989. *African Art in American Collections.* Washington and London: Smithsonian Institution Press.

Roberts, Mary Nooter, and Allen F. Roberts, eds. 1996. *Memory: Luba Art and the Making of History.* New York: The Center for African Art; Munich: Prestel.

Royal Museum for Central Africa. 1995. *Treasures from the Africa-Museum Tervuren.* Tervuren: Royal Museum for Central Africa.

Royal Museum for Central Africa. 1996. *Masterpieces from Central Africa.* Ed. by Gustaaf Verswijver et al. Munich and New York: Prestel for the Royal Museum of Central Africa, Tervuren.

Schildkrout, Enid, and Curtis Keim. 1990. *African Reflections: Art from Northeastern Zaire.* New York: American Museum of Natural History.

Segy, Ladislas. 1952. *African Sculpture Speaks.* New York: A. A. Wyn.

Sieber, Roy and Roslyn Adele Walker. 1987. *African Art in the Cycle of Life.* Washington, DC: Smithsonian Institution Press for the National Museum of African Art.

Siroto, Leon. 1968. "The Face of Bwiti," *African Arts* 1(3): 22–27, 86–89, 96.

———. 1981. Review of *L'Art Kota*, by Alain and Francoise Chaffin, 1979. In *African Arts* 14(4): 80–86.

———. 1991. "Spoons from Western Equatorial Africa." In *Spoons in African Art*. Ed. by Lorenz Homberger. Zurich: Rietberg Museum.

———. 1995. *East of the Atlantic, West of the Congo: Art from Equatorial Africa from the Dwight and Blossom Strong Collection*. Ed. by Kathleen Berrin. San Francisco: The Fine Arts Museums of San Francisco.

———. 1996. "Fang." In *The Dictionary of Art*. Ed. by Jane Turner. New York: MacMillan Publishers Limited.

Söderberg, Bertil. 1975. "Les figures d'ancêtres chez les babembé," *Arts d'Afrique Noire* 13: 21–33.

Sotheby and Co. 1972. *Catalogue of Primitive Art....* Auction catalogue (July 11). London.

Sotheby Park Bernet. 1975. *Important African, Oceanic and Pre-Columbian Art: The Property of Jay C. Leff, Uniontown, Pennsylvania*. Auction catalogue. New York.

Spring, Christopher. 1993. *African Arms and Armour*. London: British Museum Press.

Syracuse University, School of Art. 1964. *Masterpieces of African Sculpture*. Syracuse, NY: Syracuse University, School of Art.

Tanghe, Basiel. 1929. *De Ngbandi naar het leven geschetst*. Brugge: De Gruuthuuse Persen.

Tessman, Gunter. 1913. *Die Pangwe*. Berlin: E. Wasmuth.

Thompson, Robert Farris, and Joseph Cornet. 1981. *Four Moments of the Sun: Kongo Art in Two Worlds*. Washington, DC: National Gallery of Art.

Timmermans, P. 1966. "Essai de Typologie de la Sculpture des Bena Luluwa du Kasai," *Africa-Tervuren* 12(1): 17–27.

University of Florida, University Gallery. 1967. *African Tribal Art from the Jay C. Leff Collection*. Gainesville, Florida: University of Florida.

Ville de Malines. 1956. *Art Primitif Collection J. Vanderstraete*. De Zalm.

Vogel, Susan. 1980. *African Sculpture: The Shape of Surprise*. Greenvale, New York: C.W. Post Art Gallery.

———. 1981. *For Spirits and Kings: African Art from the Paul and Ruth Tishman Collection*. New York: Metropolitan Museum of Art.

Walker, Roslyn. 1976. *African Women/African Art*. New York: African American Institute.

Weeks, John H. 1909. "Anthropological Notes on the Bangala of the Upper Congo River," *Journal of the Royal Anthropological Institute* 39: 97–136.

Werth, Albert Johannes. 1970. *Kuns van Afrika/Art of Africa*. Pretoria: Pretoria Art Museum.

Westerdijk, Peter. 1984. *African Metal Implements: Weapons, Tools, and Regalia*. Greenvale, NY: Hillwood Art Gallery.

West Virginia University, University Museum, Creative Arts Center. 1969. *African Tribal Art from the Jay C. Leff Collection*. Morgantown, West Virginia.

Zirngibl, Manfred A. 1983. *Seltene Afrikanische Kurzwaffen/Rares armes courtes africaines/Rare African Short Weapons*. Grafenau, Bavaria: Morsak.

Catalogue of the Exhibition

1 Male Reliquary Guardian Figure *(eyema bieri)*
(one of a pair)
Fang peoples, Ngumba style, Cameroon
Late 19th–early 20th century
Wood, brass sheet, mirror glass
51.1 x 17.1 x 12.7 cm (20 1/8 x 6 3/4 x 5 in.)
Collection The Israel Museum, Jerusalem, gift
of Lawrence Gussman, New York, to American
Friends of the Israel Museum in memory of
Dr. Albert Schweitzer, and David C. Miller, and
in honor of Rhena Schweitzer Miller, B97.004a

2 Female Reliquary Guardian Figure *(eyema bieri)*
(second of a pair)
Fang peoples, Ngumba style, Cameroon
Late 19th–early 20th century
Wood, brass sheet, mirror glass
53.3 x 17.1 x 13.2 cm (21 x 6 3/4 x 5 1/4 in.)
Collection The Israel Museum, Jerusalem, gift
of Lawrence Gussman, New York, to American
Friends of the Israel Museum in memory
of Dr. Albert Schweitzer, and David C. Miller,
and in honor of Rhena Schweitzer Miller,
B97.004b

3 Male Reliquary Guardian Figure *(eyema bieri)*
Fang peoples, Ntumu style, Equatorial Guinea
Late 19th–early 20th century
Wood, pigment
73.7 x 16.5 x 15.2 cm (29 x 6 1/2 x 6 in.)
Collection Neuberger Museum of Art,
Purchase College, State University of New York,
gift of Lawrence Gussman in memory of
Dr. Albert Schweitzer, 1999.06.51

4 Male Reliquary Guardian Figure *(eyema bieri)*
Fang peoples, Gabon
Late 19th–early 20th century
Wood, oil
69.9 x 16.5 x 12.1 cm (27 1/2 x 6 1/2 x 4 3/4 in.)
Collection Neuberger Museum of Art,
Purchase College, State University of New York,
gift of Lawrence Gussman in memory of
Dr. Albert Schweitzer, 1999.06.47

5 Male Reliquary Guardian Figure *(eyema bieri)*
Fang peoples, Ntumu style, Oyem region, Gabon
Late 19th–early 20th century
Wood, pigment, fiber, nails
34.4 x 9.4 x 9.5 cm (13 9/16 x 3 11/16 x 3 3/4 in.)
Collection National Museum of African Art,
Smithsonian Institution, Washington, DC, gift of
Lawrence Gussman in memory of Dr. Albert
Schweitzer, 98-15-13

6 Female Reliquary Guardian Figure *(eyema bieri)*
Fang peoples, Gabon
Late 19th–early 20th century
Wood
49.5 x 16.8 x 15.2 cm (19 1/2 x 6 5/8 x 6 in.)
Collection The Israel Museum, Jerusalem, gift
of Lawrence Gussman, New York, to American
Friends of the Israel Museum in memory of
Catharine R. Gussman, B97.0071

7 Female Reliquary Guardian Figure *(eyema bieri)*
Fang peoples, Gabon
Late 19th–early 20th century
Wood, brass
49.2 x 14.9 x 15.2 cm (19 3/8 x 5 7/8 x 6 in.)
Collection The Israel Museum, Jerusalem, gift
of Lawrence Gussman, New York, to American
Friends of the Israel Museum in memory of
Dr. Albert Schweitzer, B98.0055

8 Half-length Figure on Reliquary Lid
Fang peoples, Gabon
Late 19th–early 20th century
Wood, bark, cane, brass tacks
35.6 x 14.9 x 16.2 cm (14 x 5 7/8 x 6 3/8 in.)
Collection The Israel Museum, Jerusalem, gift
of Lawrence Gussman, New York, to American
Friends of the Israel Museum in memory of
Dr. Albert Schweitzer, B97.0005

9 Harp *(ngombi)*
Fang peoples, Gabon
Early 20th century
Wood, hide, pigment, metal, nylon strings
69.9 x 19.1 x 53.3 cm (27 1/2 x 7 1/2 x 21 in.)
Collection Neuberger Museum of Art,
Purchase College, State University of New York,
gift of Lawrence Gussman in memory of
Dr. Albert Schweitzer, 1999.06.39

10 Four-faced Helmet Mask *(ngontang)*
Fang peoples, Gabon
Early 20th century
Wood, kaolin, pigment
33.3 x 22.2 x 26.7 cm (13 1/8 x 8 3/4 x 10 1/2 in.)
Collection The Israel Museum, Jerusalem, gift
of Lawrence Gussman, New York, to American
Friends of the Israel Museum in memory of
Dr. Albert Schweitzer, B97.0006

11 Arm Mask *(betsuga)* (one of a pair)
Fang peoples, Gabon
Early 20th century
Wood, leather, kaolin
15.2 x 5.7 x 1.3 cm (6 x 2 1/4 x 1/2 in.)
Collection Neuberger Museum of Art,
Purchase College, State University of New York,
gift of Lawrence Gussman in memory of
Dr. Albert Schweitzer, 1999.06.44

12 Arm Mask (betsuga) (second of a pair)
 Fang peoples, Gabon
 Early 20th century
 Wood, leather, kaolin
 15.2 x 5.7 x 1.9 cm (6 x 2 1/4 x 3/4 in.)
 Collection Neuberger Museum of Art,
 Purchase College, State University of New York,
 gift of Lawrence Gussman in memory of
 Dr. Albert Schweitzer, 1999.06.45

13 Fan
 Fang or neighboring peoples, Gabon
 20th century
 Wood, hide, gold paint
 34.3 x 21.6 x 2.5 cm (13 1/2 x 8 1/2 x 1 in.)
 Collection Neuberger Museum of Art,
 Purchase College, State University of New York,
 gift of Lawrence Gussman in memory of
 Dr. Albert Schweitzer, 1999.06.49

14 Reliquary Guardian Figure (bwiti)
 Hongwe peoples, Gabon
 19th–early 20th century
 Wood, copper-alloy sheet and wire, iron
 58.4 x 24.8 x 7.6 cm (23 x 9 3/4 x 3 in.)
 Collection The Israel Museum, Jerusalem, gift
 of Lawrence Gussman, New York, to American
 Friends of the Israel Museum in memory of
 Dr. Albert Schweitzer, B97.0009

15 Reliquary Guardian Figure
 Possibly Shamaye or northern Obamba
 peoples, Gabon
 19th–early 20th century
 Wood, copper-alloy sheet and strips, bone
 39.4 x 10.2 x 5.1 cm (15 1/2 x 4 x 2 in.)
 Collection Neuberger Museum of Art,
 Purchase College, State University of New York,
 gift of Lawrence Gussman in memory of
 Dr. Albert Schweitzer, 1999.06.59

16 Reliquary Guardian Figure (mbulu ngulu)
 Kota peoples, Franceville district, Gabon
 19th–early 20th century
 Wood, copper sheet, copper-alloy sheet and
 wire, iron, bone
 53.3 x 27 x 2.9 cm (21 x 10 5/8 x 1 1/8 in.)
 Collection The Israel Museum, Jerusalem, gift
 of Lawrence Gussman, New York, to American
 Friends of the Israel Museum in memory of
 Dr. Albert Schweitzer, B98.0052

17 Mask
 Possibly Kota peoples, Gabon
 19th–20th century
 Wood, copper-alloy sheet
 16.2 x 15.9 x 25.4 cm (6 3/8 x 6 1/4 x 10 in.)
 Collection The Israel Museum, Jerusalem, gift
 of Lawrence Gussman, New York, to American
 Friends of the Israel Museum in memory of
 Dr. Albert Schweitzer, B98.1060

18 Ritual Knife (musele)
 Kota peoples, Gabon
 19th–20th century
 Iron, wood, copper alloy
 27.3 x 27.3 x 3.5 cm (10 3/4 x 10 3/4 x 3/8 in.)
 Collection Neuberger Museum of Art,
 Purchase College, State University of New York,
 gift of Lawrence Gussman in memory of
 Dr. Albert Schweitzer, 1999.06.58

19 Whistle
 Possibly Kwele peoples, Gabon and Republic
 of the Congo
 20th century
 Wood
 9.5 x 14.6 x 7.6 cm (3 3/4 x 5 3/4 x 3 in.)
 Collection Neuberger Museum of Art,
 Purchase College, State University of New York,
 gift of Lawrence Gussman in memory of
 Dr. Albert Schweitzer, 1999.06.53

20 Mask (mvudi)
 Aduma or Mbete peoples, Gabon and Republic
 of the Congo
 19th–20th century
 Wood, pigment
 36.2 x 10.2 x 8.9 cm (14 1/4 x 4 x 3 1/2 in.)
 Collection The Israel Museum, Jerusalem, gift
 of Lawrence Gussman, New York, to American
 Friends of the Israel Museum in memory or
 Dr. Albert Schweitzer, B97.0007

21 Reliquary Figure
 Mbete peoples, Gabon
 19th–20th century
 Wood, pigment, copper-alloy strips, fiber,
 brass tacks
 48.9 x 12.7 x 10.2 cm (19 1/4 x 5 x 4 in.)
 Collection Neuberger Museum of Art,
 Purchase College, State University of New York,
 gift of Lawrence Gussman in memory of
 Dr. Albert Schweitzer, 1999.06.54

22 Gong (mokenge)
 Tsogo peoples, Gabon
 Early 20th century
 Iron, wood, pigment, copper alloy
 43.4 x 12.5 x 8.4 cm (17 1/16 x 4 15/16 x 3 5/16 in.)
 Collection National Museum of African Art,
 Smithsonian Institution, Washington, DC, gift of
 Lawrence Gussman in memory of Dr. Albert
 Schweitzer, 98-15-14

23 Reliquary Guardian Half-Figure (mbumba bwiti)
 Tsogo peoples, Gabon
 20th century
 Wood, pigment, copper alloy
 40 x 8.9 x 10.8 cm (15 3/4 x 3 1/2 x 4 1/4 in.)
 Collection Neuberger Museum of Art,
 Purchase College, State University of New York,
 gift of Lawrence Gussman in memory of
 Dr. Albert Schweitzer, 1999.06.72

24 Reliquary Guardian Head (mbumba bwiti)
 Vuvi or Tsogo peoples, Gabon
 Early 20th century
 Wood, pigment, copper alloy
 30.5 x 11.6 x 10.2 cm (12 x 4 9/16 x 4 in.)
 Collection National Museum of African Art,
 Smithsonian Institution, Washington, DC, gift of
 Lawrence Gussman in memory of Dr. Albert
 Schweitzer, 98-15-12

25 Face Mask (mukudj)
 Punu or Lumbo peoples, Gabon
 First half of 20th century
 Wood, pigment, kaolin
 32.1 x 17.8 x 15.2 cm (12 5/8 x 7 x 6 in.)
 Collection The Israel Museum, Jerusalem, gift
 of Lawrence Gussman, New York, to American
 Friends of the Israel Museum in memory of
 Dr. Albert Schweitzer, B97.0008

26 Face Mask (mukudj)
 Undetermined attribution, southern Gabon
 19th–early 20th century
 Wood, textile, kaolin, pigment
 29.2 x 14 x 15.9 cm (11 1/2 x 5 1/2 x 6 1/4 in.)
 Collection Neuberger Museum of Art,
 Purchase College, State University of New York,
 gift of Lawrence Gussman in memory of
 Dr. Albert Schweitzer, 1999.06.61

27 Female Figure (kosi)
 Punu or Lumbo peoples, Gabon
 19th–20th century
 Wood, metal bell, fiber, pigment
 24.1 x 10.2 x 5.1 cm (9 1/2 x 4 x 2 in.)
 Collection Neuberger Museum of Art,
 Purchase College, State University of New York,
 gift of Lawrence Gussman in memory of
 Dr. Albert Schweitzer, 1999.06.65

28 Female Figure (kosi)
 Lumbo peoples, Gabon
 Early 20th century
 Wood, leopard's teeth, copper alloy, pigment
 42.1 x 16.5 x 11.4 cm (16 9/16 x 6 1/2 x 4 1/2 in.)
 Collection National Museum of African Art,
 Smithsonian Institution, Washington, DC, gift of
 Lawrence Gussman in memory of Dr. Albert
 Schweitzer, 98-15-3

29 Spoon with Female Figure
 Undetermined attribution, southern Gabon
 20th century
 Wood
 17.8 x 5.1 x 5.1 cm (7 x 2 x 2 in.)
 Collection Neuberger Museum of Art,
 Purchase College, State University of New York,
 gift of Lawrence Gussman in memory of
 Dr. Albert Schweitzer, 1999.06.71

30 Female Figure
Kuyu peoples, Republic of the Congo
19th–20th century
Wood
56 x 19 x 13 cm (22 x 7 1/2 x 5 1/8 in.)
Collection The Israel Museum, Jerusalem, gift
of Lawrence Gussman, New York to American
Friends of the Israel Museum in memory of
Dr. Albert Schweitzer, B98.0058

31 Male Figure (buti)
Teke peoples, Republic of the Congo
Late 19th–early 20th century
Wood, buttons, encrustation
43.2 x 8.3 x 10.2 cm (17 x 3 1/4 x 4 in.)
Collection Neuberger Museum of Art,
Purchase College, State University of New York,
gift of Lawrence Gussman in memory of
Dr. Albert Schweitzer, 1999.06.77

32 Figure (nkira ntswo)
Teke peoples, Republic of the Congo and
Democratic Republic of the Congo
19th–20th century
Wood, encrustation
21.5 x 3.8 x 7.6 cm (8 1/2 x 1 1/2 x 3 in.)
Collection Neuberger Museum of Art,
Purchase College, State University of New York,
gift of Lawrence Gussman in memory of
Dr. Albert Schweitzer, 1999.06.78

33 Male Figure
Bembe peoples, Republic of the Congo
19th–20th century
Wood, textile, ceramic
50.8 x 11.4 x 12.1 cm (20 x 4 1/2 x 4 3/4 in.)
Collection Neuberger Museum of Art,
Purchase College, State University of New York,
gift of Lawrence Gussman in memory of
Dr. Albert Schweitzer, 1999.06.73

34 Figure (nkisi)
Bembe peoples, Republic of the Congo and
Democratic Republic of the Congo
Late 19th–early 20th century
Wood, feathers, hide, textile, fiber, mirror,
ceramic, hair
43 x 5.1 x 19.4 cm (16 15/16 x 2 x 7 5/8 in.)
Collection National Museum of African Art,
Smithsonian Institution, Washington, DC, gift of
Lawrence Gussman in memory of Dr. Albert
Schweitzer, 98-15-10

35 Dog Figure (nkisi kozo)
Kongo peoples, Democratic Republic of
the Congo
Late 19th–early 20th century
Wood, resin, mirror, ceramic
7.8 x 13.5 x 5.3 cm (3 1/16 x 5 5/16 x 2 1/16 in.)
Collection National Museum of African Art,
Smithsonian Institution, Washington, DC, gift of
Lawrence Gussman in memory of Dr. Albert
Schweitzer, 98-15-8

36 Bell (dibu)
Kongo peoples, Democratic Republic of
the Congo
Late 19th–early 20th century
Wood, stone
21.8 x 12.1 x 10.5 cm (8 9/16 x 4 3/4 x 4 1/8 in.)
Collection National Museum of African Art,
Smithsonian Institution, Washington, DC, gift of
Lawrence Gussman in memory of Dr. Albert
Schweitzer, 98-15-9

37 Kneeling Figure (ntadi)
Kongo peoples, Democratic Republic of
the Congo
16th–19th century
Steatite
34.3 x 13 x 16.2 cm (13 1/2 x 5 1/8 x 6 3/8 in.)
Collection The Israel Museum, Jerusalem, gift of
Lawrence Gussman, New York, to American
Friends of the Israel Museum in honor of Sarita
Gantz, B97.0018

38 Whistle (yisoledi)
Yaka peoples, Democratic Republic of the Congo
19th–20th century
Wood
11.1 x 3.8 x 4.4 cm (4 3/8 x 1 1/2 x 1 3/4 in.)
Collection Neuberger Museum of Art,
Purchase College, State University of New York,
gift of Lawrence Gussman in memory of
Dr. Albert Schweitzer, 1999.06.80

39 Figure (khosi)
Yaka peoples, Democratic Republic of the Congo
19th–20th century
Wood
48.3 x 20.3 x 22.9 cm (19 x 8 x 9 in.)
Collection Neuberger Museum of Art,
Purchase College, State University of New York,
gift of Lawrence Gussman in memory of
Dr. Albert Schweitzer, 1999.06.79

40 Female Figure (biteki)
Suku peoples, Democratic Republic of the Congo
19th–20th century
Wood
48.9 x 12.4 x 12.7 cm (19 1/4 x 4 7/8 x 5 in.)
Collection The Israel Museum, Jerusalem, gift of
Lawrence Gussman, New York, to American
Friends of the Israel Museum in honor of James
Shasha, B97.0011

41 Cup (kopa)
Suku peoples, Democratic Republic of the Congo
19th–20th century
Wood, brass tack
8.9 x 13.3 x 6.4 cm (3 1/2 x 5 1/4 x 2 1/2 in.)
Collection Neuberger Museum of Art,
Purchase College, State University of New York,
gift of Lawrence Gussman in memory of
Dr. Albert Schweitzer, 1999.06.81

42 Stringed Instrument (kalumbeti or kakosha)
Holo peoples, Luremo region, Angola
20th century
Wood, nylon strings
48.3 x 15.2 x 9.5 cm (19 x 6 x 3 3/4 in.)
Collection Neuberger Museum of Art,
Purchase College, State University of New York,
gift of Lawrence Gussman in memory of
Dr. Albert Schweitzer, 1999.06.84

43 Vessel in Form of Female
Wongo peoples, Democratic Republic of
the Congo
Early 20th century
Wood
27.5 x 9 x 7.5 cm (10 13/16 x 3 9/16 x 2 15/16 in.)
Collection National Museum of African Art,
Smithsonian Institution, Washington, DC, gift of
Lawrence Gussman in memory of Dr. Albert
Schweitzer, 98-15-4

44 Vessel in Form of Drum
Kuba peoples, Democratic Republic of the Congo
19th–20th century
Wood
22.5 x 11.7 x 11.7 cm (8 7/8 x 4 5/8 x 4 5/8 in.)
Collection The Israel Museum, Jerusalem,
gift of Lawrence Gussman to American Friends
of the Israel Museum in memory of Dr. Albert
Schweitzer, B97.0021

45 Vessel in Form of Female Figure
Kuba peoples, Democratic Republic of the Congo
19th–20th century
Wood
21.6 x 10.2 x 14 cm (8 1/2 x 4 x 5 1/2 in.)
Collection Neuberger Museum of Art,
Purchase College, State University of New York,
gift of Lawrence Gussman in memory of
Dr. Albert Schweitzer, 1999.06.90

46 Bowl
Kuba peoples, Democratic Republic of the Congo
19th–20th century
Wood
7.9 x 15.9 x 15.2 cm (3 1/8 x 6 1/4 x 6 in.)
Collection Neuberger Museum of Art,
Purchase College, State University of New York,
gift of Lawrence Gussman in memory of
Dr. Albert Schweitzer, 1999.06.91

47 Ngady amwaash Mask
 Kuba Peoples, Democratic Republic of the Congo
 19th–20th century
 Wood, textile, pigment, beads, cowries
 26.7 x 17.8 x 21.6 cm (10 1/2 x 7 x 8 1/2 in.)
 Collection Neuberger Museum of Art,
 Purchase College, State University of New York,
 gift of Lawrence Gussman in memory of
 Dr. Albert Schweitzer, 1999.06.92

48 Female Figure (bwanga bwa bwimpe or lupingu
 lwa bwimpe)
 Lulua peoples, Democratic Republic of the Congo
 19th–20th century
 Wood
 25.4 x 5.1 x 5.1 cm (10 x 2 x 2 in.)
 Collection The Israel Museum, Jerusalem, gift
 of Lawrence Gussman, New York, to American
 Friends of the Israel Museum in honor of
 Herbert Gussman, B97.0012

49 Female Figure (bwanga bwa bwimpe or lupingu
 lwa bwimpe)
 Lulua peoples, Democratic Republic of the Congo
 19th–20th century
 Wood
 29.8 x 6.3 x 6.4 cm (11 3/4 x 2 1/2 x 2 in.)
 Collection Neuberger Museum of Art,
 Purchase College, State University of New York,
 gift of Lawrence Gussman in memory of
 Dr. Albert Schweitzer, 1999.06.96

50 Mask (kibwabwabwa)
 Kete or Mbagani peoples, Democratic Republic
 of the Congo
 19th–20th century
 Wood, kaolin, pigment
 28.3 x 18.7 x 17.1 cm (11 1/8 x 7 3/8 x 6 3/4 in.)
 Collection The Israel Museum, Jerusalem, gift
 of Lawrence Gussman, New York, to American
 Friends of the Israel Museum in memory of
 Dr. Albert Schweitzer, B97.0017

51 Mother and Child Figure
 Lwena peoples, Democratic Republic of the
 Congo, Angola, and Zambia
 19th–20th century
 Wood
 19.4 x 5.7 x 5.1 cm (7 5/8 x 2 1/4 x 2 in.)
 Collection The Israel Museum, Jerusalem, gift
 of Lawrence Gussman, New York, to American
 Friends of the Israel Museum in memory of
 Dr. Albert Schweitzer, B98.0059

52 Female Figure
 Lwena peoples, Democratic Republic of the
 Congo, Angola, and Zambia
 20th century
 Wood
 36.8 x 7 x 7.6 cm (14 1/2 x 2 3/4 x 3 in.)
 Collection Neuberger Museum of Art,
 Purchase College, State University of New York,
 gift of Lawrence Gussman in memory of
 Dr. Albert Schweitzer, 1999.06.100

53 Staff of Office (kibango)
 Luba peoples, Lualaba River region, Democratic
 Republic of the Congo
 19th–20th century
 Wood, iron, copper alloy, beads, cord
 150.4 x 12.7 x 6.4 cm (59 1/4 x 5 x 2 1/2 in.)
 Collection The Israel Museum, Jerusalem, gift
 of Lawrence Gussman, New York, to American
 Friends of the Israel Museum in memory of
 Dr. Albert Schweitzer, B97.0013

54 Staff of Office (kibango)
 Luba peoples, Democratic Republic of the Congo
 19th–20th century
 Wood, copper
 148.6 x 14 x 5.7 cm (58 1/2 x 5 1/2 x 2 1/4 in.)
 Collection Neuberger Museum of Art,
 Purchase College, State University of New York,
 gift of Lawrence Gussman in memory of
 Dr. Albert Schweitzer, 1999.06.109

55 Staff of Office (kibango)
 Luba peoples, Democratic Republic of the Congo
 19th–20th century
 Wood
 148.6 x 10.2 x 6.4 cm (58 1/2 x 4 x 2 1/2 in.)
 Collection Neuberger Museum of Art,
 Purchase College, State University of New York,
 gift of Lawrence Gussman in memory of
 Dr. Albert Schweitzer, 1999.06.110

56 Ceremonial Axe (kibiki or kasolwa)
 Luba peoples, Democratic Republic of the Congo
 19th century
 Wood, iron, copper
 31.1 x 22.9 x 6 cm (12 1/4 x 9 x 2 3/8 in.)
 Collection The Israel Museum, Jerusalem, gift
 of Lawrence Gussman, New York, to American
 Friends of the Israel Museum in memory of
 Dr. Albert Schweitzer, B98.1061

57 Ceremonial Adze (nseso)
 Luba peoples, Democratic Republic of the Congo
 19th century
 Wood, iron
 34.3 x 40.6 x 3.2 cm (13 1/2 x 16 x 1 1/4 in.)
 Collection Neuberger Museum of Art,
 Purchase College, State University of New York,
 gift of Lawrence Gussman in memory of
 Dr. Albert Schweitzer, 1999.06.112

58 Female Figure
 Luba peoples, Democratic Republic of the Congo
 19th century
 Wood, copper, iron
 28.6 x 3.8 x 5.1 cm (11 1/4 x 1 1/2 x 2 in.)
 Collection Neuberger Museum of Art,
 Purchase College, State University of New York,
 gift of Lawrence Gussman in memory of
 Dr. Albert Schweitzer, 1999.06.108

59 Divination Implement (kakishi)
 Luba peoples, Democratic Republic of the Congo
 19th–20th century
 Wood
 12.7 x 5.1 x 3.1 cm (5 x 2 x 1 1/4 in.)
 Collection Neuberger Museum of Art,
 Purchase College, State University of New York,
 gift of Lawrence Gussman in memory of
 Dr. Albert Schweitzer, 1999.06.106

60 Headrest with Female Figure
 Luba peoples, Democratic Republic of the Congo
 Late 19th–early 20th century
 Wood, beads
 16.5 x 14 x 8.9 (6 1/2 x 5 1/2 x 3 1/2 in.)
 Collection Neuberger Museum of Art,
 Purchase College, State University of New York,
 gift of Lawrence Gussman in memory of
 Dr. Albert Schweitzer, 1999.06.105

61 Mask (kifwebe)
 Luba or Songye peoples, Democratic Republic
 of the Congo
 19th–20th century
 Wood, pigment
 38.1 x 25.7 x 18.4 cm (15 x 10 1/8 x 7 1/4 in.)
 Collection The Israel Museum, Jerusalem, gift
 of Lawrence Gussman, New York, to American
 Friends of the Israel Museum in memory of
 Rosaline Gussman, B97.0015

62 Female Figure
 Kusu peoples, Democratic Republic of the Congo
 19th–20th century
 Wood, iron, encrustation
 29.8 x 6.4 x 7 cm (11 3/4 x 2 1/2 x 2 3/4 in.)
 Collection Neuberger Museum of Art,
 Purchase College, State University of New York,
 gift of Lawrence Gussman in memory of
 Dr. Albert Schweitzer, 1999.06.118

63 Male Figure
 Hemba peoples, Democratic Republic of
 the Congo
 19th–20th century
 Wood
 69.9 x 17.8 x 16.5 cm (27 1/2 x 7 x 6 1/2 in.)
 Collection Neuberger Museum of Art,
 Purchase College, State University of New York,
 gift of Lawrence Gussman in memory of
 Dr. Albert Schweitzer, 1999.06.115

64 Mask *(misi gwa so'o)*
Hemba peoples, Democratic Republic of
the Congo
19th–20th century
Wood
19.7 x 14 x 20.3 cm (7 3/4 x 5 1/2 x 8 in.)
Collection The Israel Museum, Jerusalem, gift
of Lawrence Gussman, New York, to American
Friends of the Israel Museum in memory of
Dr. Albert Schweitzer, B97.0014

65 Mask *(emangungu)*
Bembe peoples, southern part of Nganza,
Democratic Republic of the Congo
19th–20th century
Wood, pigment
42.2 x 13.7 x 7.6 cm (16 5/8 x 5 3/8 x 3 in.)
Collection The Israel Museum, Jerusalem, gift
of Lawrence Gussman, New York, to American
Friends of the Israel Museum in memory of
Dr. Albert Schweitzer, B98.0056

66 Mask *(lukwakongo)*
Lega peoples, Democratic Republic of the Congo
19th–20th century
Wood, kaolin, raffia
43.2 x 9.1 x 4.6 cm (17 x 3 9/16 x 1 13/16 in.)
Collection The Israel Museum, Jerusalem, gift
of Lawrence Gussman, New York, to American
Friends of the Israel Museum in memory of
Dr. Albert Schweitzer, B 97.0016

67 Female Janus Figure
Lega peoples, Democratic Republic of the Congo
19th–20th century
Ivory
12.2 x 4.5 x 2.5 cm (4 3/4 x 1 3/4 x 1 in.)
Collection The Israel Museum, Jerusalem, gift
of Lawrence Gussman, New York, to American
Friends of the Israel Museum in memory of
Dr. Albert Schweitzer, B98.0060
Shown only in the Israel Museum exhibition

68 Head
Lega peoples, Democratic Republic of the Congo
19th–20th century
Ivory, fiber, cowries
14.6 x 7.9 x 11.4 cm (5 3/4 x 3 1/8 x 4 1/2 in.)
Collection Neuberger Museum of Art,
Purchase College, State University of New York,
gift of Lawrence Gussman in memory of
Dr. Albert Schweitzer, 1999.06.135
Not shown in the Israel Museum exhibition

69 Ceremonial Blade
Lega peoples, Democratic Republic of the Congo
19th–20th century
Ivory
13.3 x 5.7 x .6 cm (5 1/4 x 2 1/4 x 1/4 in.)
Collection Neuberger Museum of Art,
Purchase College, State University of New York,
gift of Lawrence Gussman in memory of
Dr. Albert Schweitzer, 1999.06.130
Not shown in the Israel Museum exhibition

70 Female Figure
Metoko peoples, Democratic Republic of
the Congo
19th–20th century
Wood, pigment
68.6 x 18.7 x 10.8 (27 x 7 3/8 x 4 1/4 in.)
Collection Neuberger Museum of Art,
Purchase College, State University of New York,
gift of Lawrence Gussman in memory of
Dr. Albert Schweitzer, 1999.06.138

71 Male Figure *(ofikpa)*
Mbole peoples, Democratic Republic of
the Congo
19th–20th century
Wood, pigment
50.8 x 12.7 x 10.2 cm (20 x 5 x 4 in.)
Collection Neuberger Museum of Art,
Purchase College, State University of New York,
gift of Lawrence Gussman in memory of
Dr. Albert Schweitzer, 1999.06.141

72 Female Figure
Possibly Ngala peoples, Democratic Republic
of the Congo
19th–20th century
Wood, beads, metal, shell
52.1 x 11.4 x 14 cm (20 1/2 x 4 1/2 x 5 1/2 in.)
Collection Neuberger Museum of Art,
Purchase College, State University of New York,
gift of Lawrence Gussman in memory of
Dr. Albert Schweitzer, 1999.06.145

73 Knife with Sheath
Yakoma peoples, Democratic Republic of
the Congo
19th–20th century
Iron, copper wire, leather
45.7 x 15.2 x 5.7 cm (18 x 6 x 2 1/4 in.)
Collection Neuberger Museum of Art,
Purchase College, State University of New York,
gift of Lawrence Gussman in memory of
Dr. Albert Schweitzer, 1999.06.147

74 Male Figure
Ngbandi peoples, Democratic Republic of
the Congo
Late 19th–early 20th century
Wood, copper alloy
44.9 x 15.2 x 14 cm (17 11/16 x 6 x 5 1/2 in.)
Collection National Museum of African Art,
Smithsonian Institution, Washington, DC, gift of
Lawrence Gussman in memory of Dr. Albert
Schweitzer, 98-15-5

75 Female Figure *(yanda: nazeze type)*
Zande peoples, Democratic Republic of the
Congo
19th–early 20th century
Wood
24.1 x 9.2 x 7.9 cm (9 1/2 x 3 5/8 x 3 1/8 in.)
Collection The Israel Museum, Jerusalem, gift
of Lawrence Gussman, New York, to American
Friends of the Israel Museum in memory of
Dr. Albert Schweitzer, B98.0061